ARTISTS/HAWAII

JOAN CLARKE AND DIANE DODS, EDITORS
DANA EDMUNDS, PHOTOGRAPHER

UNIVERSITY OF HAWAI'I PRESS
HONOLULU

Published by University of Hawai'i Press
2840 Kolowalu Street, Honolulu, HI 96822

Design by Communication Design Corporation
Honolulu, HI 96816

Printed in Singapore by Tien Wah Printing Co. Ltd.

01 00 99 98 97 96 5 4 3 2 1

LIBRARY OF CONGRESS CATALOGING-IN-PUBLICATION DATA

Artists/Hawaii / Joan Clarke and Diane Dods, editors ;
 photography by Dana Edmunds.
 p. cm.
 ISBN 0-8248-1859-8 (alk. paper)
 1. Artists—Hawaii—Interviews. 2. Art, American—Hawaii.
 3. Art, Modern—20th century—Hawaii. I. Clarke, Joan, 1949–
 II. Dods, Diane, 1945–
 N6530.H3A76 1996
 709.9'969'09045—dc20 96–11756
 CIP

CONTENTS

V PREFACE

VI INTRODUCTION

THE ARTISTS

2 SATORU ABE

8 ALLYN BROMLEY

14 GAYE CHAN

20 DOROTHY FAISON

26 SALLY FRENCH

32 ALAN LEITNER

38 RICK MILLS

44 HIROKI MORINOUE

50 JOHN TAKAMI MORITA

56 MARCIA MORSE

62 TIMOTHY P. OJILE

68 FRED H. ROSTER

74 FRANCO SALMOIRAGHI

80 TADASHI SATO

86 ESTHER SHIMAZU

92 LAURA SMITH

98 TOSHIKO TAKAEZU

104 MASAMI TERAOKA

110 MICHAEL TOM

116 ROY VENTERS

122 SUZANNE WOLFE

128 DOUG YOUNG

134 PHOTO CREDITS

Dedicated to the artists of Hawaii

When we began this project, we had no idea how fascinating it would be to get to know twenty-two artists in Hawaii. Whether it be with camera, paint, bronze, clay, paper, glass, wood, or a combination of media, these contemporary artists from Oahu, Maui, Kauai, and Hawaii represent a diverse spectrum of personalities and works of art. And each has become a voice for artistic expression in Hawaii.

Among the hundreds of artists who live and work in the fiftieth state, we found the field of artists to be wide and the talent so deep that it was difficult to know whom to include. We used a novel approach, adapting a two-tier nomination process developed by sociologist Floyd Hunter in his assessment of community power.

In the first phase, we asked a broad cross section of nominators—curators, collectors, critics, and others interested in the visual arts—to recommend artists born or residing in Hawaii whom they thought should be featured in *Artists/ Hawaii*. More than 160 artists working in a variety of media were mentioned.

In the second phase, forty-five of the most mentioned artists were asked to nominate twenty peers from the original list of 160. Those included in this book are the twenty-two artists most mentioned by their colleagues.

Interviews with the artists followed, using a series of questions that would capture a personal picture of the artist and his or her work. We asked them to talk about their background, their style and medium, and how Hawaii influenced their work. We asked about mentors in their careers and "If you could meet any artist anywhere in the world at any point in time, who would it be?" These personal and revealing sketches are presented in the first person, reflecting the conversation of the interviews.

We are indebted to the nominators and artists who gave us their time, attention and enthusiastic support. Special thanks for their support and cooperation go to Georgiana Lagoria and James Jensen, The Contemporary Museum; George Ellis, Honolulu Academy of Arts; Sharon Smith, The Persis Collection; and Ron Yamakawa, Hawaii State Foundation on Culture and the Arts.

University of Hawaii art professors Duane Preble and Tom Klobe visited with each artist to select the works featured in this book. Two pieces were identified as "career best" and two as outstanding recent works. Duane's and Tom's perseverance in search of the best reveals their appreciation of the artists' work and their knowledge of each artist's career.

Photographer Dana Edmunds photographed all of the artists and their work, except for those where high-quality, reproducible transparencies already existed. Dana's challenge was to capture the unique personae of the artists in their studios, lofts, or residences. His talent, keen insight, dedication, and sense of humor were central to the project.

Designer Kunio Hayashi of Communication Design Corporation created a book that speaks of art in itself. His bold ideas and commitment to perfection carried the design process.

When we approached William Hamilton, director of the University of Hawai'i Press, with the idea of publishing this book, we were delighted with his immediate and enthusiastic response. We appreciate Bill's personal support of the project and assistance throughout this undertaking.

Jeffrey Watanabe, Ronald Leong, and Seth Reiss of Watanabe, Ing and Kawashima, got us through the nuts and bolts, providing sound legal guidance and documentation for our project. Artistic support and encouragement came from Nick Ng Pack, Mike Wagner, and Jim Fitts of Milici Valenti Ng Pack. Gerry Keir offered a skilled editorial hand. Aloha Airlines and Budget Rent-A-Car provided assistance with transportation.

Finally, we thank First Hawaiian Bank for its commitment to the arts and to this publication. Island artists and their works hold a special interest at First Hawaiian Bank; its chairman, Walter Dods, initiated and underwrote this project in support of the art community. In addition, The Contemporary Museum at First Hawaiian Center has been dedicated exclusively to the works of Hawaii artists. It will no doubt serve to further enhance their creative talents.

We are pleased to commit the royalties from this book to The Contemporary Museum and to the University of Hawai'i Press. Together with First Hawaiian Bank, their participation produced this tribute to these twenty-two contemporary artists of Hawaii.

JOAN CLARKE AND DIANE DODS
EDITORS

PREFACE

INTRODUCTION

"If there is anything that unites contemporary artists
of Hawaii, it perhaps has as much to do with a geographic
consideration as an aesthetic one. Living and working
on a group of islands surrounded in all directions by vast
stretches of water, the natural perspective is of limitless
horizons. That circumstance, like the human creative spirit,
is free of confines and restrictions, expansive, expectant,
and always hopeful."

JAMES JENSEN
THE CONTEMPORARY MUSEUM

Artists/Hawaii reveals the breadth, richness, and diversity of contemporary art in Hawaii, providing a fresh look at the achievements of twenty-two of the finest artists currently active in the Islands. Chosen by their peers for inclusion in this publication, this group is a selective sampling of the large number of artists who comprise the contemporary arts community of Hawaii. Collectively they represent a remarkable diversity of visual perspectives, attitudes, styles, media, and techniques.

These artists follow an inspirational generation of earlier Island painters, sculptors, designers, and weavers profiled in a two-volume series, *Artists of Hawaii*, published by the University of Hawai'i Press in 1974 and 1977. Together, the two volumes outlined the contribution of many of the artists who played a significant role in the emergence of a vital contemporary arts community in Hawaii during the third quarter of the twentieth century.

More recently, in 1991, a landmark exhibition, *Encounters with Paradise:*

Hawaii and Its People, 1776-1940, traced the development of visual art in Hawaii from the time of first contact with the Western world to just before the beginning of World War II. Organized by David Forbes and presented at the Honolulu Academy of Arts, this overview heralded a growing interest in Hawaii's art history. As the twentieth century wanes and we stand at the threshold of the twenty-first, it seems appropriate here to highlight aspects of the art history of the past fifty years which have helped develop and shape Hawaii's contemporary arts scene.

As in most fields of endeavor, progress is often the result of the vision, ingenuity, energy, and determination of individuals recognized for their superior contributions to the field. Such is the case with contemporary art in Hawaii. Making a significant impact was Ben Norris, a painter from California who came to the Islands in 1936 to join the art faculty of the University of Hawaii. As department chairman from 1945 to 1955, Norris aggressively expanded the art course offerings and doubled the number of faculty. By 1960, the UH art department was well positioned to offer a broad curriculum to those interested in a professional career in art.

Norris was responsible for bringing to the University another individual who would play a crucial role in

contemporary art in Hawaii: Jean Charlot came to Hawaii in 1949, enthusiastically sharing with artists and students his academic training, interest in modern movements, and extensive knowledge of the art of ancient Mexican civilizations. His interest in and respect for the dignity, customs, and legends of the Hawaiian people became a recurrent theme in his locally produced paintings, prints and frescoes.

Internationally known artists have taught for limited periods at the University of Hawaii, sharing their experiences and insights. The surrealist painters Max Ernst and his wife, Dorothea Tanning, demonstrated how artists could tap into the realm of dreams and the unconscious for inspiration. Painter Josef Albers and his wife, weaver Anni Albers, exponents of non-objective art, taught the importance of negative and positive space, the interaction of color, and the rigors of technical discipline. Over the years, acclaimed artists have continued to

visit the Islands providing an exchange of knowledge, forms, concepts, and techniques that has benefited Hawaii's artists as well as the University community.

Equally significant are Hawaii-born and -raised artists who ventured to art centers on the Mainland to further their training and careers. Painter and printmaker Isami Doi established an exceptional reputation in New York, then returned to Hawaii to forge a style combining aspects of abstraction with a love for Hawaii's exotic landscape forms. Doi became an inspiration and model to a younger generation of emerging artists such as Tadashi Sato and Satoru Abe, who ventured to New York and returned to Hawaii, adding their expanded knowledge of contemporary art to the Islands' artistic milieu.

As important as certain individuals have been to the growth of Hawaii's contemporary arts scene, no less significant have been the improvements to the support structures which nurture artists through exhibitions, educational opportunities, and the funding of works of art with grants and direct purchases.

A significant benchmark for Hawaii's arts community was the establishment of the State Foundation on Culture and the Arts in 1965 as the official arts agency of the State of Hawaii. Through the Foundation's grant support, arts programs—visual arts, performing arts, lectures, workshops, films, publications—grew in number and quality. The arts were thrust suddenly into the public consciousness and made accessible to everyone, increasing public response, demand and support.

The passage of the Art in State Buildings Act in 1967 was another boost for contemporary visual artists. This law requires that one percent of the amount spent on a state building project be set aside for the acquisition of works of art. As a result, Hawaii artists have had broad-based support through the purchases and commissions of art by the Foundation's Art in Public Places Program as well as through its Individual Artists Fellowships, established in 1995.

Beginning in the 1960s, increased possibilities for public and private sector recognition and remuneration of Hawaii artists' creativity meant that more individuals could give serious thought to pursuing viable careers in art. The demand and interest brought about an expansion of the art department at the University of Hawaii, a new art building in 1976, and more educational offerings in art there and in several smaller art departments created at new community colleges.

Ongoing forums for the continuous exhibition, examination, and critical evaluation of art are necessary components for maintaining a vital contemporary arts scene. Gallery spaces are scattered throughout the islands in colleges, cultural centers, and art centers, ensuring the visibility of local artists' work. The Contemporary Arts Center of Hawaii, housed in the Honolulu Advertiser Gallery of the News Building, was for many years an important showcase for the most recent and experimental art being created in the state.

The Contemporary Museum, which grew out of the Contemporary Arts Center and opened in 1988, is dedicated to the consideration and presentation of a broad range of contemporary art from around the world. An important part of the museum's mission is to display and promote

Hawaii's contemporary artists through individual exhibitions and the *Biennial of Hawaii Artists*, offering a sampling of some of the best recent work by Hawaii artists.

The Honolulu Academy of Arts, founded in 1927, has long been one of the state's most important proponents of contemporary art and Hawaii artists. The Academy has presented numerous exhibitions serving as the primary introduction of contemporary art developments to Hawaii. The most anticipated and prestigious exhibition held each year in Hawaii's contemporary art community is *Artists of Hawaii*, the Academy's annual juried exhibition. It provides exposure and encouragement for accomplished and younger promising artists alike.

The newest addition to the remarkable recent growth of the contemporary arts scene in Hawaii is The Contemporary Museum at First Hawaiian Center, opening in downtown Honolulu in 1996. Dedicated as a showcase for Hawaii artists, this space was underwritten by First Hawaiian Bank and conceived and created

through the vision and efforts of its Chairman and Chief Executive Officer, Walter A. Dods, Jr. This new space presents an exceptional opportunity to expand public awareness of and appreciation for the achievements of contemporary artists in Hawaii.

The contemporary art world in Hawaii is, like Hawaii itself, a melting pot, a complex and richly varied composite of many contrasting but coexisting elements: ethnic ancestries, cultural heritages, educational backgrounds, personal sensibilities, political views, and social outlooks.

It isn't surprising, then, that the art which emerges from such a lively, evolving mix is exceedingly eclectic and diverse. In looking at the works of the twenty-two outstanding artists reproduced in this volume, one becomes keenly aware of their striking differences. Indeed, Hawaii's artists today celebrate their individuality and uniqueness by creative work born of personal discovery and motivation.

Their art assumes myriad forms, encompasses diverse materials, and expresses manifold ideas. Some of the works appears intimate, some expressionistic; some quiet, some overt; some refined, some deliberately rough. In distinct ways, these artists do not hesitate to address and explore their private feelings about individual circumstance, personal history, family,

community, society, and involvement with place. Nor are these artists disconnected from the public issues of our times: commentaries on AIDS, the environment, and the difficult social, political, and interpersonal conflicts of the late twentieth century are also expressed, often with considerable visual passion.

If there is anything that unites contemporary artists of Hawaii, it perhaps has as much to do with a geographic consideration as an aesthetic one. Living and working on a group of islands surrounded in all directions by vast stretches of water, the natural perspective is of limitless horizons. That circumstance, like the human creative spirit, is free of confines and restrictions, expansive, expectant, and always hopeful.

JAMES JENSEN
THE CONTEMPORARY MUSEUM

"Selecting the art works for this book provided a unique opportunity to talk with twenty-two artists in their homes and studios. There, it was fascinating to see the extent to which each work of art springs from the relationship between artist and environment.

All of these artists work hard at what they do, many against tremendous odds. But all share a sense of humor and an open-ended, imaginative approach to life. In many cases their whole lives have become works of art.

These artists and their work represent extremely diverse visions that not only reflect but interpret the times in which we live. In turn, their creative visions recreate the context and consciousness of the times.

We were struck by the commitment, energy, and enthusiasm they bring to their art and their lives in Hawaii. We will long treasure this experience."

TOM KLOBE AND DUANE PREBLE
CURATORS

THE ARTISTS

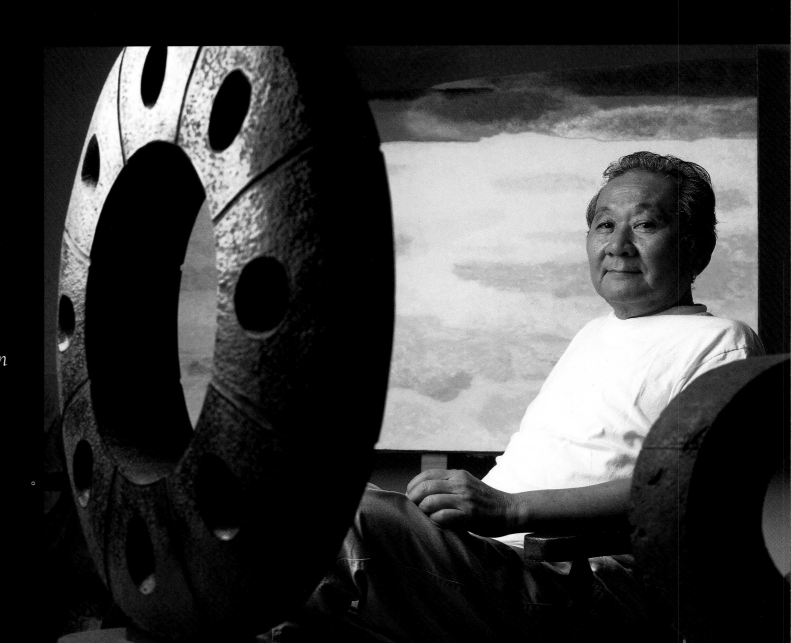

SATORU ABE

*"When I think of an artist
I'd like to meet, I find that I'm
looking for company. Somewhere in
the world, maybe in a third world
country, there is an artist like
me who gets excited over the same
artistic forms and discoveries
and who thinks like me."*

I went through high school half sleeping, spending my time on leather craft, painting, drawing, and photography. Academics never interested me. Later, I realized that I'm both dyslexic and left-handed. Two disadvantages.

After holding a number of menial jobs, I just decided one day that I was going to be an artist. In 1948, I left Hawaii for New York City with just a little money and only the vaguest connection with the art world—some recognition of Rembrandt. When I arrived, I didn't know where to go so I checked the yellow pages for an art school. Well, the first school in the directory listing was the Art Students League. Little did I know when I registered for classes that it was a leading art school for noted New York artists. There, I studied painting under Louis Bouche, John Carroll, and George Grosz. One day during recess, I saw a girl in the hallway who was from Wahiawa. She had graduated from the Traphagen School of Fashion and decided to study fine arts at the Art Students League. I knew that we were meant for each other. How lucky I was.

Returning to Hawaii in 1950, I was obsessed with painting. I was passionate but lacked technique and an understanding of colors. It was during this period that I first met Isami Doi, who became both an artistic and spiritual inspiration.

I got involved in sculpture when an interior decorator offered Bumpei Akaji and me some bronze rods he no longer needed. I took twenty pounds and went to Tonaki Service Station where I taught myself to weld.

A few years later, I went to Japan where I painted and reconnected with my Buddhist heritage. I had two solo shows there.

It wasn't until 1955 that I returned to New York as both a painter and sculptor. Again, I consulted the city phone book, this time to find a place to weld. Skimming through, I saw a descriptive entry: Sculpture Center. I couldn't believe my luck. It turned out to be in a three-story brownstone with a gallery exclusively for sculpture exhibitions and a whole floor devoted to welding stations. When the founder and director of the center, Miss Dorothea Denslow, invited me to use the facility and materials without charge, I was speechless. It was fate. I've been fortunate to have a lot of things happen to me unexpectedly to further my career.

Painting and sculpture are two different animals. I do both because I feel incomplete doing just one. Painting is faster. You can instantly set your ideas down and finish quickly. I'm a sculptural painter. I paint sculptural forms. My earlier paintings were primarily figurative. They eventually became too personalized. The tree form I now use evolved from the human form, a derivative of hands. I find it to be a much more flexible form with which to work.

Sculpture takes much more time than painting. I have been combining wood and metal in my work because wood alone is too small and limited. Metal allows me to extend the piece. Tree forms are also an important part of my sculpture.

Today, I can start with any material and make something. There is always a moment of void, a moment of what to do. But in no time, I get into the mood. When it is completed, there is a moment of both happiness and relief.

"Isami Doi was a beautiful person and a personal inspiration. More than a mentor, he's like a father figure. Although he passed away more than thirty years ago, I long to see him again. Actually, I talk to him when I'm working in my studio, often asking 'Isami, what do you think of this? How do you like it?'"

BORN

Honolulu, Hawaii,
1926

EDUCATION

Sculpture,
Sculpture Center,
New York, New York

Painting,
Art Students League,
New York, New York

MEDIA

Sculpture, painting

AWARDS

Grant,
John Simon Guggenheim
Foundation,
New York, New York,
1963

Artist-in-Residence Grant,
National Endowment
for the Arts,
Washington, D.C.,
1970

Living Treasure of Hawaii,
Honpa Hongwanji
Hawaii Betsuin,
Honolulu, Hawaii,
1984

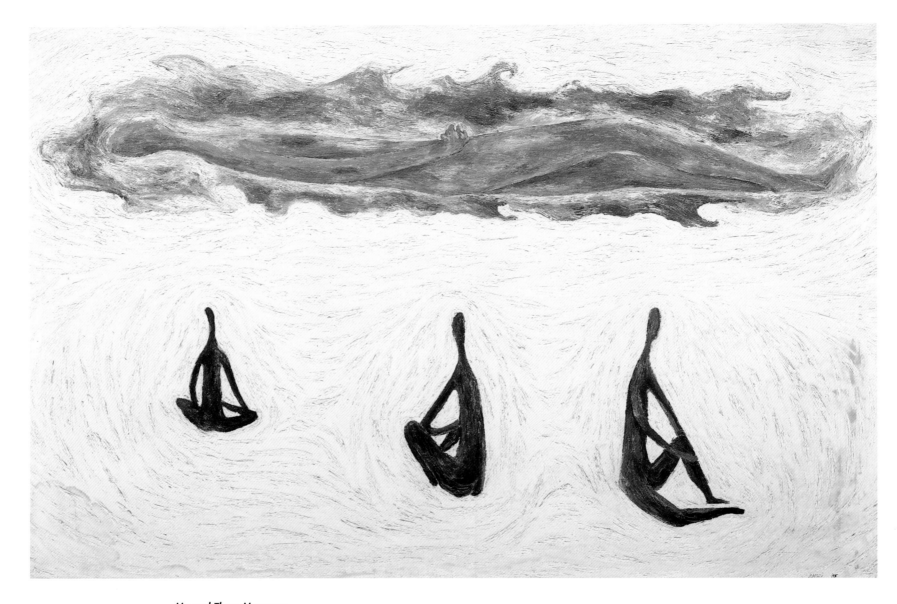

Me and Three Mourners
1955
Oil on canvas
38" x 56"
Collection of the artist

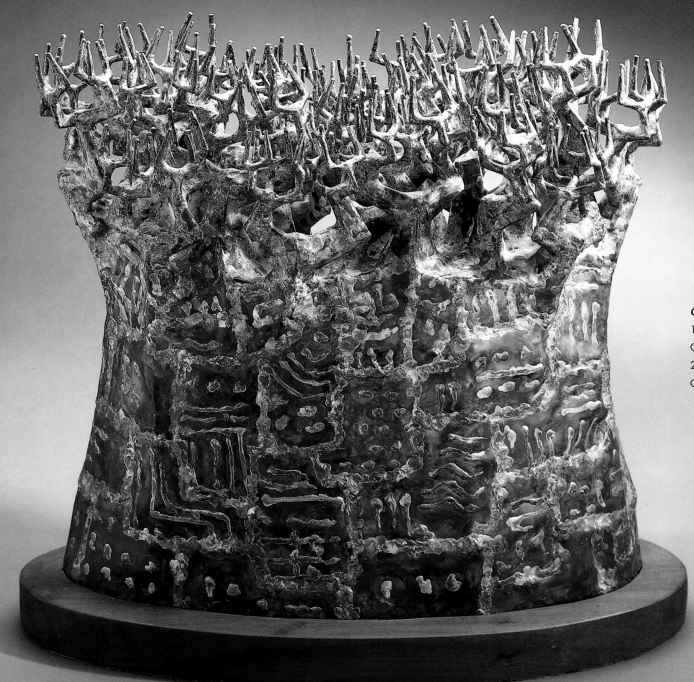

One Tree
1985
Copper, bronze
22" x 22" x 11"
Collection of the artist

SOLO EXHIBITIONS

A. Satoru,
Sculpture Center,
New York, New York,
1958

Works from New York,
Contemporary
Arts Center,
Honolulu, Hawaii,
1971

*200 Miniature
Copper Cutouts,*
Bishop Square,
Honolulu, Hawaii,
1986

Retrospective,
Tokyo Central Museum,
Tokyo, Japan,
1986

*Satoru Abe—Sculptures
and Paintings,*
The Contemporary
Museum,
Honolulu, Hawaii,
1988

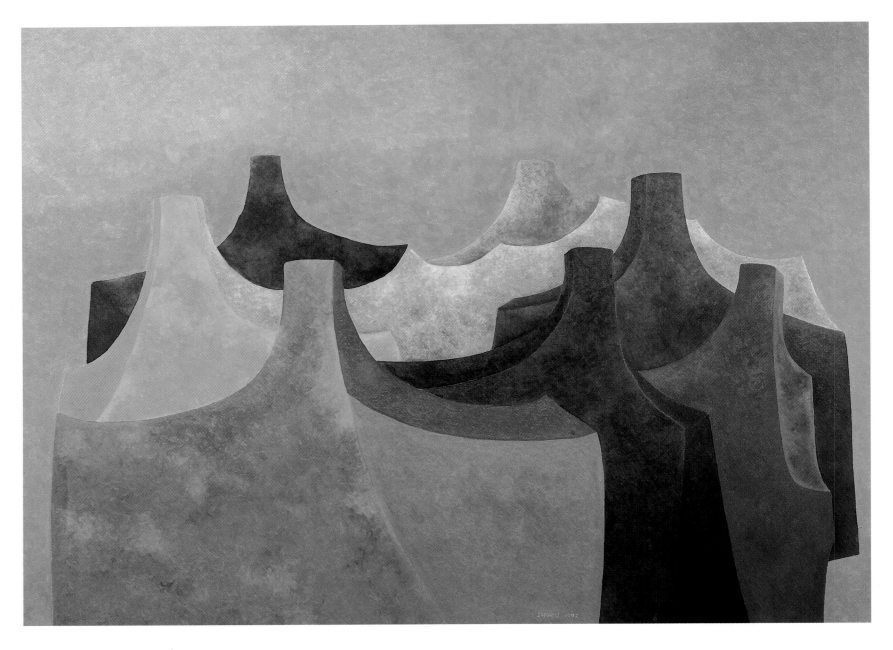

Seven
1992
Oil on canvas
40″ x 54″
Collection of the artist

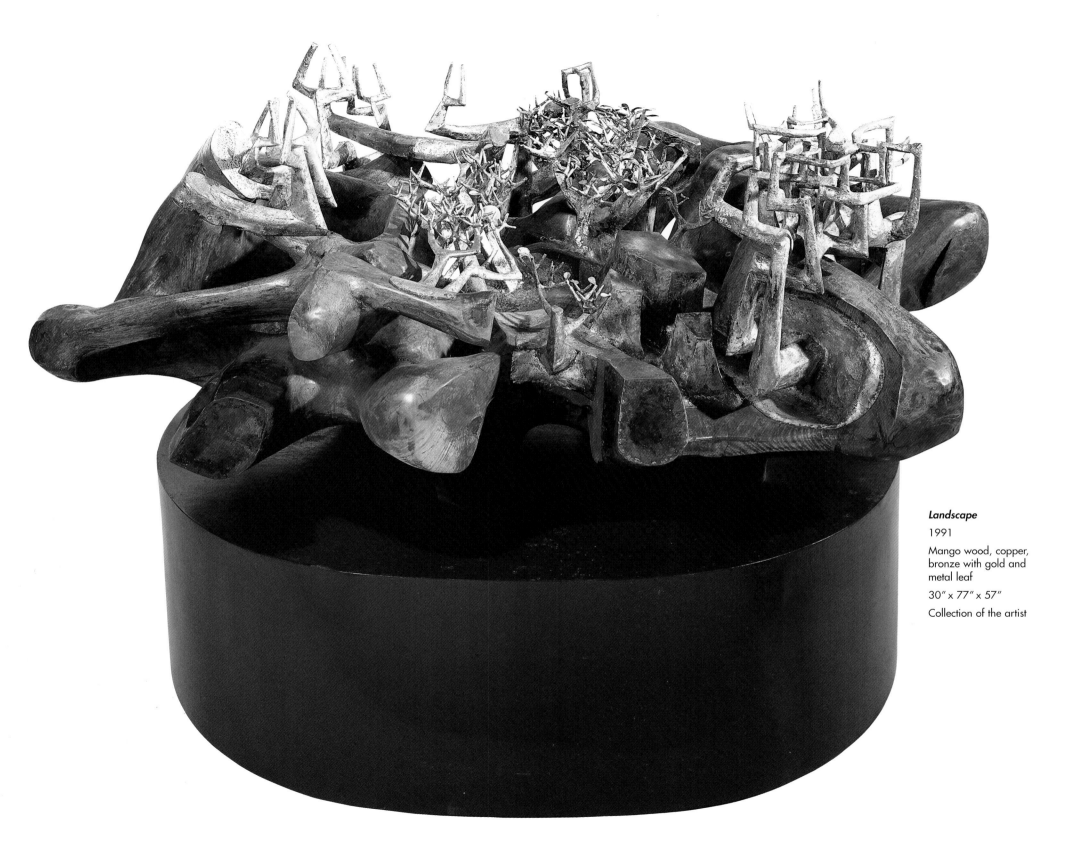

Landscape

1991

Mango wood, copper, bronze with gold and metal leaf

30" x 77" x 57"

Collection of the artist

ALLYN BROMLEY

"Frans Hals, the seventeenth-century Dutch master, is definitely an artist I would enjoy meeting. Because of his lively brushstrokes, his lascivious use of paint, and his sensuous response to subject matter, I think he would be a rambunctious painter to have a glass with. And Blinky Palermo, a contemporary New Zealand artist, whose paintings provoke revulsion, bewilderment, and intrigue."

My mother had been an artist and sent me to art classes as a child. I've always known that I'd be one, too; it was pre-destined, in a way, as if creativity was part of my genetic code. I had this need to draw and make things. I was blessed with good manual dexterity and imagination.

I once watched a group of Hawaiian feather-lei makers offering a prayer of thanks to God for their gifted hands. I felt a real kinship with them, expressing gratitude for their blessed hands as if they were mere conduits for a creative source somewhere beyond themselves. I feel much the same about my hands and my own creative endeavors.

I started off as an oil painter and later turned to printmaking. I understood the alchemy and magic of making prints and enjoyed drawing and etching on plates and on stone.

I fell into screenprinting by accident when I took a summer course at San Jose State University in 1972. There, I had two wonderful teachers who inspired me—Kenneth Auvil, a wizard in the fine art of screenprinting; and his co-teacher, Stephen French. I was in the right place at the right time, with excellent instruction and screenprinting facilities not then available at most other art schools. This discipline was enjoying a revival as a result of new technology and its use by Andy Warhol. For me, it was perfect for expressing the scintillating light and color of the Hawaiian landscape.

Looking back, much of this was luck. Originally, I had no intention of pursuing screenprinting and had actually misregistered for that course at San Jose State. It's ironic that a mistake has become a lifetime career. When I returned to Hawaii with this relatively new print form, it was a medium in demand and I was available to teach it, beginning a long and rewarding career in teaching.

Recently, I've come full circle by painting on my screened prints. Traditionally, that's been a "no-no" because an editioned print is supposed to be consistent. It took me seventeen years to go against my teachers and act on my suppressed impulse to slather, slash, paste, and crumple the surface of some of my work. In the last few years, the artist has gained new freedom. If you can get away with it, you can do it. Even if you can't get away with it all the time, you can *still* do it.

Challenging traditions has allowed me to add other things to the surface of my prints besides paint. I now use all sorts of other material—lead foil, gold and silver leaf, fragments of other prints, collaged elements of plastic modeling clay.

My early work tended to be more romantic and decorative. It was about color and light in response to a beautiful environment. It was pretty, an optimistic representation of a gentler time. Now, I feel a sense of urgency, the need to comment on social and political change rather than the natural beauty of our Islands. Being a resident of Hawaii for forty-three years, I've seen many changes that are distressing.

As I grow older, I'm becoming more anxious about a world out of control. I can't simply extol the beauty of our Islands without being reminded of the collision course we seem to be on with nature. I'm concerned about Hawaii's population growth, about indiscriminate development. Now I use art to try to make other people aware, too.

"John Hoag at the University of Colorado was the most influential among my many outstanding teachers. His scope, dedication, and total immersion in the field of the visual arts inspired me and set standards for my own teaching."

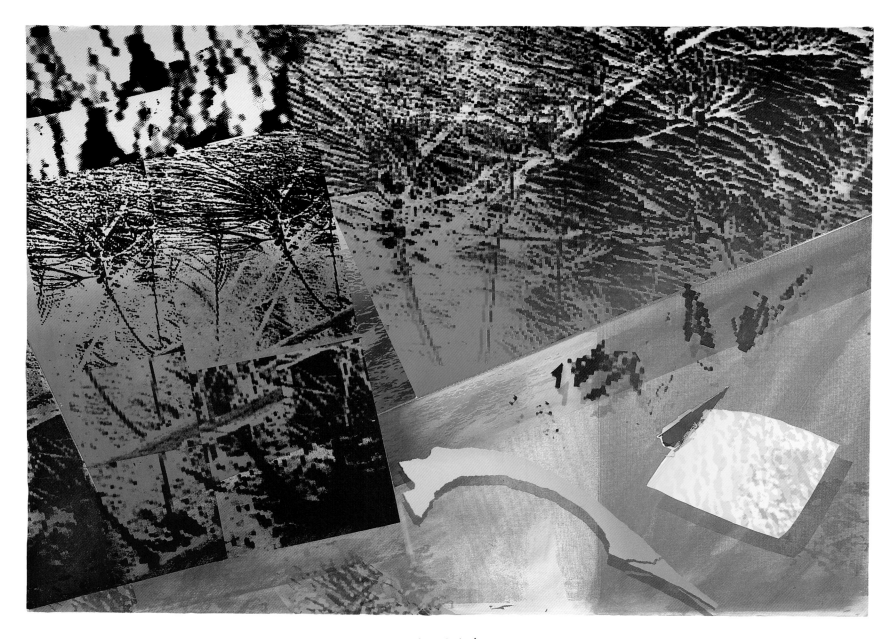

Laser Latitude

1989

Screenprint

52.75″ x 71.5″

Collection of the Hawaii
State Foundation on Culture
and the Arts

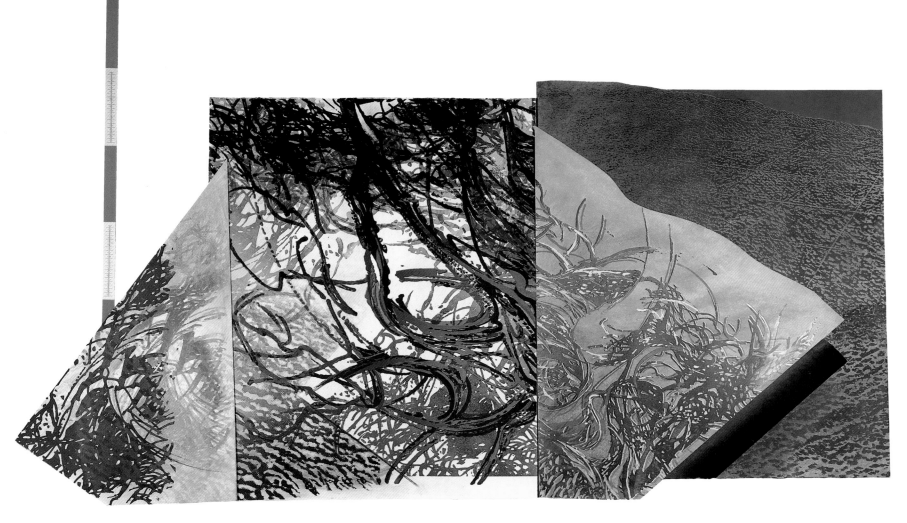

Miloli'i
1990
Screenprint
56" x 103"
Collection of the artist

BORN

San Francisco, California,
1928

EDUCATION

B.F.A., Printmaking/
Painting,
University of Hawaii
at Manoa,
Honolulu, Hawaii

M.F.A., Printmaking/
Painting,
University of Colorado,
Boulder, Colorado

MEDIA

Printmaking,
screenprinting, painting

AWARDS

Research Revolving
Fund Award,
University of Hawaii
at Manoa,
Honolulu, Hawaii,
1979

Screenprinting
Association International
Educators Grant,
Screenprinting
Association International,
Fairfax, Virginia,
1989

Center for Arts and
Humanities Award,
University of Hawaii
at Manoa,
Honolulu, Hawaii,
1990, 1991, 1993, 1994

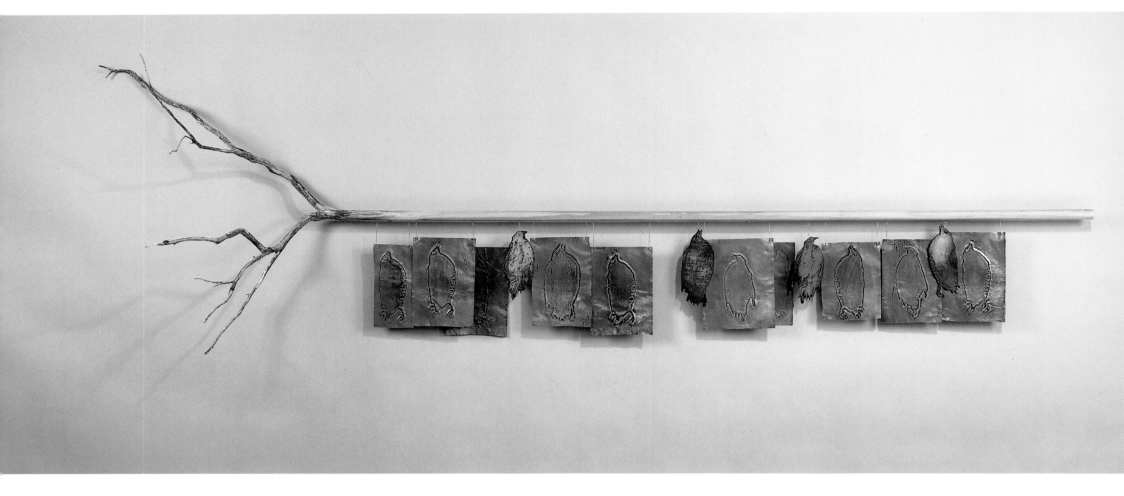

Denouement 1
1993
Lead embossment, wood, zinc
30" x 168" x 20"
The Persis Collection, Hawaii

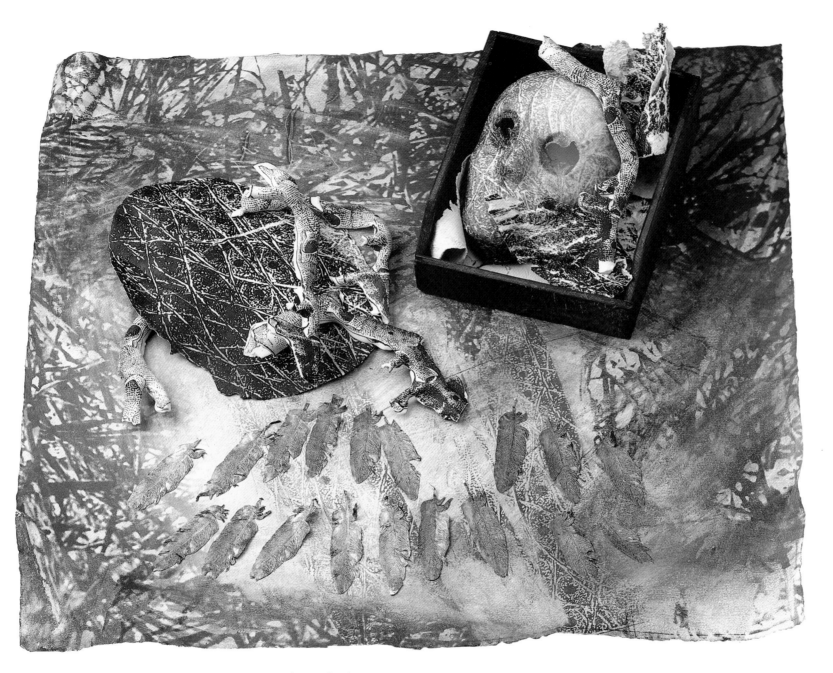

Reliquary for the Future

1995

Polymer clay, screenprint,
lead embossment

22" x 24" x 12"

Collection of the artist

SOLO EXHIBITIONS

*Drawings or Prints
or Sculpture,*
Honolulu Advertiser
Gallery,
Honolulu, Hawaii,
1976

The Extended Image,
The Contemporary
Museum,
Honolulu, Hawaii,
1991

Loss/Gain?
The Contemporary
Museum Gallery at
Alana Waikiki,
Honolulu, Hawaii,
1993

GAYE CHAN

"The artist I would like to meet changes every day. Today, I'd like to meet Annette Messager, a French multimedia artist. I would like to talk with her about femininity, levitation, and farm animals."

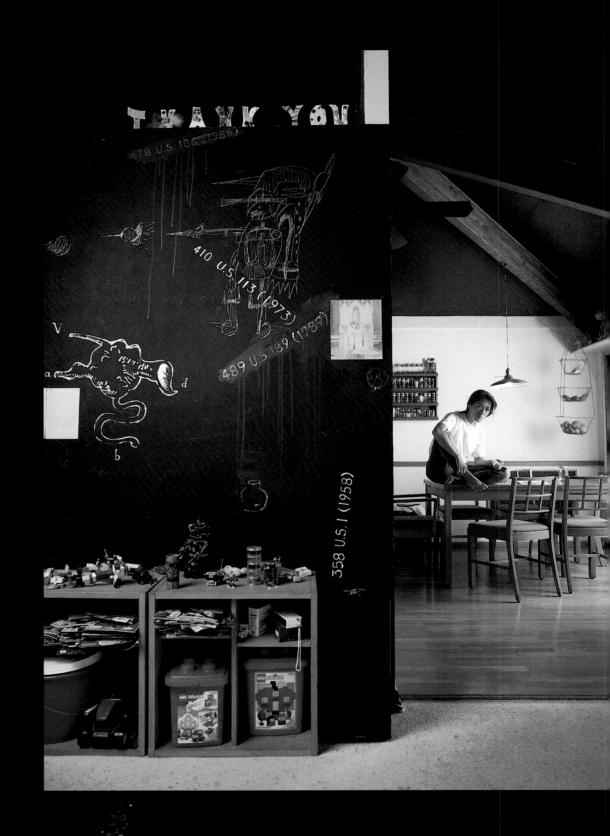

ike most children, I started making visual images at an early age. However, I didn't see art as a significant activity until I was in high school. As a rather inept adolescent, I found art to be an effective avenue to communicate things that were difficult to say.

My work is very much inquiry- and idea-based. It is grounded in my idiosyncratic questions and interpretation of life experiences, particularly those which confuse, bother, or anger me.

I try to select those media that express my thoughts most accurately and interestingly. Each medium—each material—comes with its own history. The choice of which to use is determined by which is appropriate to the idea I'm trying to convey. In choosing to photograph rather than paint, for example: contemporary culture expects painting to be more allegorical, expressive, and subjective; photography is expected to be more factual, descriptive, and objective.

This applies to materials as well. For example, choosing an image of a stopwatch, a household clock, or a time clock would suggest different ideas about time. One might imply competition; another, domesticity; and the other, regimentation.

Because my educational training is in photography, I look at life like a photograph: collecting, reassembling, trying out different angles and points of view. But I work in many different media: drawing, painting, sculpture, assemblage—combining and reassembling found objects—and photography. Recently, I have been most interested in found objects—things I collect from garage sales, sidewalks, or wherever. I'm interested in the history these objects bring with them. If I'm painting on a canvas, I prefer to find a used canvas, one that had its own life before I interact with it.

My work has taken a long time to evolve. Each individual piece builds on those I made before. For example, a few of my recent pieces include measuring devices. I first used rulers twelve years ago. I was fascinated by the way archaeologists used them to denote scale in photographs documenting digs. I became interested in these objects/symbols that we collectively "agree" to rely on as standards. I appropriated the ruler to suggest the status quo, the social yardstick. I had hoped that by exposing these objects/symbols, we might be moved to reexamine our concurrence with the "agreement."

The ruler continues to reappear in different forms and contexts. In the past year, I have begun to use folding rulers to form shapes, such as houses, illustrating the notion that the type of home in which a person lives in this country is an important measure of status and security.

Finding interesting ways to reference these pedantic concepts has taken me years. I'm still surprised to discover connections to work that is decades old. I'm fascinated by my artistic evolution even while I see such repetition of ideas and paradigms on my use of symbols. They surface, fade, and return in a different form.

"Angel Ramirez, a Filipino-American outsider artist whose work I followed for ten years until his death in 1994. Since he never spoke to me in a language I could understand, his work will always remain an eternal mystery. It is invested with much of the pleasure and horror of living: shameless joy, outrageous misinformation, gluttonous obsession, misdirected passion, willful fancy, irrational fear, and unreasonable optimism."

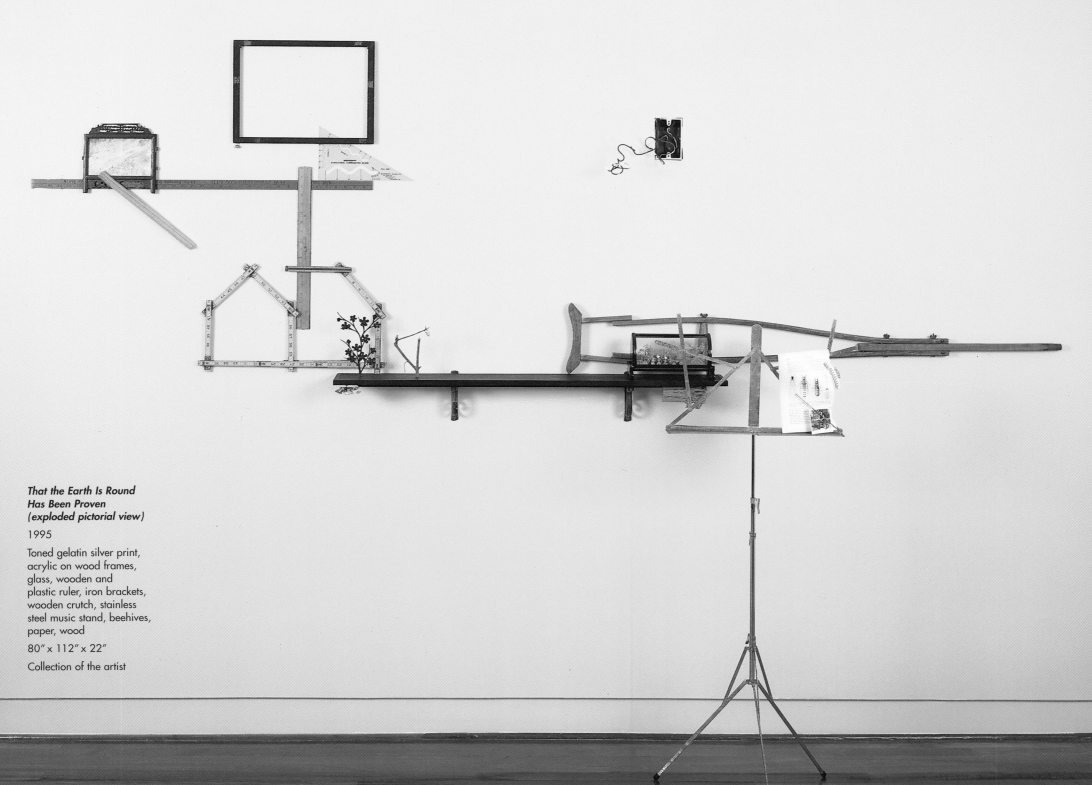

**That the Earth Is Round
Has Been Proven
(exploded pictorial view)**

1995

Toned gelatin silver print,
acrylic on wood frames,
glass, wooden and
plastic ruler, iron brackets,
wooden crutch, stainless
steel music stand, beehives,
paper, wood

80" x 112" x 22"

Collection of the artist

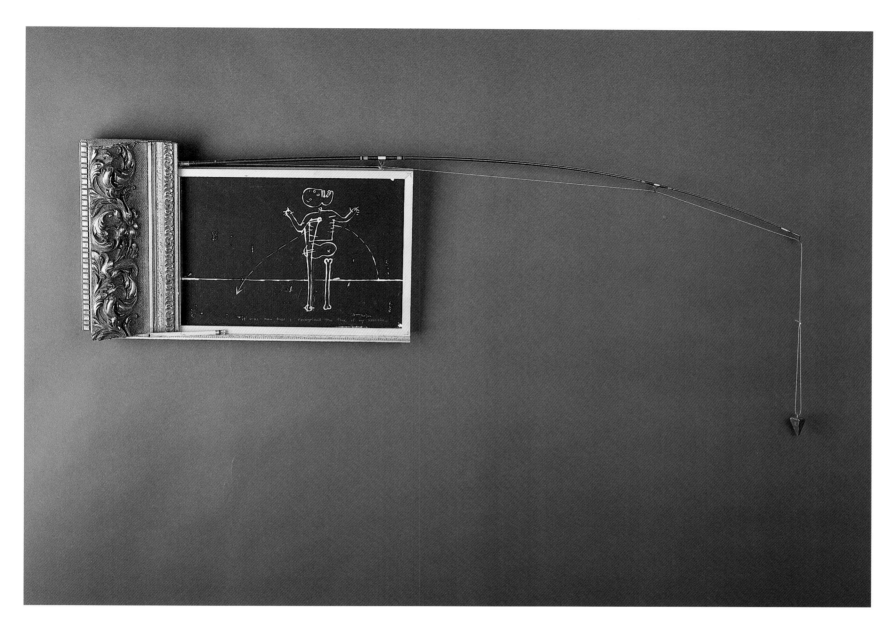

BORN

Hong Kong,
1957

EDUCATION

B.F.A., Graphic Design/
Photography,
University of Hawaii
at Manoa,
Honolulu, Hawaii

M.F.A., Photography,
San Francisco Art
Institute,
San Francisco, California

MEDIA

Photography, mixed
media, drawing,
painting, sculpture

AWARDS

Artist-in-Residence,
Lightwork,
Syracuse, New York,
1993

Research grant,
Office of Women's
Research,
University of Hawaii
at Manoa,
Honolulu, Hawaii,
1994

Mentor Travel Grant,
Rockefeller Foundation,
New York, New York,
1994

*It was then that I recognized
the face of my assassin . . .*

1991

Acrylic on paper, yardsticks,
fishing rod, pencil, gilded frame

28" x 46" x 4"

Collection of the artist

SOLO EXHIBITIONS

Constructions,
Blue Sky Gallery,
Portland, Oregon,
1982

*Tongue in Cheek,
Heart in Hand,*
North Fort Gallery,
Osaka, Japan,
1986

The Sleep of the Just,
The Contemporary
Museum,
Honolulu, Hawaii,
1991

Solo,
The Center for Photography at Woodstock,
Woodstock, New York,
1994

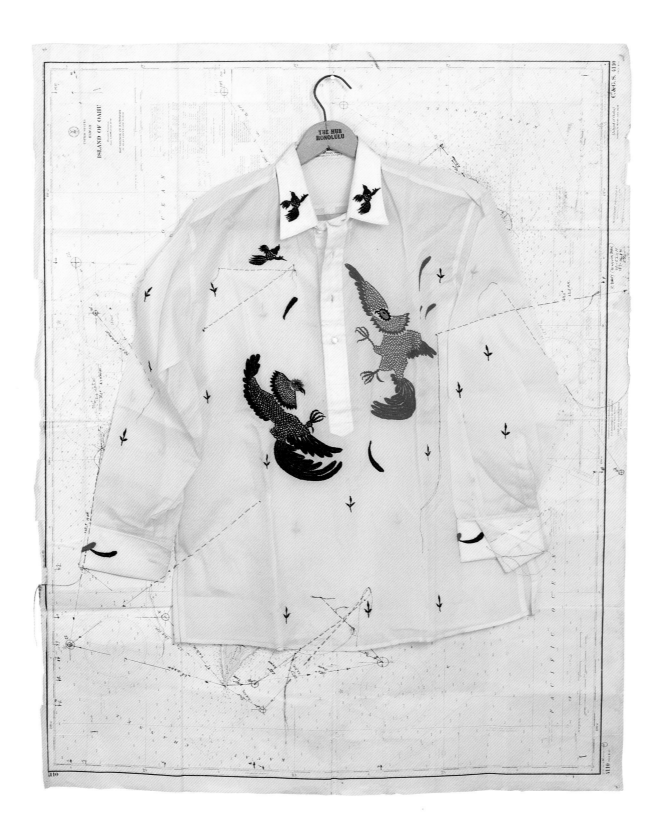

*That the Earth Is Round
Has Been Proven
(front sectional view)*

1995

Felt-tip marker on paper
map, wooden hanger,
embroidered shirt, thread

48" x 37" x 3.5"

Collection of the Hawaii
State Foundation on Culture
and the Arts

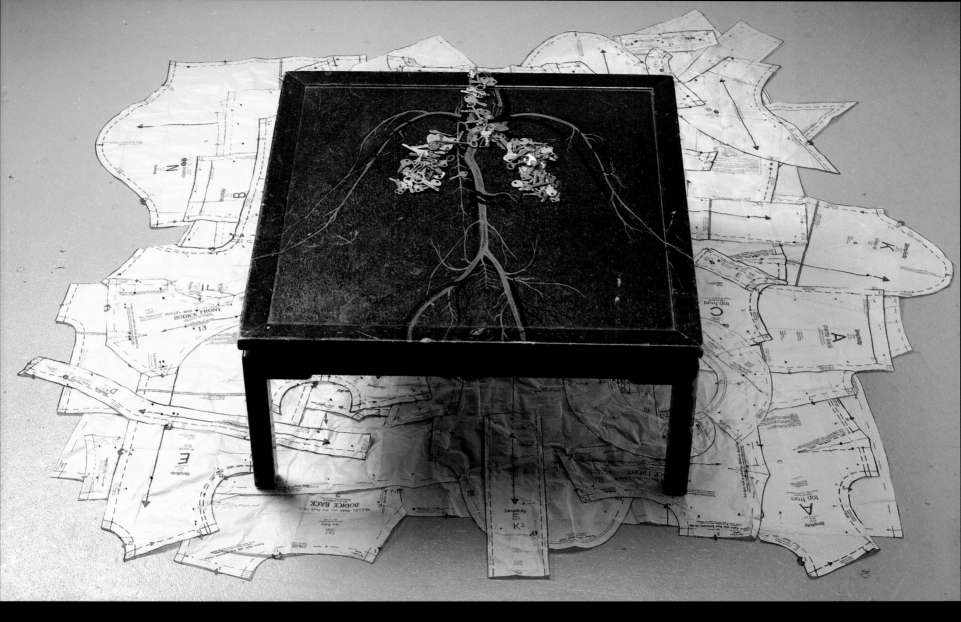

Accident of Birth
(top sectional view with
hidden features)

1995

Acrylic on wooden coffee table,
keys, stainless steel pins, paper

69" x 73" x 16"

DOROTHY FAISON

*"I would've liked to have
met and listened to Joseph Beuys,
Bertrand Russell, Joseph Campbell,
or Albert Camus. We're lucky
to be of this time, to have the works
of so many artists and writers
so accessible."*

My childhood and early adolescence were spent in New York, Costa Rica, and Bolivia. This exposed me to strong yet diverse cultures, images, and rituals. I was touched by the ancient mysteries and traditions of the Quechuan and Aymaran cultures and by the influence of Spain on these cultures. The vast, desolate landscape of the Andean Altiplano ringed by snow-covered mountains later surfaced subconsciously in my work.

I moved from Latin America to Hawaii during my adolescent years. Here, I found empathy, passion, and strong family ties integral to the Hawaiian culture, the power and meaning of images, and the color of the earth. All are apparent in my work.

I start with content and imagery and choose the form that best reinforces and communicates those ideas. I work primarily in two dimensions because for me this offers increased freedom to control image, space, and time. When I work three-dimensionally, it's usually as a natural extension to my painting. I often experiment with materials to find methods that are more powerful or that better convey my content. As pigment and drawing tools, I've used dog hair, metals, wax, and dirt that I have collected.

My work is not easily categorized under any "ism." The work includes aspects of narrative and allegorical art. My painting vocabulary has been developing and expanding since 1977. It's a symbology of images connected to human issues. Earlier work focused on reason, conscience, our human-animal nature, and the role of the socialized individual. That is still the foundation for my work, with a new concentration now on individual and social responsibility and on protection. Protection, particularly of children, in life and in death is very strong across cultures. Rather than focusing on a literal interpretation of a particular activity, it is the universality of the human experience that most interests me. While the work has deep autobiographical roots and imagery, I try to use symbols which transcend this individual experience.

I endeavor to combine the power, mystery, and purpose of ancient, tribal, and medieval art within the context of contemporary painting. I have the good fortune of coming after the progressive artists of the twentieth century. Their work expanded the avenues of expression available to artists working today. I'm very free to use any method of spatial representation or even multiple methods within the same work, which I often do.

Complexity and layering are important to my work. Neither its content nor its formal aspects can be quickly read or separated. I often work on a piece over a long period, sometimes reworking a painting previously considered finished in an effort to distill and strengthen it. I want the work to have an indefinite quality to it. I avoid using imagery or content that ties the work to a specific time.

"Betye Saar, who taught at Otis while I was there, showed me that you could integrate being female, being a mother, and being an artist. At a time in the late 1970s when most of my peers were worried about being stars before their thirties, she was an excellent role model."

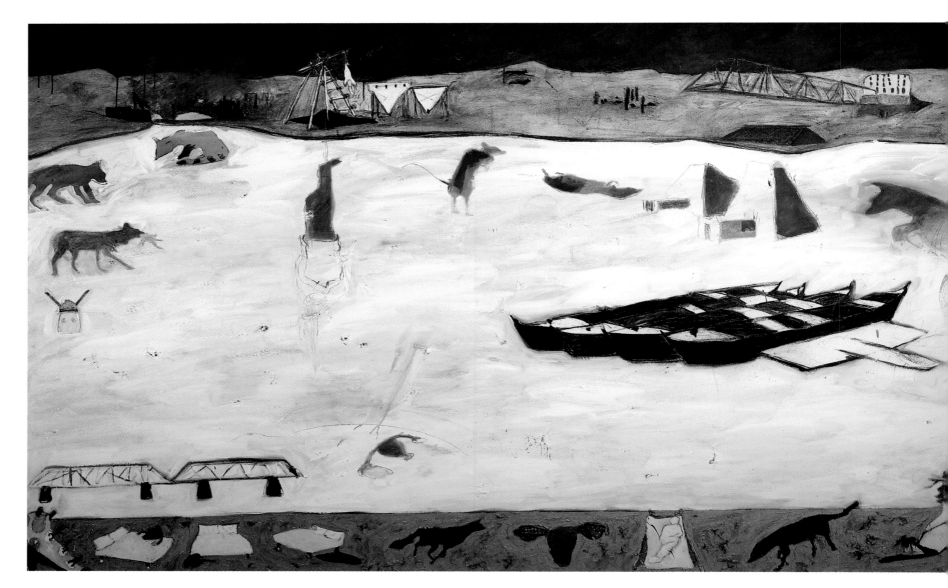

Instinct Crossing

1990

Oil, acrylic, pastel,
charcoal, dog hair
on canvas

81.5" x 113"

The Persis Collection,
Hawaii

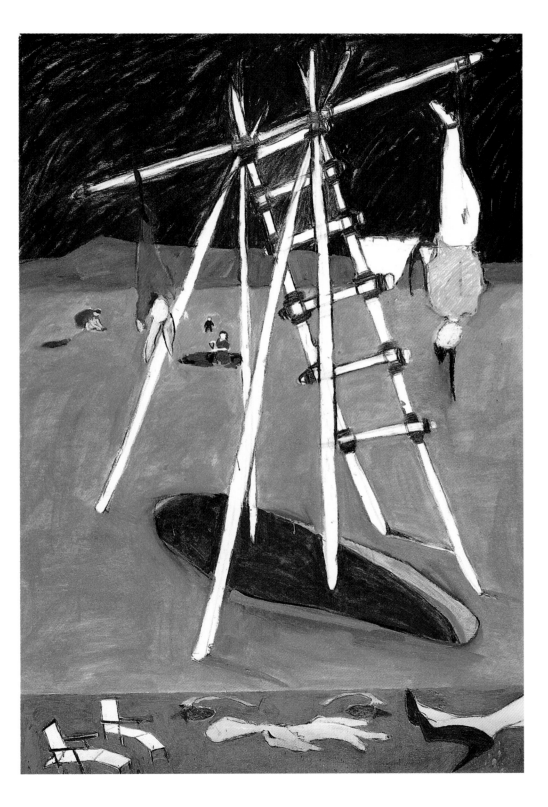

The Garden Club
1990
Watercolor, acrylic,
bronze powders,
charcoal, pastel,
dog hair on paper
48″ x 32″
Collection of the artist

BORN

Schenectady, New York,
1955

EDUCATION

B.F.A., Drawing/Painting,
University of Hawaii
at Manoa,
Honolulu, Hawaii

M.F.A., Intermedia,
Otis Art Institute,
Los Angeles, California

Sophia University,
Tokyo, Japan

Edinburgh College of Art,
University of Edinburgh,
Edinburgh, Scotland,
United Kingdom

MEDIA

Mixed media

AWARDS

First Place (Hawaii)/
Fifth Place (U.S.A.),
The National Society of
Arts & Letters Drawing
Competition,
New York, New York,
1981

Catharine E. B. Cox
Award for Excellence in
the Visual Arts,
Honolulu Academy
of Arts,
Honolulu, Hawaii,
1989

Melusine Award
for Painting,
Honolulu Academy
of Arts,
Honolulu, Hawaii,
1992

AWARDS

Western States
Regional National
Endowment for the Arts
Fellowship in Painting,
Western States Arts
Federation,
Santa Fe, New Mexico,
1994

Individual Artist
Fellowship Merit Award,
Hawaii State Foundation
on Culture and the Arts,
Honolulu, Hawaii,
1995

SOLO EXHIBITIONS

For Bubbles Was Great,
Otis Art Institute,
Los Angeles, California,
1979

Rachel Reads the Fables,
Croissanterie Gallery,
Honolulu, Hawaii,
1984

*Some of Us Are Just
Born Different,*
Koa Gallery, Kapiolani
Community College,
Honolulu, Hawaii,
1988

Recent Work,
Cox Award Exhibition,
Honolulu Academy
of Arts,
Honolulu, Hawaii,
1990

First Biennial,
The Contemporary
Museum,
Honolulu, Hawaii,
1993

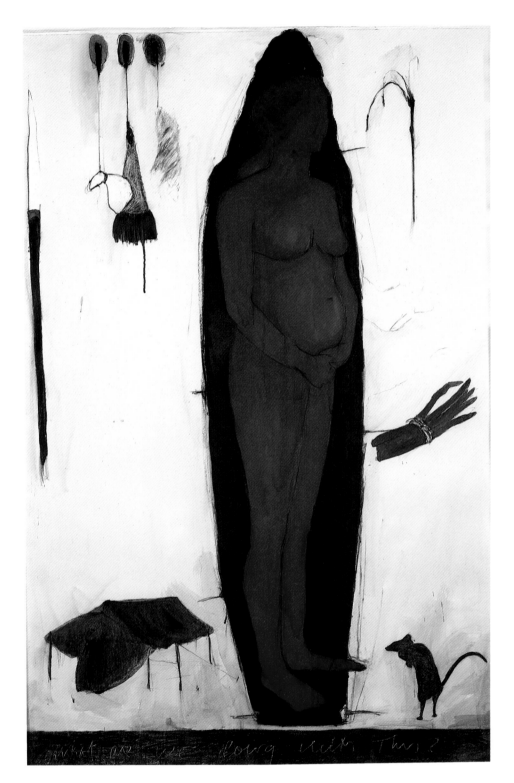

**What Are We Doing
with This?**

1994

Dirt, pigments, gum arabic,
charcoal on paper

67″ x 42″

Collection of the artist

▶

Ritual Protection

1993

Oil, dog hair on canvas

75″ x 85″

Collection of the Honolulu
Academy of Arts, Hawaii

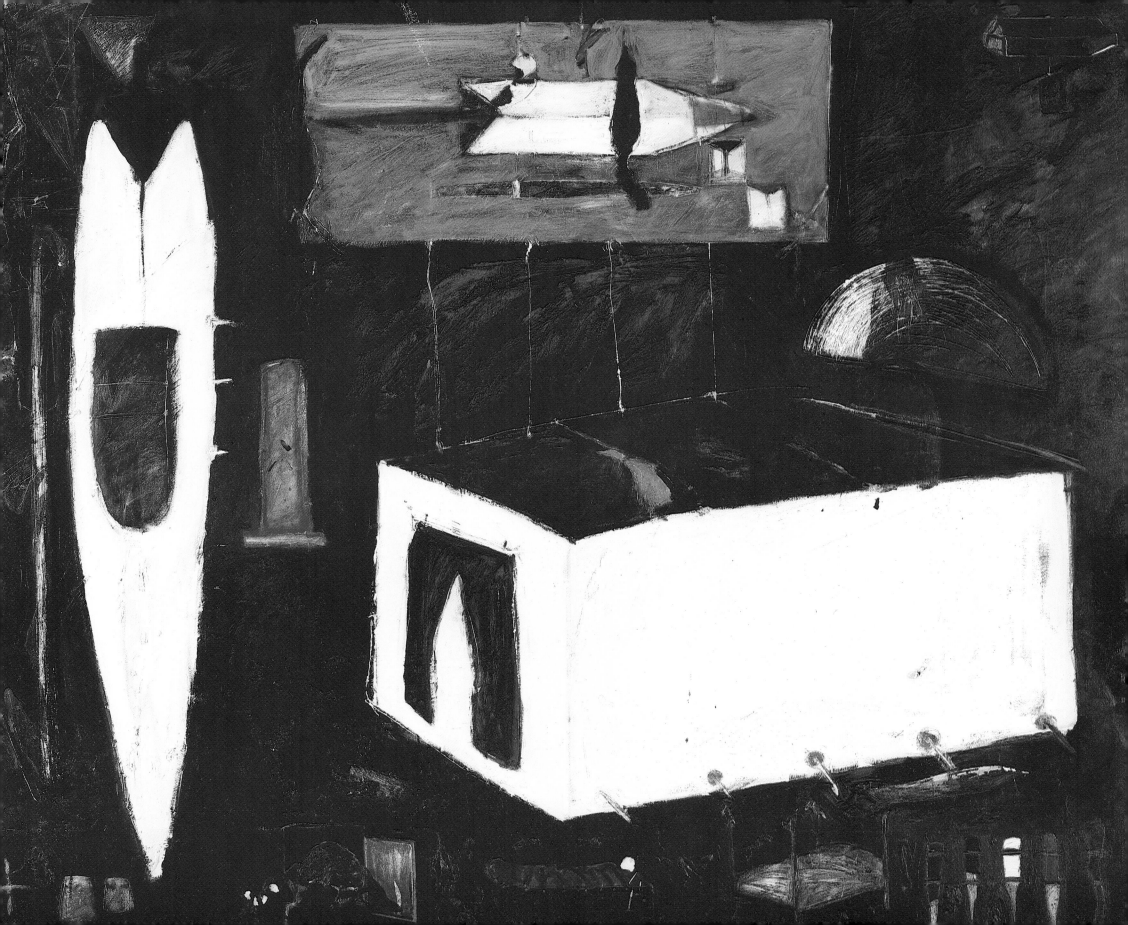

SALLY FRENCH

*"I have always wanted to meet
Andy Warhol. Not so much to
meet him and transport him to my
environment, but to meet him
on his ground and his space at The
Factory with all his scene around.
And then, watch him technically
work. He had something and
he knew it."*

work in beeswax and oil paint on a rigid surface. It's a hot wax process; I brush on the hot wax and draw my cartoon or sketch into the wax on a black ground. Then I rub or glaze oil color into that, sometimes thick and sometimes just rubbed in or floated on. Sometimes I scratch through it; it's a very pliable, workable surface. I like wax for its texture and translucency; it gives me a lot of flexibility because of its continued impermanence. I can keep going back and scratch into it.

I like to let the medium come forward and stand on its own. If I'm working in paint, I like to give the piece a painterly look. I like to push the paint around. If I'm working in beeswax, I want to make sure you see the wax quality. If I'm doing installation work, I think it's fun to see the structure that these things are hanging on. One aspect of my medium is a raw sort of quality.

My style is gestural or raw as opposed to refined because I want to express power and feelings. Those two things come more easily for me when I'm not working towards perfection and a refined quality. It seems to come more directly if I can work fast. Right now, I'm trying to not be so easily read. I want to stay at a gut level. The best thing is to catch a first impression and then move on.

Compositionally, something really has to move me visually before I want to develop it. I tie threads from a former work or former piece of art into what I'm doing and use my own language of symbols to continue my explorations. Some symbols I use often are red chairs, personified houses, humanistic animals, and now shopping carts. They might get modified into new forms; they might get wiped out altogether.

My ideas often come from dreams. When I examine them, the original inspiration is a gut feeling, then I transfer that into a material reality, a physical thing. My paintings are usually personally relevant, something about me or my community or a political concern. Hopefully, when I'm done the painting gets up and walks away; it becomes its own animal.

The rat is a kind of identity for me personally. It's an animal that scurries; it's small and works in holes. It's my real life style and it's also a form I like—the long tail and the long nose.

The dog seems to be the masculine antagonist in my pieces. The rabbit has a timidity about it; there's something endearing about its features that I enjoy expressing over and over again. The long form of the ears, the longness of the face, all at the end of this oblong form.

Hawaii is in my work in the color. The palette is intensified from being and living here. Not necessarily just the greens, but all the colors seem to be intense. I've also taken symbols from Hawaiiana and used them in a way that makes a statement about a particular circumstance or concern of mine.

"The late Reuben Tam was very meaningful to my work, my life, and my well-being. Also, the late Carlos Almaraz for his painterly, lively style."

BORN

Stockton, California,
1947

EDUCATION

Illustration,
Academy of Art College,
San Francisco, California

Fine Arts,
University of Colorado,
Boulder, Colorado

Fine Arts,
Stephens College,
Columbia, Missouri

MEDIA

Oil and beeswax, pastels

AWARDS

Grant,
Environmental
Educational Project
for Children,
National Endowment
for the Arts,
Washington, D.C.,
1974

Cynthia Eyre Award,
Artists of Hawaii
Exhibition,
Honolulu Academy
of Arts,
Honolulu, Hawaii,
1990

L.A.C.E. Artists'
Projects Grant,
Los Angeles
Contemporary
Exhibitions,
Los Angeles, California,
1992

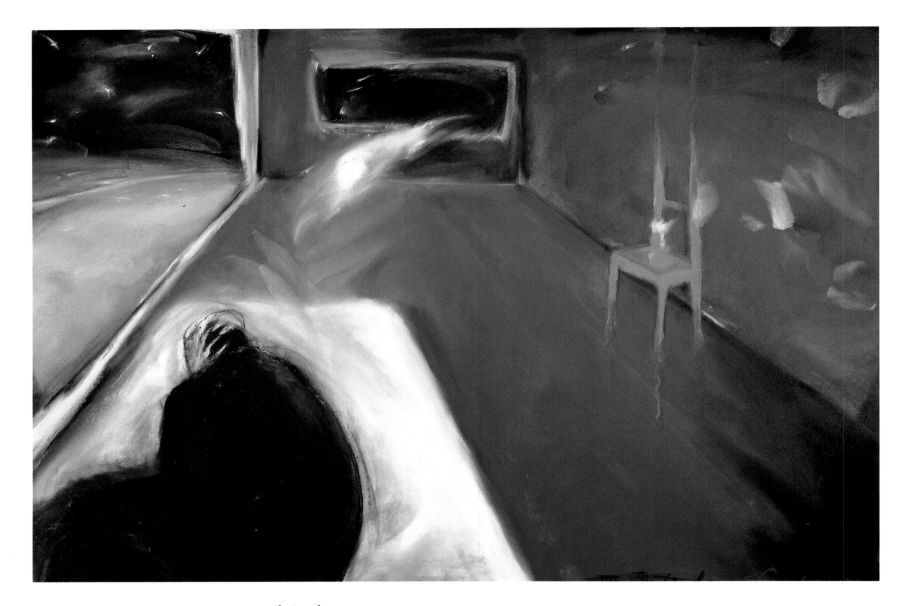

The Intruder
1988
Pastel on black paper
32.5″ x 46″
Collection of the Hawaii
State Foundation on Culture
and the Arts

▶

**Steaming Hot from
the Night Kitchen**
1987
Pastel on black paper
25″ x 30″
Private collection

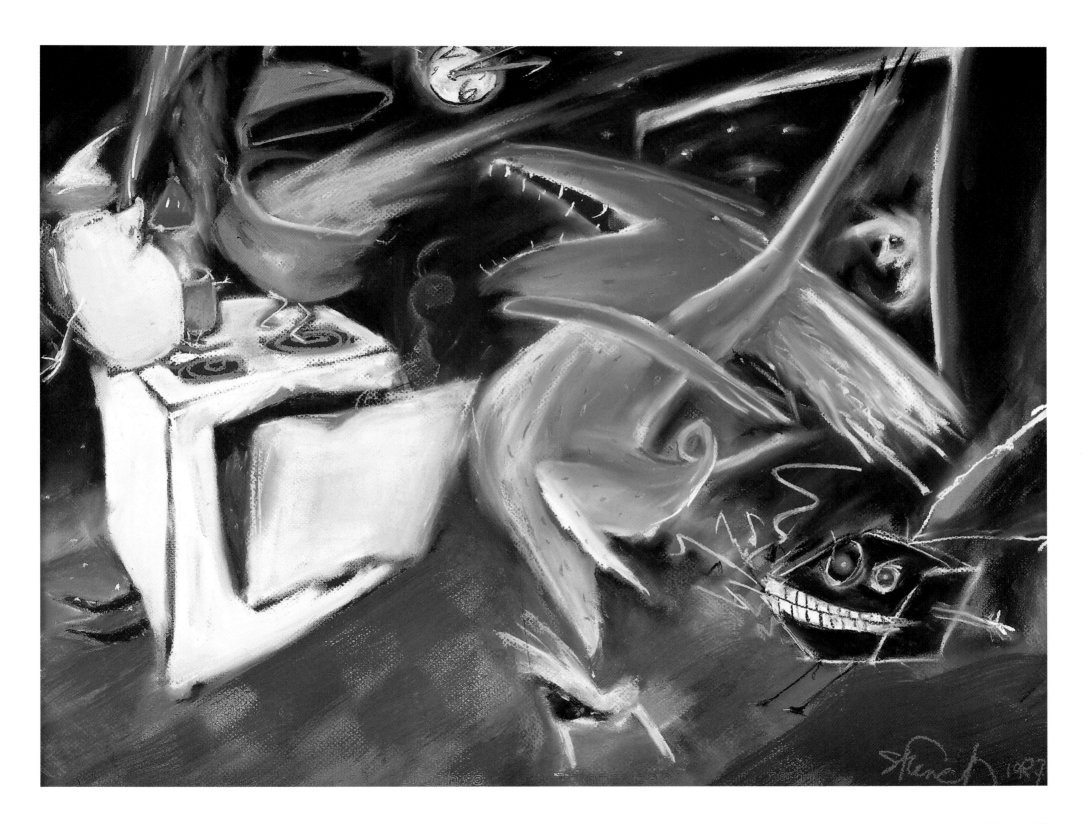

SOLO EXHIBITIONS

Tracked!
Queen Emma Gallery,
Honolulu, Hawaii,
1982

*Mad Dogs, Flying
Beds and Me,*
Kahana Ki'i Gallery,
Koloa, Hawaii,
1989

Trouble in Paradise,
Hawaii Loa
College Gallery,
Kailua, Hawaii,
1990

Trouble in Paradise,
The Contemporary
Museum,
Honolulu, Hawaii,
1992

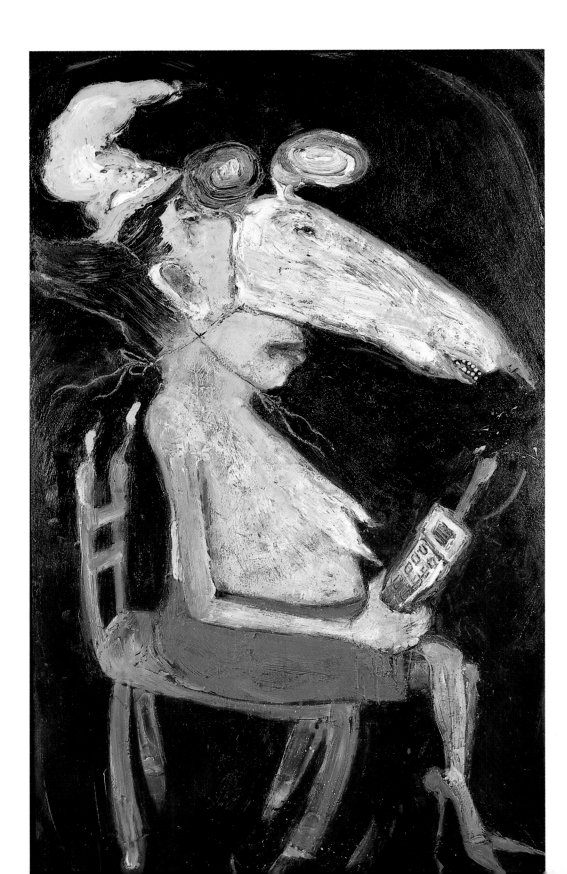

Call-Waiting in a Ratmask
1993
Beeswax, oil on wood
56" x 36"
Private collection

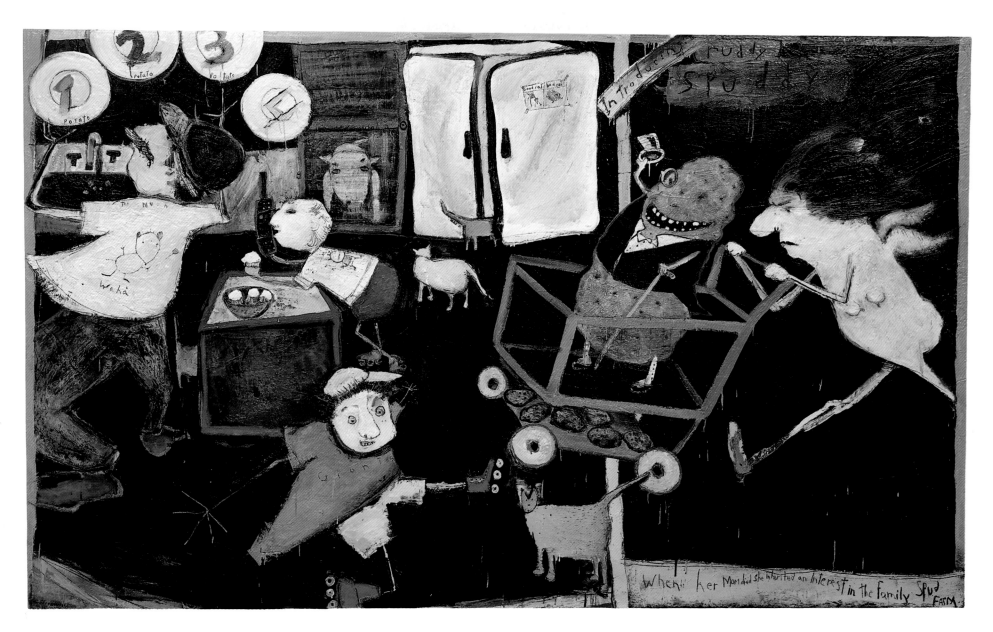

Introducing Ruddy Spuddy

1995

Oil, beeswax on wood

84" x 132"

Collection of the Hawaii
State Foundation on Culture
and the Arts

Alan Leitner

"Wassily Kandinsky is one artist I would have liked to meet: For his color, his cool and intellectual approach to what appears to be romantic abstraction. Cy Twombly is another; I enjoy his marks, his handwriting, and his obscure ideas. Jackson Pollock also; he was the last of the type of artist who may or may not ever come again. He was opinionated, aloof, and troubled. He was a maverick and transformed the concept of what painting is. And finally Terry Winters; his work is primal, organic, and refreshing; he uses his materials beautifully."

've always wanted to paint. When I was a kid, I never wanted to be anything else but a painter. In the sixth grade, we had to prepare a vocational notebook and I did mine on cartooning. Later, I remember looking at a *Life* magazine with a cover photo of Jackson Pollock. Looking at Pollock and his paintings, I thought how much I admired him and what a wonderful man he was. It was at that moment that I knew I was going to be a painter.

Painting is a way to give definition to your existence, to give meaning to what appeals to you and stimulates you intellectually or emotionally. Painting can express ideas, concepts, or emotional connections in ways that ordinary, everyday language cannot. It deals with the core of an individual's sincerity in a quest for the essence of truth or beauty. For me, the process of painting is a state of becoming and never arriving. It is an interesting journey because you are always challenged, the process is always changing, and your life is always changing.

My work has gone through a number of transformations over the last twenty years. Until recently, I was involved with abstract expressionism which establishes a dialogue between yourself and your materials. Action painting, as it is sometimes called, is a process in which the artist establishes the nature of the work through decisions made while the activity of painting takes place. You are sort of finding out what your true subject is while it unfolds in front of you. The painting is established through a dialogue between you and the materials. It's fun to paint that way. However, it now no longer seems to serve my purpose. Richard Diebenkorn said something to the same effect, noting that he felt he had to perform every time he went into the studio and he eventually got tired of it. I got tired of it as well, for similar reasons.

Now, I'm doing a form of abstraction which also has its roots in surrealism, but in a figurative way as opposed to automatism. I take forms that are vaguely recognizable and use them as metaphors for human experience. Currently, I'm dealing with many plant forms, flowers, and carnivorous plants; they appeal to me visually. I develop the painting through an open-ended dialogue, creating a tangible paint environment in which to place my form, my object, my flower. The expression comes in terms of how the surface is handled, how the colors are used.

Sometimes, I still walk into the canvas with only a vague notion of what is going to happen. When I start with my drawing and layering of paint, the painting then begins to tell me what it needs. It is mostly an editing process. I may decide that some particular form is not necessary and eliminate it completely or just move it somewhere else. I still enjoy the process and have held on to remnants of action painting. I like the painting to act as a metaphor for life with contingencies, accidents, surprises.

I want the spectators to engage the painting in terms of the subject and the paint itself. I don't want them to go into the painting and wander around in an illusory space. Rather, they should go into the painting, be taken by the object I'm using, and then engage the material as substance or as an object in its own right. Plant form, paint, and surface become unified. The observer will respond to the subject relative to the painted environment and come away with an idea or a feeling. That's the level of experience I'm hoping that the spectator has with my work.

Many of the ideas for my work come from looking at art, past and present, and reading. I've always enjoyed philosophy, particularly existentialism. I also like Voltaire. I think that *Candide*, which I reread at least once a year, has given me a great deal of material. Some of my ideas come from the experiences I have in everyday living. Just going through one's daily activities provides lots of stimulation. It's really all about the complexity of human relations.

"Of the people whom I consider my mentors, I would have to include Dr. Robert MacDonald, one of my first art instructors at Woodbury University from 1968 to 1970. His influence had an enormous impact on shaping my views and attitudes toward art. Since moving to Hawaii in 1971, I was fortunate to have gained many insights from Ken Bushnell, Helen Gilbert, Lee Chesney, and Les Biller."

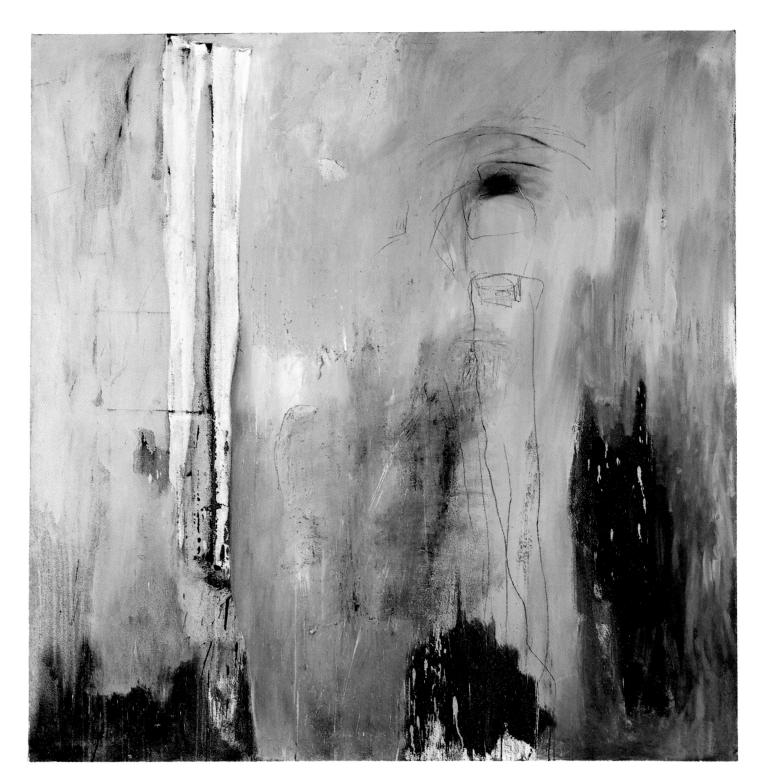

Fear to Fly
1991
Oil on canvas
60" x 56"
Collection of the artist

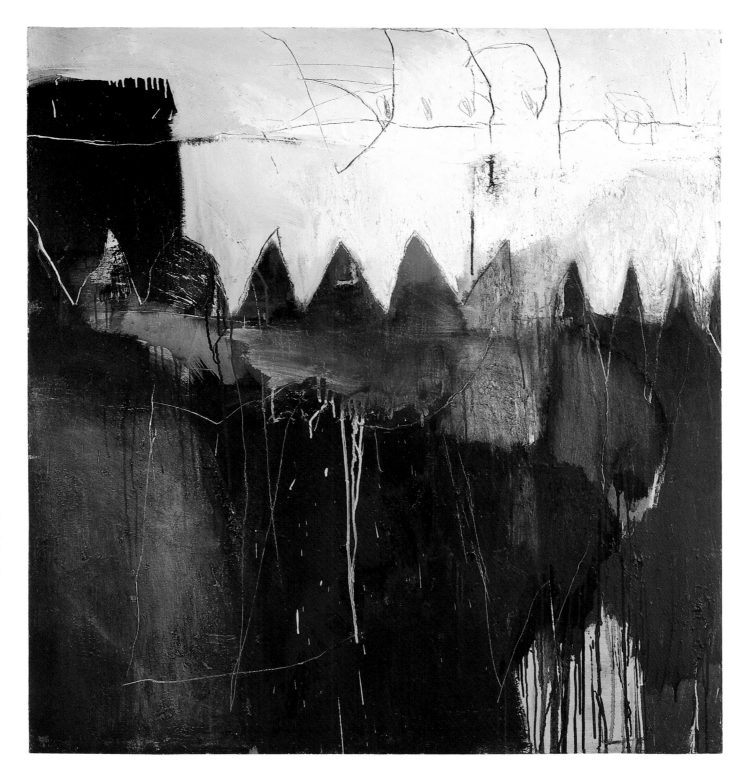

Flora Index #1
1992
Oil on canvas
50.5" x 46.5"
Collection of the artist

BORN

Los Angeles, California,
1947

EDUCATION

B.S., Art,
Woodbury University,
Los Angeles, California

M.F.A., Painting,
University of Hawaii
at Manoa,
Honolulu, Hawaii

MEDIUM

Oil painting

AWARDS

Jurors Award,
Honolulu Printmakers,
Honolulu, Hawaii,
1981

Jurors Award/Art Loft
Gallery Award,
Hawaii Artists League,
Honolulu, Hawaii,
1982

Scholarship,
The Persis Corporation,
Honolulu, Hawaii,
1984

SOLO EXHIBITIONS

Recent Works,
Koko Head Gallery,
Honolulu, Hawaii,
1974

Drawings,
Queen Emma Gallery,
Honolulu, Hawaii,
1978

Back to Square One,
Keiko Hatano Gallery,
Honolulu, Hawaii,
1991

Recent Paintings,
Foyer Gallery, Leeward
Community College,
Pearl City, Hawaii,
1994

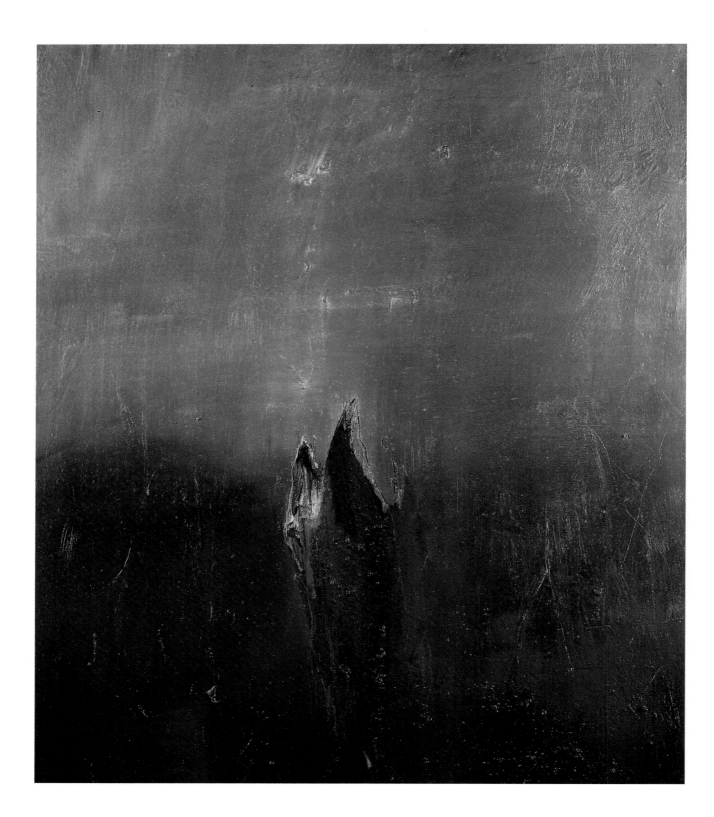

Flora Emblem #2

1994

Oil on canvas

36.25" x 31"

Collection of the City and
County of Honolulu Office
of Culture and the Arts,
Hawaii

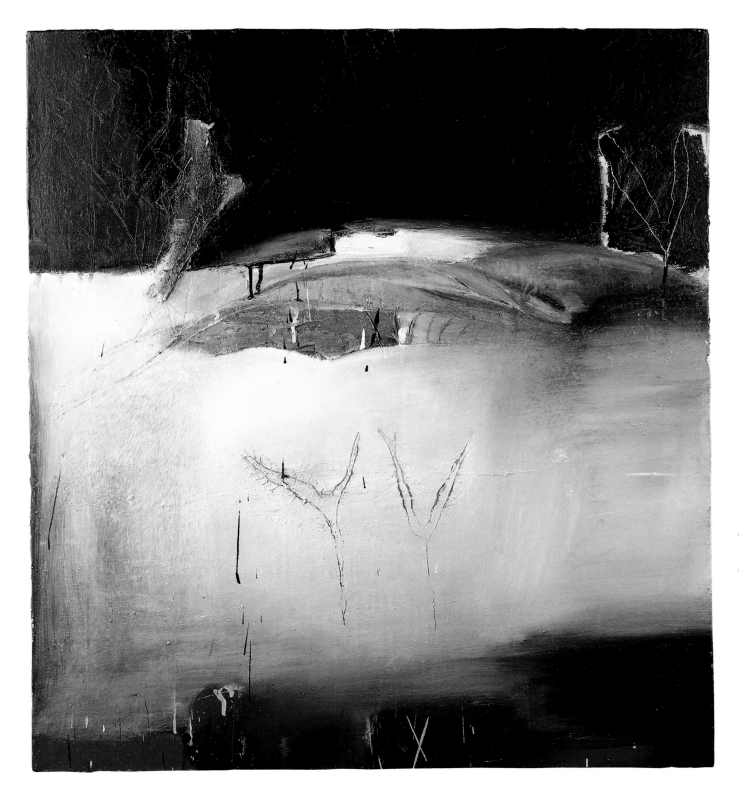

Flora Emblem #8
1995
Oil on canvas
36.25" x 32"
Collection of the artist

RICK MILLS

*"Edgar Allan Poe is a person
I would enjoy meeting."*

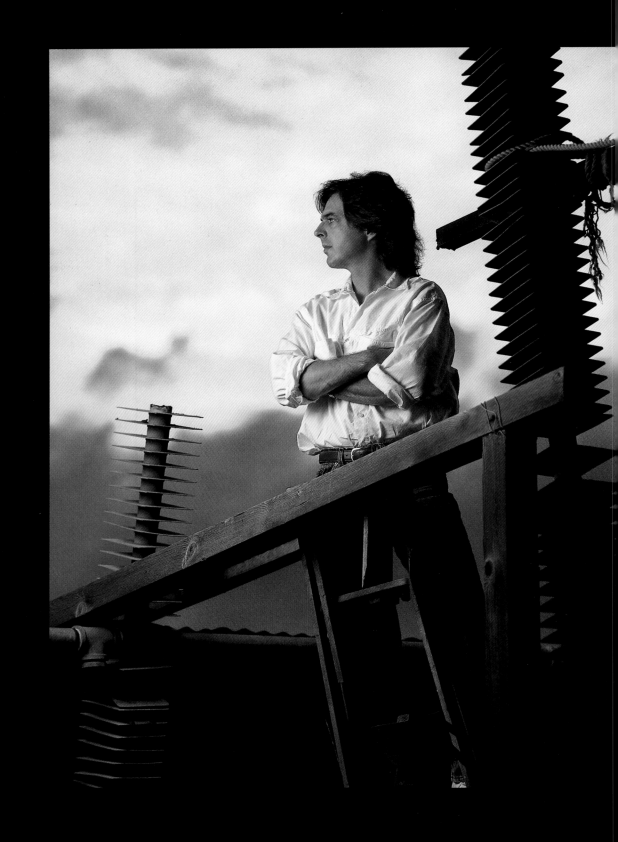

've always felt a natural attraction to art, working with my hands and making things that haven't been made before. There's a great sense of satisfaction in transforming an abstract idea into a three-dimensional object, responding to the qualities of a given material and facing the challenges that a technical process dictates.

In 1980, during my last semester at Ohio State University, the art department reopened its glass program. After spending four years working in bronze and wood sculpture, I was excited with the prospect of working with glass. The processes and techniques involved in glassmaking were totally new to me. It seemed to me that the book hadn't yet been written on it.

I was first attracted by the newness of the material. And secondly, I was drawn by the cooperation and collaboration in the glassmaking community. Unlike the world of sculpture, where each artist worked independently, almost competitively, glassmaking found faculty and stu-

dents working together for a common cause. Michael Scheiner, a graduate student in glass at Ohio State, asked me to assist in making some of his pieces. That vote of confidence was very encouraging.

A great influence on my glassmaking comes from my hometown of Marion, Ohio, the birthplace of President Warren G. Harding. Once a major industrial center for manufacturing large coal mining equipment, Marion is now part of the rust belt. Rather than becoming a noted city in the state, it has become a wasteland of fast-food restaurants, generating a sense of ennui. I spent a better part of my first eighteen years there, mired in apathy. It's that sense of apathy and the willingness to give up pursuing one's destiny found in Marion that I wanted to do something about. It wasn't until I received my B.F.A. and got involved in glass that I began to take command of who I was, what I was, what I was doing, and what I wanted to do.

I continue to be moved by these early experiences in Marion. An earlier series of sculptures, *Falling Shelters*, was inspired by the dilapidated industrial warehouses and farm structures in and around the city. The beauty of these relics from a prosperous age also led me quite naturally to the artifacts which have influenced more recent work.

There's something about the transparency in glass itself which implies immateriality. We respond to it at a very intuitive level. To contradict this transparency, I started a series of pieces dealing with larger-scale castings of human heads and implements which are attached to architectural structures. They look like anything but what you expect glass to look like—transparent, beautiful, hard-edged, reflective, prismatic. These pieces look much more like quarried stone or alabaster. They're much more artifact-like, removing the recognition that they are composed of glass. An example is the sculpture entitled *Struck by Blindness*.

Most of my time is spent with cast glass and welded steel, cast bronze, and wood. Often, I work with a reverent disrespect for the material, trying to contradict its accepted use. Recently, I've worked with a series of vestige pieces—vestiges with human heads embedded in solid blocks of glass surrounded by mosaic panels. These illustrate an entrapped environment in which individuals are surrounded by distortions of themselves caused by permutations of their desire. Part of the influence of these pieces is a pure fascination with artifacts as they elicit

a sensibility for life for any time period. I often think of myself as making artifacts.

This type of glass casting is a highly technical process. It takes weeks, if not a month, to model and make the individual inclusions for the final casting. They're modeled, cast, ground, polished, and placed in a block of molten glass which then cools for up to two months. From start to finish, it takes three months to complete a piece. Failure rates can be as high as fifty percent. Throughout the process I strive to push the preconceived limitations of the material and, thus, one's anticipations of its capabilities.

With all this very methodical, time-consuming, laborious preparation, I try to preserve certain unpredictable qualities of the casting process in the final piece. I believe there is an element of truth born out of the fire and the reactions it generates among all the materials involved. These pieces become a record of the encapsulation process—frozen and indelible.

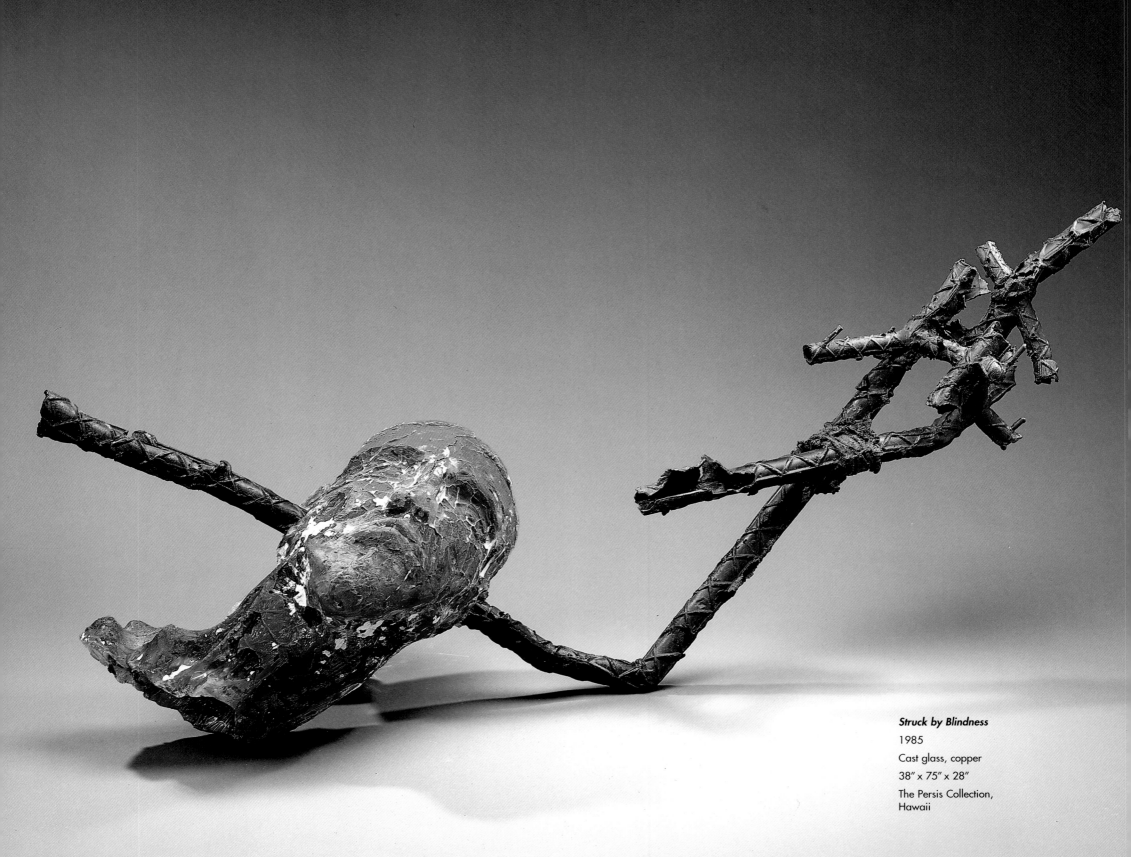

Struck by Blindness
1985
Cast glass, copper
38" x 75" x 28"
The Persis Collection,
Hawaii

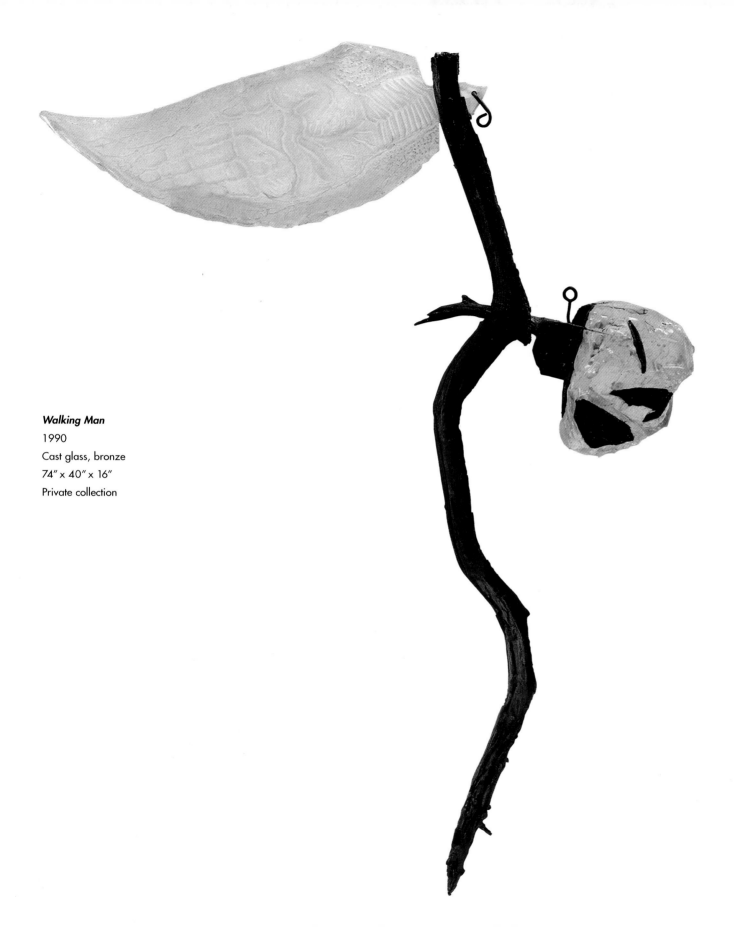

Walking Man
1990
Cast glass, bronze
74″ x 40″ x 16″
Private collection

BORN

Marion, Ohio,
1957

EDUCATION

B.F.A., Sculpture,
Ohio State University,
Columbus, Ohio

M.F.A., Sculpture,
University of Hawaii
at Manoa,
Honolulu, Hawaii

MEDIA

Glass and bronze
sculpture, blown glass
vessels

AWARDS

Fellowship,
Creative Glass Center
of America,
Millville, New Jersey,
1986

Scholarship for
Outstanding Achievement,
Art Department,
University of Hawaii
at Manoa,
Honolulu, Hawaii,
1987

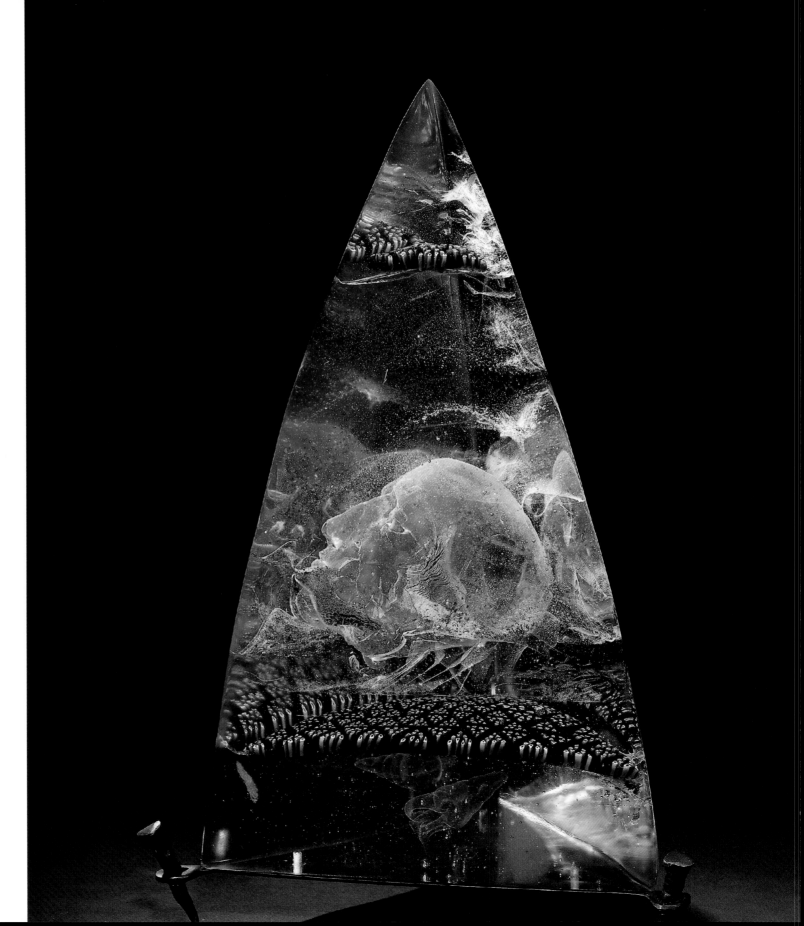

SOLO EXHIBITIONS

Walking Sticks,
Jay Mews Studio,
Royal College of Art,
London, England,
1988

Greasing the Wheel,
Queen Emma Gallery,
Honolulu, Hawaii,
1989

Artificial Curiosities,
The Contemporary
Museum,
Honolulu, Hawaii,
1996

Still Water
1993
Cast glass, bronze
32" x 17" x 17"
Collection of the artist

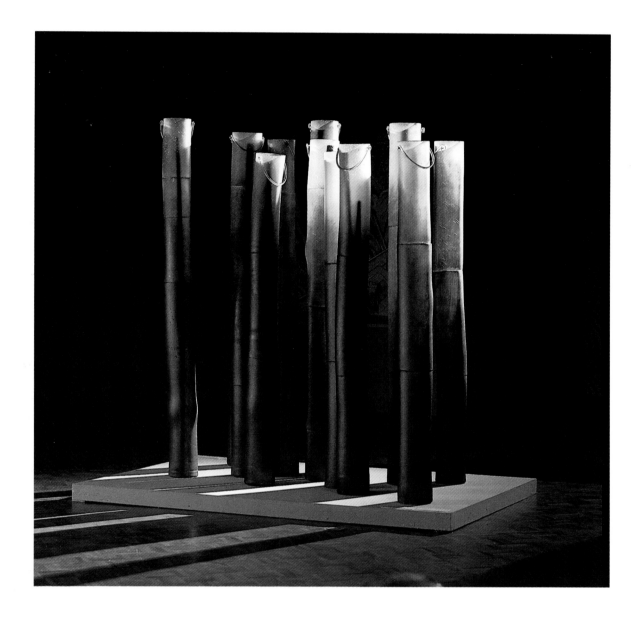

The Midden and the Made
1994
Blown glass, wood
7′ x 4′ x 8′
Collection of the artist

HIROKI MORINOUE

"I would like to meet Picasso at a coffee shop. He's an artist who didn't reach professional maturity until the age of fifty. I still have a couple more years."

The interest in art was there. In high school, I sketched madly—students, movie stars. I drew for the annual.

My first exposure to more formal art training came when I met Bob and Carol Rogers at the Kona Art Center. I spent two years working with them and became one of their most active students. Bob took me under his wing and gave me extra time, accompanying me on landscape field trips. I found that I recorded very fast and learned quickly. With his help and encouragement, I went on to the California College of Arts and Crafts in Oakland where I received my B.F.A.

In 1974, I began to paint full time in watercolors, almost always on location where I learned to see things. I kept several paintings going at the same time because whenever the sun changed, I would have to stop work on one painting and begin on another. I couldn't imagine the change. Later, I learned to visualize light changes without actually seeing them.

In 1981, I went to Japan for three years to study Japanese woodblock printing techniques. Walking through the gardens, temples, and other quiet spaces in Japan, I found that Japanese sensitivity was a part of me, manifested in the subtle use of space and form in my art work.

While in Japan, I painted granite rocks, not lava rocks. Stepping stones became part of my imagery, as did the linear divisions found in Japanese architecture. In fact, Japanese architecture remains a very strong image. It relates directly to all my prints and paintings, with strong linear divisions between space, rocks, and sky.

Today, I'm more of a printmaker than a painter. I now produce prints both in Hawaii, where I employ hand-printed techniques and Japanese water-based ink, and on the Mainland with publishers in Arizona and Colorado. In my own studio, I primarily do wood-block prints and monotypes, which are paintings on plexiglass, free-form and more like a painting than a print because there's only one. In between printmaking, I work on large pieces in acrylic and oil. They require large blocks of time.

I like working in both prints and acrylics. If I have an idea, I work it quickly in a monotype and then transfer the image and vision of space and color to oil or acrylic. Paintings are more difficult than prints because prints have an inherent quality of clarity missing from paintings.

My style has slowly evolved from very representational and realistic landscapes to more abstract scapes. But it's always landscape. Initially, I was a value painter, seeing things more in black and white and shades of gray. Then, as I involved more color in my work, my paintings became more abstract.

Throughout this evolution, Hawaii has continued to influence my art work. When my work was primarily representational, it was obvious. Now, even as I travel more often and have moved to more abstraction, my subject matter is still landscape, and still basically Hawaiian. I simplify the landscape into water, rocks, and other basic forms and do variations of these forms.

Recently, I've turned to working in wood sculpture, which satisfies my love for architecture and keeps me in touch with the physical world. Somehow, painting alone has failed to do this for me. Sculpture has become a medium in which I can express more of my personal feelings, and provides a balance to the more intellectual aspects of painting.

I'm beginning to try a number of different things. I'm transitioning and searching for an idea on which I'd like to spend more time, one that will work in all the media I've tried. It's coming.

"Arthur Okamura, my painting teacher at the California College of Arts and Crafts. With his few words, I understood what I needed to do. I worked myself to new goals by searching deeper and deeper. He made me feel I had the answers inside of me."

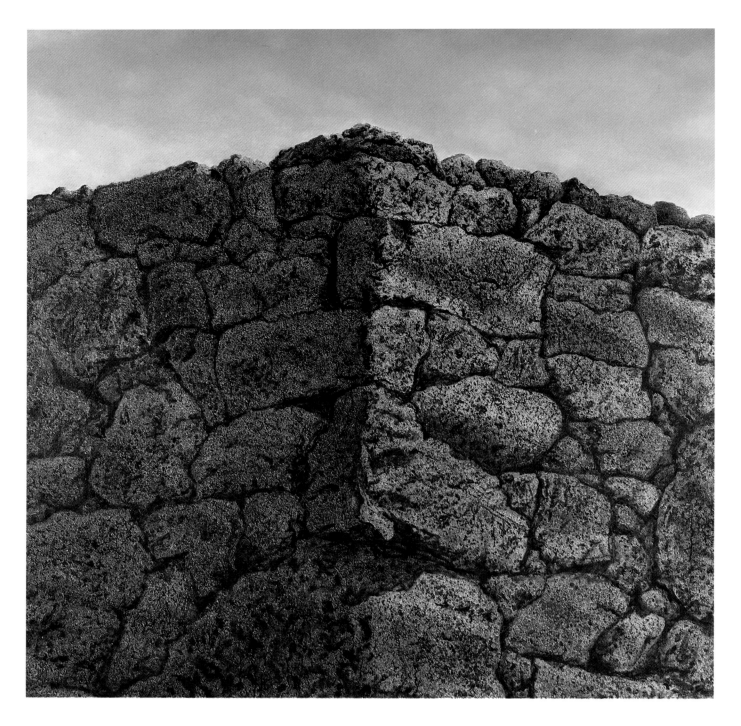

Corner of Heiau

1975

Oil on canvas

48″ x 48″

Collection of the artist

▶

Sand Ripples

1976

Acrylic on canvas

48″ x 60″

Collection of the
Honolulu Academy
of Arts, Hawaii

AWARDS

Fifty-third Annual
Kanagawa Prefectural
Governor's Award
Hama Ten,
Kanagawa, Japan,
1977

First Prize,
Kanagawa Suisa
Renmei Ten,
Kanagawa, Japan,
1983

First Place,
Honolulu Japanese
Chamber of Commerce
Exhibition,
Honolulu, Hawaii,
1991

SOLO EXHIBITIONS

Eclipse,
Contemporary Arts
Center,
Honolulu, Hawaii,
1978

Tokyo Exhibit,
Kabutoya Gallery,
Tokyo and Nagoya, Japan,
1984

Recent Works,
Amaury St. Gilles
Contemporary
Fine Art,
Tokyo, Japan,
1985

Inagaki Garden,
The Contemporary
Museum,
Honolulu, Hawaii,
1989

Landspace,
Joanne Chappell Gallery,
San Francisco, California,
1991

*Land Space—Recent
Paintings and Prints,*
The Contemporary
Museum Gallery at
Alana Waikiki,
1994

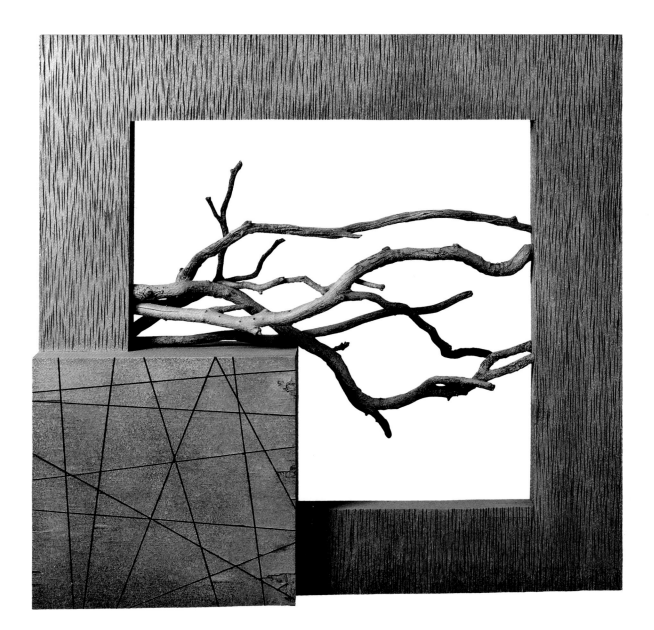

Window Space 1
1992
Wood
48" x 48" x 11"
Collection of the artist

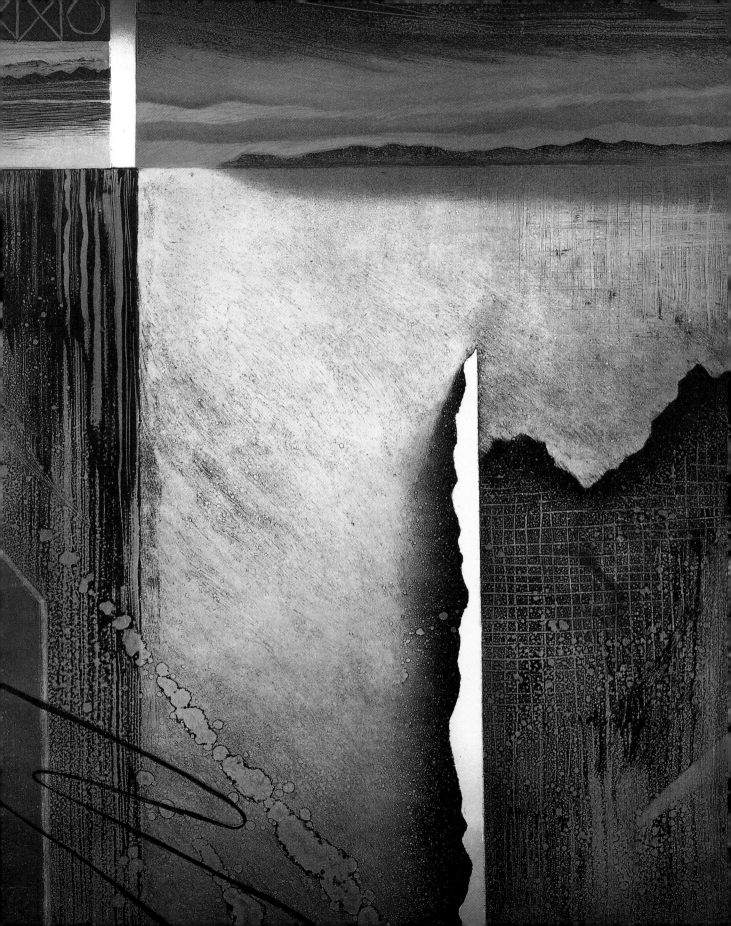

ITA

sts.

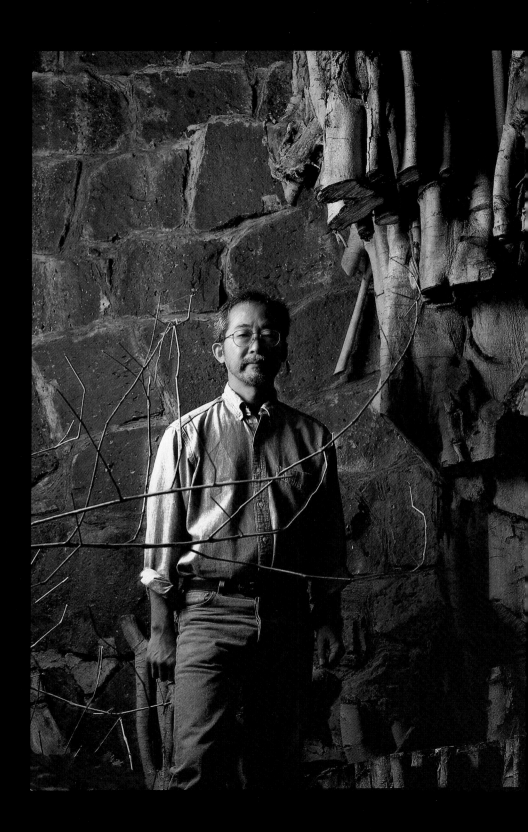

I n the sixth grade, I saw an art advertisement which claimed that to become an artist your first exercise should be drawing circles and boxes. From then on, I doodled whenever I was in the classroom, always drawing circles and boxes. As a result, when I finally attended the San Francisco Art Institute many years later, I had already developed the finger muscles to draw strong, expressive lines even if I had never really drawn any pictures.

My interest in photography began with a camera I won at a poker game while in the Army stationed in Germany. With that camera, I went all over Europe taking thousands of pictures. One of my photographs was entered in a military photography contest. It was awarded first place in the experimental category in the all-Army competition and second place in the interservice contest.

I returned to Honolulu and worked as a photographer's assistant for two and one-half years. Then, I surprised myself and everyone else and enrolled in an art school. There, I began to put together my interest in drawing and photography in a series of photoetchings.

Working with various etching techniques was a very natural process for me. Perhaps, I unconsciously remembered the Old Testament illustrations from the Seventh-Day Adventist bedtime stories my mother read to me every night when I was young. Drawn by some of the foremost art illustrators of the past century, these illustrations provided me with very sophisticated visual information. They were in black and white, very graphic and powerful.

I've found that I express myself more clearly through a visual medium than verbally. This still amazes me because I'm not exactly nonverbal. However, a lot of what I want to express is more understandable and appreciated by others in my art.

My print series is my personal visual art diary. It began with the family of Charlie and Linda Ware and their children, Gabriel and Laura, who lived in a rough section of San Francisco. I wanted to create a family saga that would overlap generations. I started this project in 1972, when I was a student at the San Francisco Art Institute. Since then, I have taken over 20,000 photos of the members of this family and created over one hundred etchings and photoetchings of them. My long-range goal is to create an etching of Gabriel, who was only two weeks old at the inception of the project, when he's fifty—the age of his father Charlie when I first met him. Gabriel is now twenty-three years old!

Other members of this family appear in most of my later prints.

My second series of large photoetchings depicts my own family and prints of ancestral funerals in Hawaii and Japan. I initiated this series to bring together my San Francisco family series with my own family and ancestors in Hawaii and Japan. In this funeral series, I tried to address the essence of a situation where the experiences of the event often become more important than the words used to describe them.

In the late 1970s, I was invited to participate in three human rights tours of Israel and the Occupied Territories of the West Bank and Gaza. There, I witnessed how easily a dominant culture can dehumanize a minority people in its effort to rob them of identity and dignity. That experience has profoundly affected me. My feelings and thoughts are expressed in a collection of large prints entitled *The Palestine Intifada (Rebellion) Series.*

While many of my images are from San Francisco and the Middle East, the root of my work reflects in black and white forms my personal experiences in Kalihi Valley where I grew up and still live. Currently, I am photographing a Hawaiian sovereignty group in Waimanalo.

"The person most responsible for my becoming a printmaker is Patricia Benson, my etching instructor at the San Francisco Art Institute. Her artistic integrity and commitment to her students make her stand out in her influence over my art development.

Another major influence is Rolando Castellon, former curator at the San Francisco Museum of Modern Art. He included my first photoetching in an exhibition at the San Francisco Museum of Art in 1973 and organized my solo show at the San Francisco Museum of Modern Art in 1979. He was also the first to show my large photoetchings at the University of California at Santa Cruz."

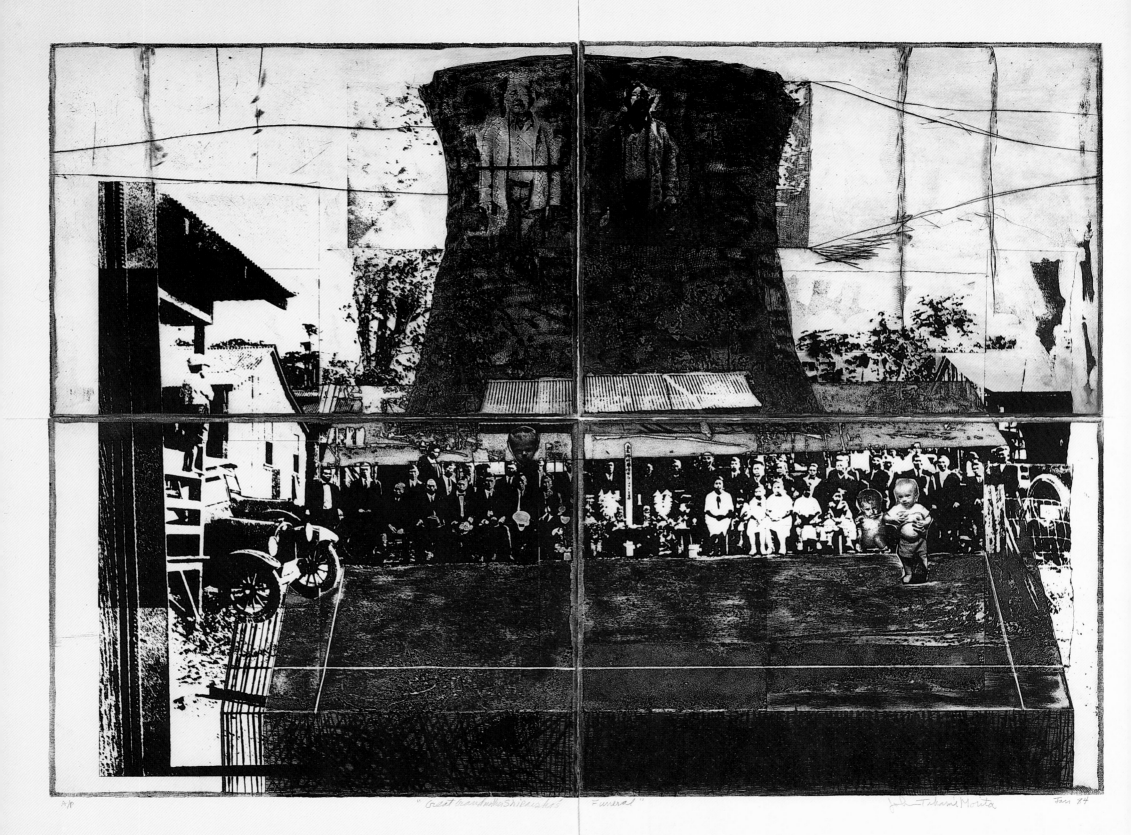

"Great Grandmother Shiraishi's Funeral" John Takami Morita Jan 84

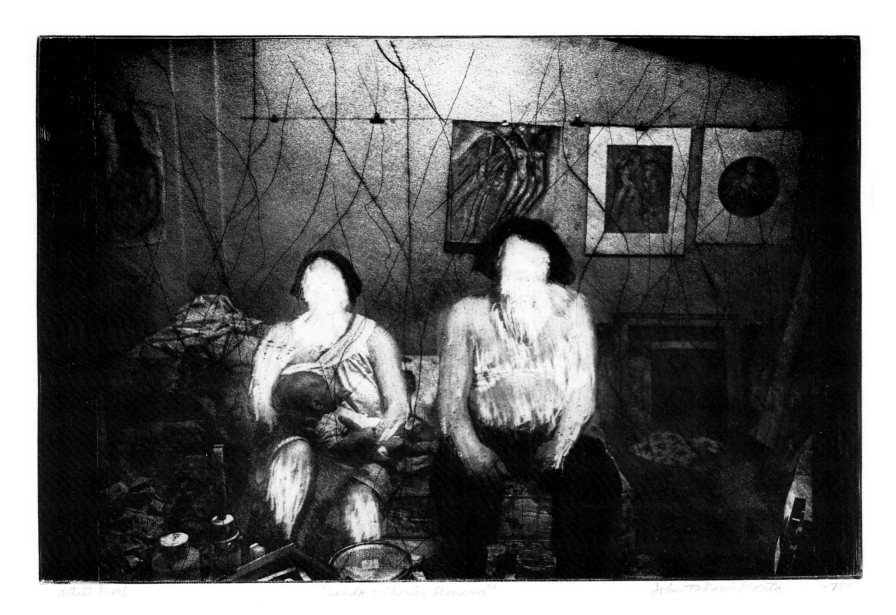

◀

**Great Grandmother
Shiraishi's Funeral**

1984

Photoetching

36" x 47.5"

Collection of the Hawaii
State Foundation on Culture
and the Arts

**Linda and Charles
Removed**

1975

Photoetching

15" x 22"

Collection of the artist

BORN

Honolulu, Hawaii,
1943

EDUCATION

B.A., History,
Chaminade College,
Honolulu, Hawaii

B.F.A., Photography,
San Francisco Art
Institute,
San Francisco, California

M.A., Printmaking,
San Francisco
State University,
San Francisco, California

MEDIA

Printmaking,
photoetching,
photography

AWARDS

Fellowship,
National Endowment for
the Arts,
Washington, D.C.,
1986

First Prize,
Intergrafik, International
Print Triennial,
Berlin, Germany,
1987

Print Club
Selection Award,
The Print Club,
Philadelphia,
Pennsylvania,
1988

Grant,
State of Hawaii
Commission on the
Columbian
Quincentennial
Observance,
Honolulu, Hawaii,
1992

Individual Artist
Fellowship Merit Award,
Hawaii State Foundation
on Culture and the Arts,
Honolulu, Hawaii,
1995

SOLO EXHIBITIONS

*Etchings by
John Takami Morita,*
Honolulu Academy
of Arts,
Honolulu, Hawaii,
1977

*John Takami
Morita/Prints:
The Charles and Linda
Ware Family Series,*
San Francisco Museum
of Modern Art,
San Francisco, California,
1979

*John Morita: Recent
Prints/Matrix Gallery,*
Alternative Museum,
New York, New York,
1987

*John Takami Morita:
Radierungen USA,*
Intergrafik '90,
Berlin, Germany,
1990

*John Takami Morita:
Intifada Series,*
The Print Club,
Philadelphia,
Pennsylvania,
1990

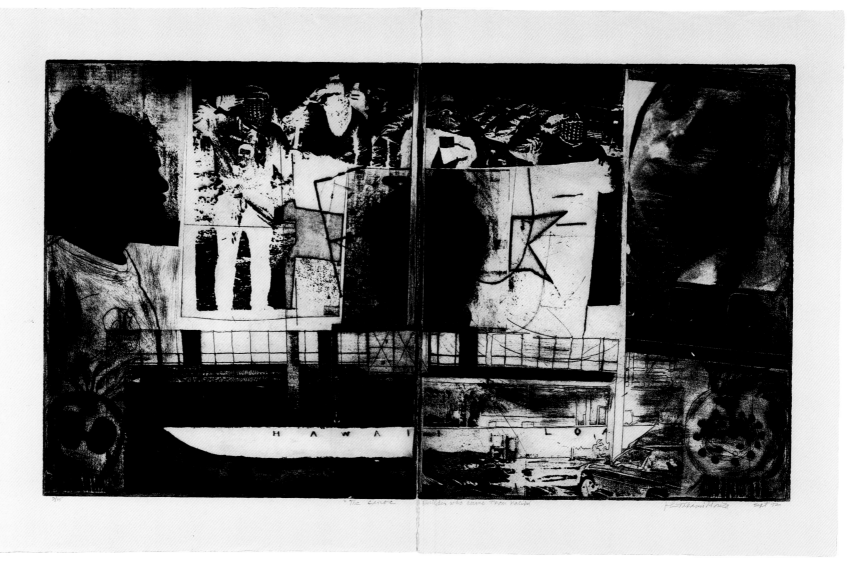

**The Canoe Builder Who
Came from Kalihi**

1992

Photoetching

24″ x 36″

Collection of the City and
County of Honolulu Office
of Culture and the Arts

▶

Gabriel with Martyrs

1989

Photoetching

34″ x 40″

Collection of the City and
County of Honolulu Office
of Culture and the Arts

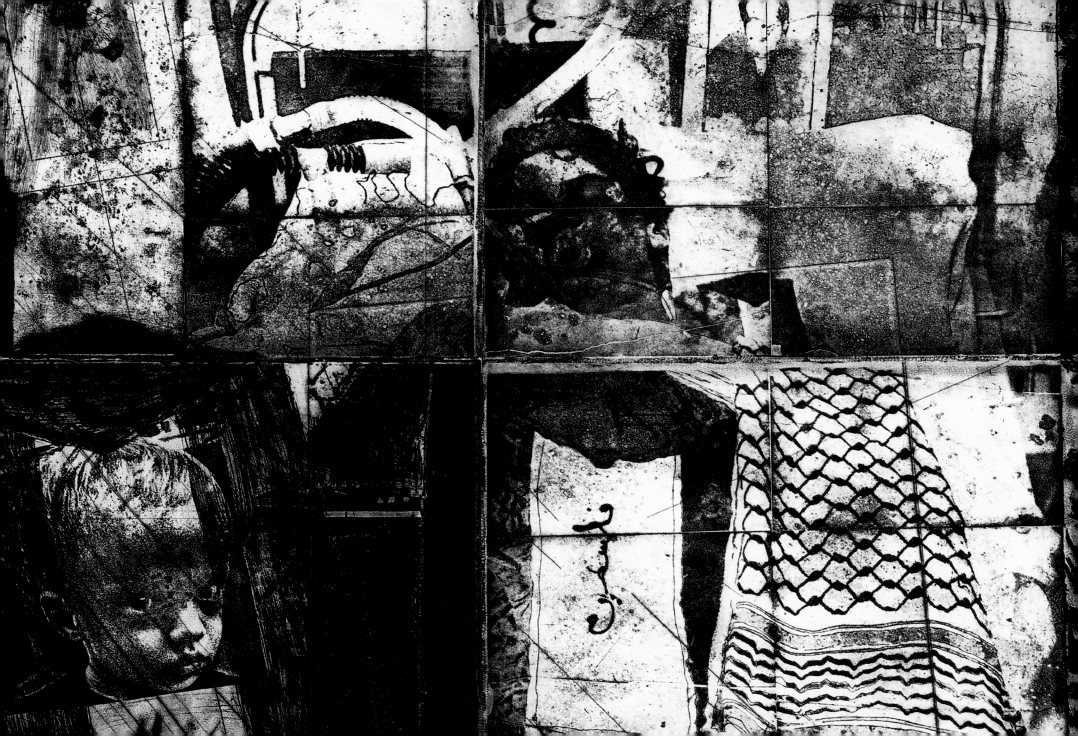

MARCIA MORSE

"I'd love to meet Hildegarde of Bingen, a twelfth-century nun who founded a nunnery, an extraordinary accomplishment at the time. She was also a mystic, composer, artist, and philosopher. I like the shape of a multifaceted life, and the combination of art and spirituality. Visually, her work on the illuminated page is exquisite."

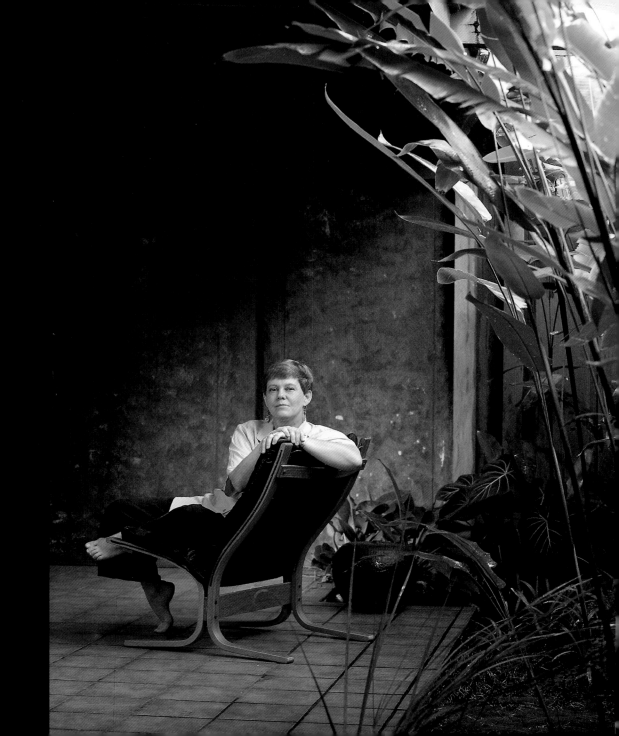

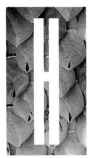

How I ended up both as an artist and a teacher is still a source of amazement and amusement. Growing up, I remember always having a pencil in my hand. I remember lying on my stomach under my mother's harpsichord or piano while she was playing, and drawing and really enjoying the process.

I grew up in Hawaii, attending Hanahauoli and Punahou schools. My undergraduate work at Harvard was primarily in the social sciences. I was geared for an academic, professional career.

It was in South America, where I spent two and one-half years after graduating from college, that I was casually introduced to printmaking. For the first time, I connected with a medium. I always liked the graphic process—drawing rather than painting, more line and value rather than color and paint. I did a lot of work in printmaking and had my first solo show in Ecuador.

Returning to the West Coast, I ended up at the University of California at Santa Cruz as the director of student services and teacher of printmaking. I realized that if I was going to continue teaching art, I had to go to graduate school. I applied and was accepted in the graduate program at Stanford University where I received my M.F.A.

Returning to Hawaii, I got a position teaching at the Honolulu Community College and served as art critic for the *Honolulu Star-Bulletin*. Since that time, I've been active in drawing, printmaking, and papermaking.

My interest in papermaking developed at graduate school during a renaissance of handmade paper in California. Exploring the process of making paper, I suddenly had different materials with which to work beyond what was available commercially. The more I learned about paper, the more fascinated I became, until my interest shifted to making and working with paper rather than exclusively printmaking.

There's nothing like making a sheet of paper for the first time. It's a very seductive process. You put pulpy material into a vat of water and pick up a certain amount of it on the screen. When the water drains, you end up with a lovely mat of fibers. It's a very clean, non-polluting process. You're using natural materials and there's a sense of being in control from the very beginning. It's quite wonderful as an artist to be able to make the very material on which you're working.

You learn that papers have personalities, which is also a nice part of it. Different fibers will work in different ways to create different surfaces. While the process is simple, it is very labor-intensive. I like this aspect of it. The time and energy you devote to making the paper and working the surface allow you to be very meditative.

Working with paper, I discovered it had strong sculptural possibilities. Manipulating a sheet of paper or actually working with the pulp material is rather like working with sculptural materials like wet clay. While I never had any formal training in three dimensional art, I'm moving in that direction through my experimentation with paper. Another related area of interest is the application of papermaking and the graphic process to the production of books as an art form.

Being an artist is an ongoing process. You're always pushing at the boundaries. The more successful you are with taking risks, the more able you are to do it.

Where I am now is trying to draw things together again by bringing printmaking and drawing back into papermaking. I've had a few projects where I've basically designed the paper knowing that an image was going to be put on it, so that the two things could work together. I like going back and forth between working in one medium, to working in another, to working with a different subject matter. It's the chemistry of change and evolution that I feel is personally important as an artist.

"The three people I identify as mentors are those who helped me find and stay on the artist's path.

Dick Nelson, one of my all-time favorite teachers from Punahou. Dick was an excellent teacher and a working artist. Doing what you teach gives an essential credibility to the whole enterprise.

Kurt Muller, with whom I studied printmaking while I was living in Ecuador. Kurt was a supporter of my entry into the professional art world. I had my first solo exhibition in Quito.

Nathan Oliveira, teacher and advisor during my graduate studies in printmaking at Stanford and exemplar of the artist-teacher."

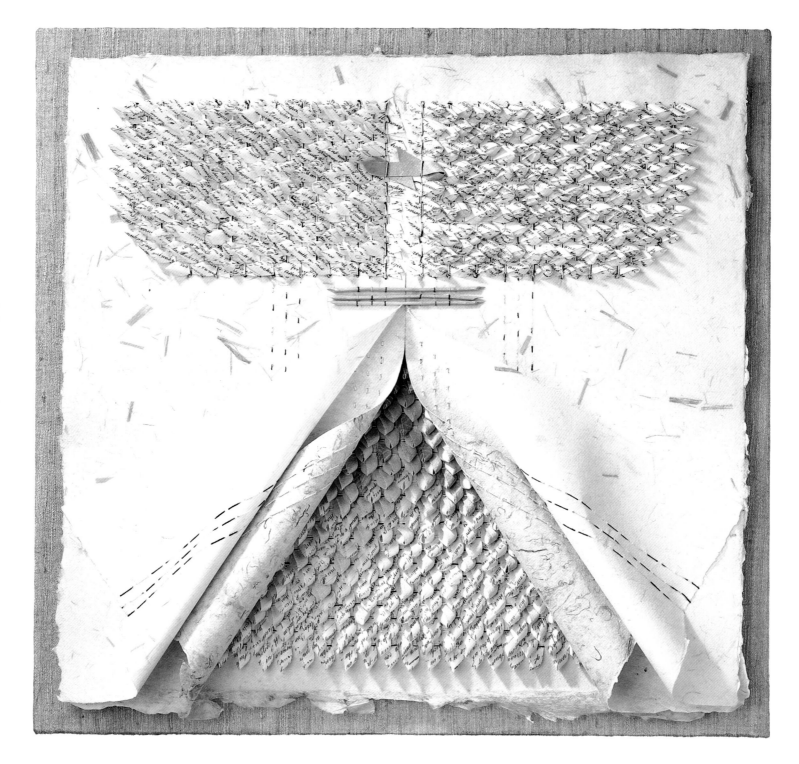

Widow Queen's
Morning Song

1984

Handmade paper,
vellum, silk cord

20″ x 20″ x 4″

Collection of the artist

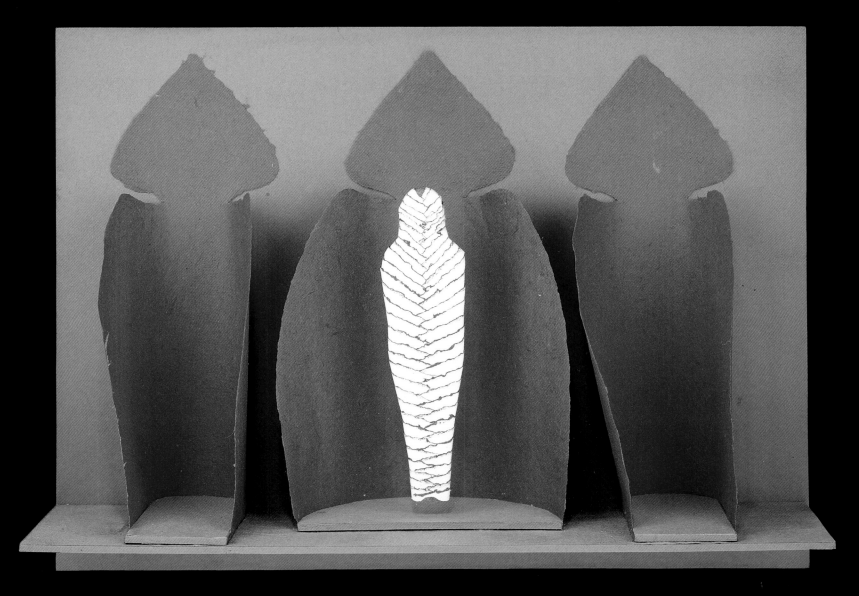

Soul Sanctuary
1990
Handmade paper, wood
18" x 24" x 8"
Collection of the artist

BORN

Detroit, Michigan,
1944

EDUCATION

B.A. cum laude,
Sociology/Clinical
Psychology,
Harvard University

M.F.A., Printmaking,
Stanford University

MEDIA

Papermaking,
printmaking, drawing,
sculptural uses
of paper

AWARDS

Graduate study grant,
Stanford University,
Stanford, California,
1972-74

Grant,
Hawaii State Foundation
on Culture and the
Arts/Hawaii Newspaper
Agency,
Honolulu, Hawaii,
1976-1977

Artist-in-schools grant,
National Endowment for
the Arts/Hawaii State
Foundation on Culture
and the Arts,
Washington, D.C./
Honolulu, Hawaii,
1977-1978, 1981

Craftsmen's Fellowship,
National Endowment
for the Arts,
Washington, D.C.,
1981-82

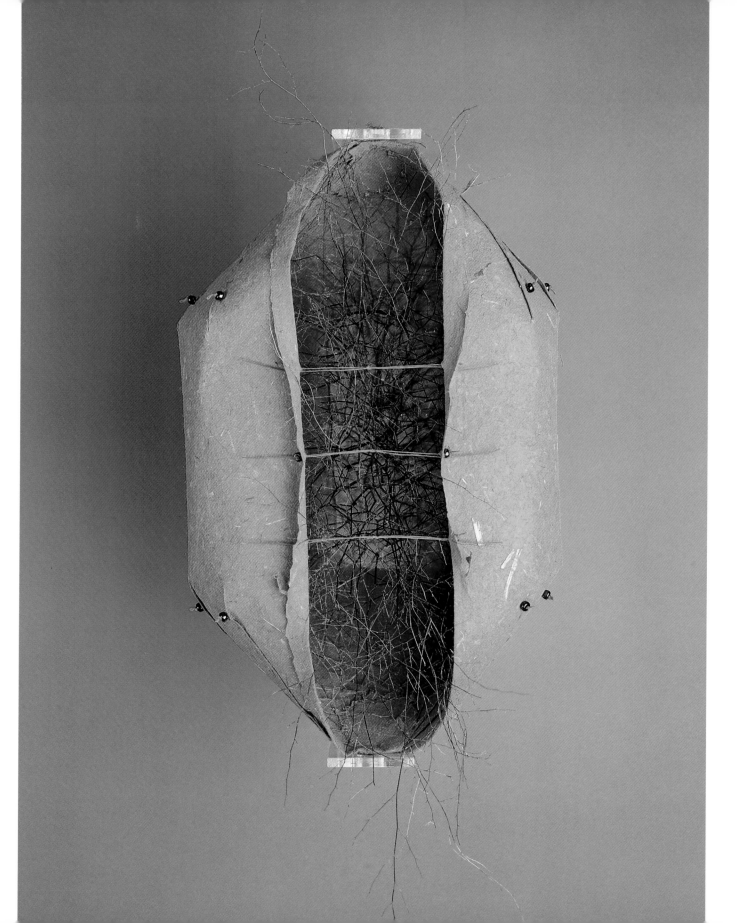

SOLO EXHIBITIONS

Grabados (Prints),
Galeria Artes,
Quito, Ecuador,
1968

Ritual Cloth,
Contemporary Arts
Center of Hawaii,
Honolulu, Hawaii,
1978

New Paperworks,
R. Gallery,
Kyoto, Japan,
1983

New Paperworks,
Art Space Niji,
Kyoto, Japan,
1986

Secret Garden,
The Contemporary
Museum,
Honolulu, Hawaii,
1991

Pod
1992
Handmade paper, maiden-
hair fern, plexiglas
22″ x 9″ x 14″
Collection of the artist

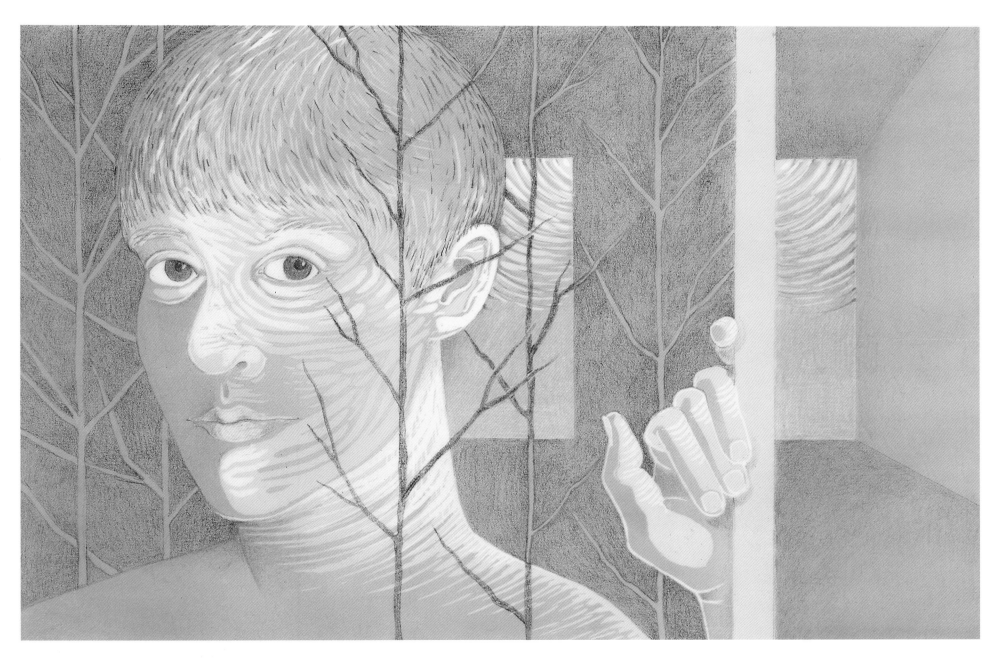

Through the Thicket
1993
Woodcut with handcoloring
12″ x 18″
Collection of the artist

TIMOTHY P. OJILE

*"I would have liked to meet
Van Gogh, especially after reading
his letters to his brother, Theo."*

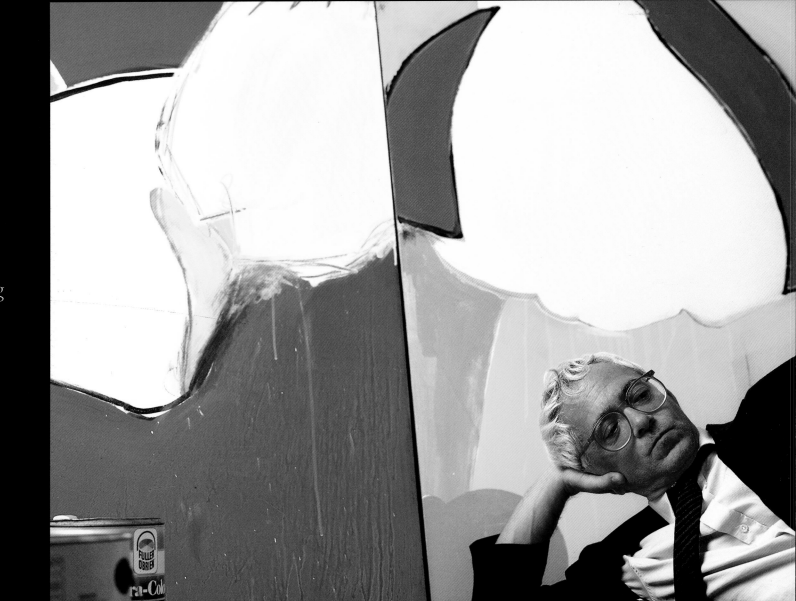

I can't remember a time when I wasn't interested visually in the world around me. My generation was the first to be raised on television and I think this had everything to do with my interest in the moving image; in shape, line, and color in painting; and in the graphic arts generally.

At a very early age, my interest in the visual arts led me to the public library, where I learned a great deal about such artists as Kandinsky, Picasso, DeKooning, Pollock, Rauschenberg, Twombly, and Tapies. Although I contributed drawings to my prep school newspaper, I didn't begin to paint actively until after college, where I earned a degree in Eastern art history.

Several years later, I moved to New York City, where I took a job and also painted for many hours each day. The impact of the New York art world on me is immeasurable.

Fond as I was of New York, I was ready to try something else after spending ten years there. And so, being interested in all things occult, I consulted a famous astrologer about my future. She firmly suggested that I leave New York and relocate. Her letter was so supercharged and provided such good guidance that I decided to leave the city and make a temporary stop in Hawaii to visit with friends. As I rather liked the idea of staying, I took a job at the Honolulu Academy of Arts as a graphic designer for the Academy Theatre.

I came to Hawaii in an offbeat way which actually fits into my idea about art. We are taught to have so much restraint and logic in our thinking when actually everything we do is affected by myriad probabilities and in ways that are basically intuitional and illogical. Ideas have their own logic. It's true of art work; it's true of painting. In creating art, you need to intuitively "see under events." While painting, you must get outside yourself, so to speak, and allow another, "larger self" take over. You need to find a way to both express and transform this process of "seeing" in each and every brushstroke.

Initially, I used more mixed media in my work than I do now. One of the first things I did in Hawaii was to tie up fibers and plant leaves and paint them. It was both conceptual and objective in response to the environment. I worked with canvases in different ways, tying and painting them. For example, I made little bento boxes with objects tied and painted in different colors. I think people came to identify me with that kind of art.

In time, I have become more interested in simply painting. I like the hands-on immediacy of painting, as opposed to other processes such as printmaking which I find somewhat indirect. Because paint is wet, your hands can get wet. It's an immediate sensation.

Recently, I've trained myself to paint on smaller formats such as paper. I find them to be a much more effective way to express my ideas quickly before fleshing them out onto canvas.

For the most part, my work is now nonobjective. I hesitate to use this term because there's always an objective in painting, but it's not always obvious and often remains hidden.

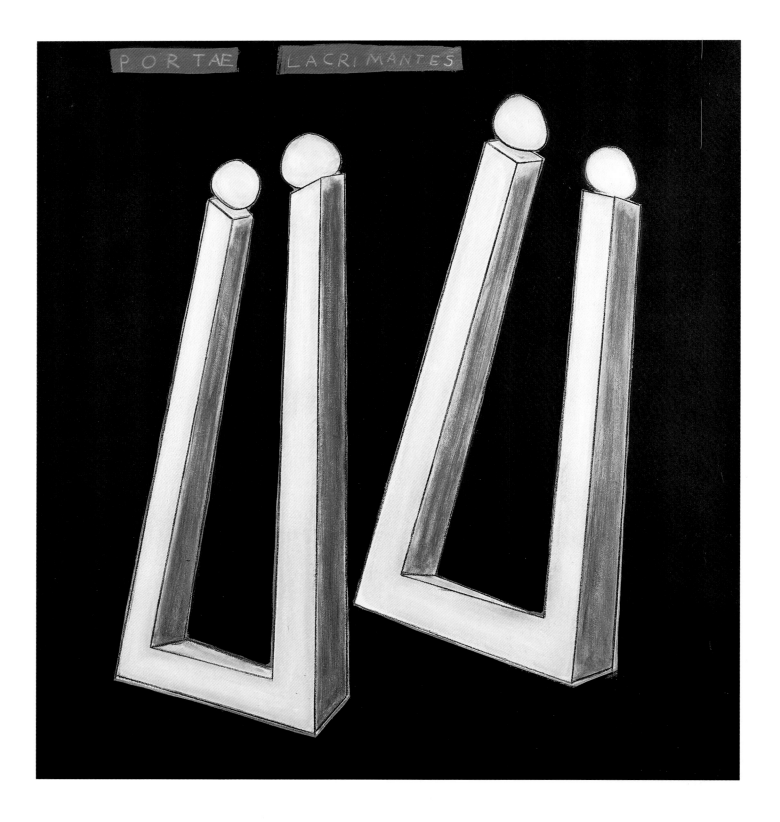

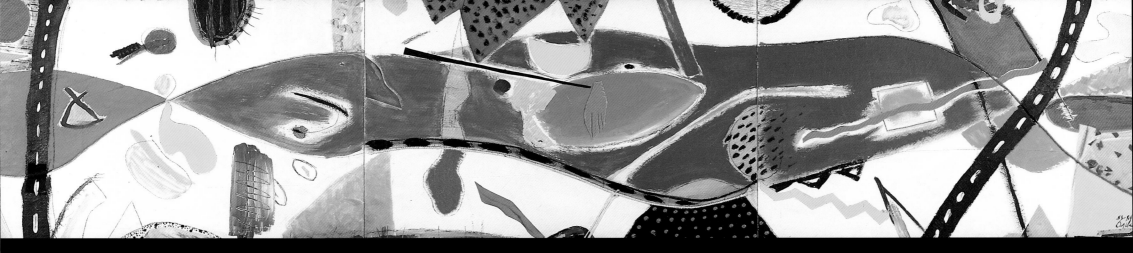

Topograph
1983
Mixed media on wood
32" x 141"
The Persis Collection,
Hawaii

SOLO EXHIBITIONS

New Work,
Printmakers Gallery,
Honolulu, Hawaii,
1982

*Recent Works by
Timothy P. Ojile,*
Gallery Cuore,
Osaka, Japan,
1987, 1989

New Work,
Queen Emma Gallery,
Honolulu, Hawaii,
1988

Womb of Superstition,
The Contemporary
Museum,
Honolulu, Hawaii,
1991

New Work,
Keiko Hatano Gallery,
Honolulu, Hawaii,
1992

Lyric,
The Contemporary
Museum Gallery at
Alana Waikiki,
Honolulu, Hawaii,
1995

**O Fons Bandusiae
Splendidior Vitro
(O Fountain of Bandusia
Brighter than Glass)**

1993

Acrylic, latex, crayon,
pencil on canvas

66" x 78"

Private collection

▶

**Still Life with Fruit
and Flowers**

1993

Acrylic, latex, crayon,
pencil on paper

53" x 66"

Collection of the artist

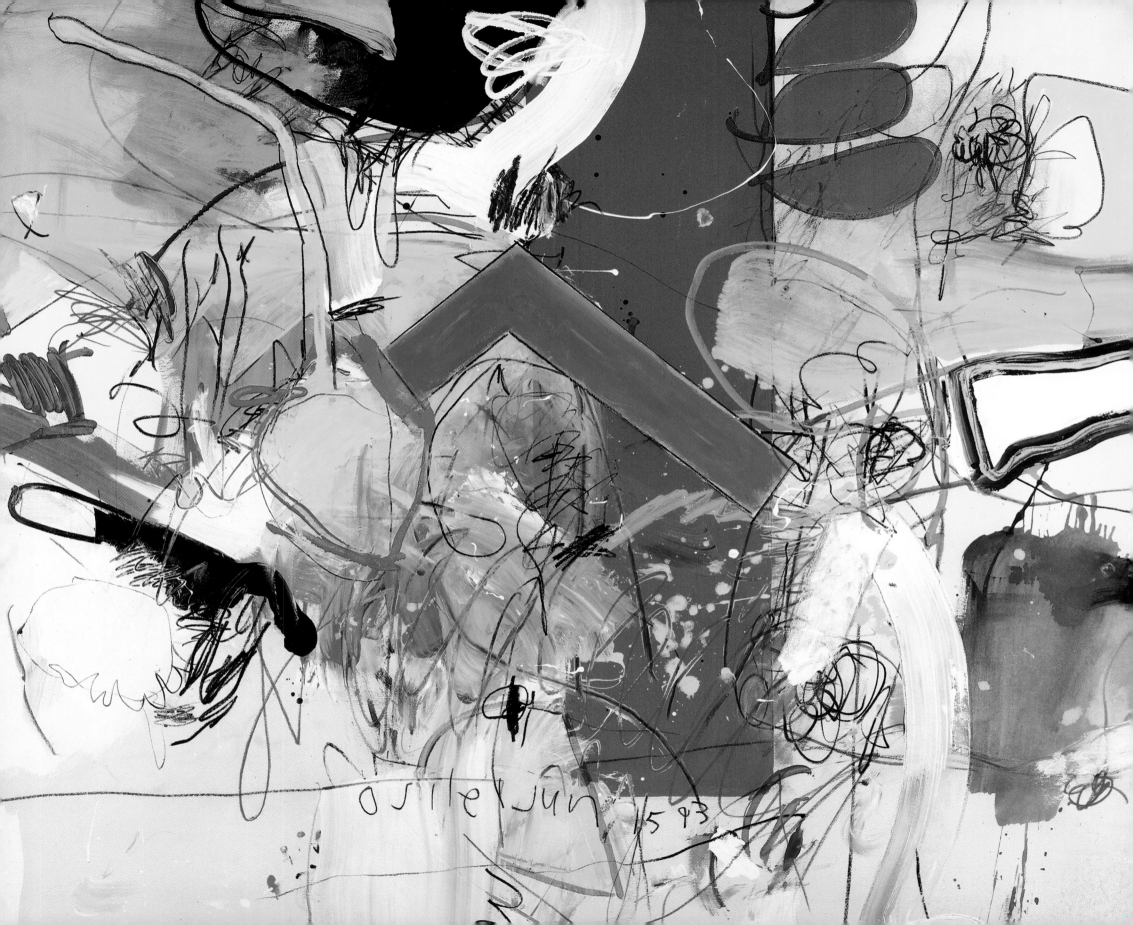

FRED H. ROSTER

"Leonardo da Vinci is at the top
of the list of artists I would like to
meet because of the way he combines
different kinds of thinking/perceptions.
He would frame scientific thought
in aesthetically beautiful ways;
to me, that's very important. I'm
perpetually testing things, trying to
figure out ways to do what's not
supposed to be done. Leonardo didn't
seem to have limitations. He would
find ways to do things, invent."

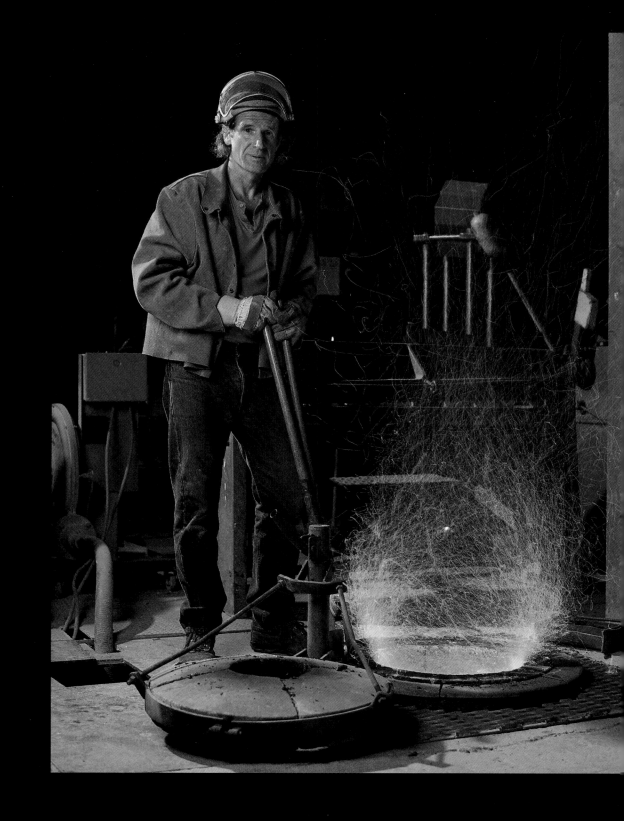

orking with my hands goes back to making mud balls in Palo Alto; the lingering smell of clay or earth was an early introduction into forming things and being empowered by that thing you've made. Another lingering subliminal message from my childhood is that of the smell of clear pine I worked with in elementary school. My parents were always building houses, so I grew up with the smell of fresh lumber. It had an impact on me—the idea that you can build things and it's part of life.

I came to Hawaii in 1969 on my honeymoon, having just finished my masters degree in ceramics. I ended up entering the M.F.A. program at the University of Hawaii and later joined the faculty when a position in sculpture opened up. I had only dabbled in sculpture, so I spent some very anxious early years trying to stay ahead of my students. I became a mixed-media artist when I started to explore those things I was to teach at UH-Manoa as a mechanism for understanding processes.

Clay is my three-dimensional foundation. I use it as a sketching medium, a conceptualizing, transitional material. For years, I'll work in wood or bronze, but it keeps cycling back to other things. I model in clay, but I might not want to express clay in the final piece. I might carve out of wood, make molds then cast in bronze, but say something about the wood. So a singular material like bronze still seems like mixed media to me. More often than not I assemble things; I can make that union and integrate disparate materials and forms. I use various materials to speak of or inform the image. Mixed media just seems like a larger vocabulary.

My work takes on shapes and structures resembling things I'm involved with. It might be athletic things like bicycles, volleyball, boating, and fishing. The form might be attached to those things, but metaphorically it wanders toward social and human concerns for the planet.

In the mid-1970s, I started working more figuratively. Narration became more important. I didn't want a person to believe they could understand my work in the brief time they viewed it at an exhibition. Recently, I've allowed the work to speak more clearly; the layers are more emphatic and hopefully convey a clearer message. Much of the time the work is topical, dealing with global issues. Invariably, there is a personal subtext.

I want my work to have a formal viability that will propel it into the future whether or not it remains relevant conceptually. The purely aesthetic qualities of the work should give it some staying power. The construction and process, too, need to be refined enough so that the work can be appreciated for its technical mastery and ingenuity.

My goal is to try to convey whatever insights I might have. But it seems kind of pompous to say that that's important, that I should talk about social conditions and global concerns. I haven't thoroughly studied these topics, but they are there and do drive the work. At this point in time, a number of people—authorities and critics—say that unless the work is socially loaded or potent, it's not really important work. So the artist is being put in the curious position of being a kind of visual conscience.

The diversity of cultures in Hawaii creates contrasts of perception that allow an observer, such as myself, a richer, more complex realm of experiences. This diversity is expressed in the work as an important part of what is largely an autobiographical continuum. In the same way that work in mixed media offers a larger visual vocabulary, Hawaii's cultural mix creates an expanded perceptual field: a microcosm that is also a lens, both internal and external.

"I owe a lot to a lot of people and to those artists I've looked at over the years. Anthony Caro, who worked with steel as if it were big slabs of clay. Louise Bourgeois, for her audaciousness and tenacity. Kanjiro Kawai, whose mastery and freedom coupled with incredible restraint still allowed chance to enter the work. Accidents are as important as an end logically gotten to; that inability to control everything is a factor that makes a work dynamic and revelatory."

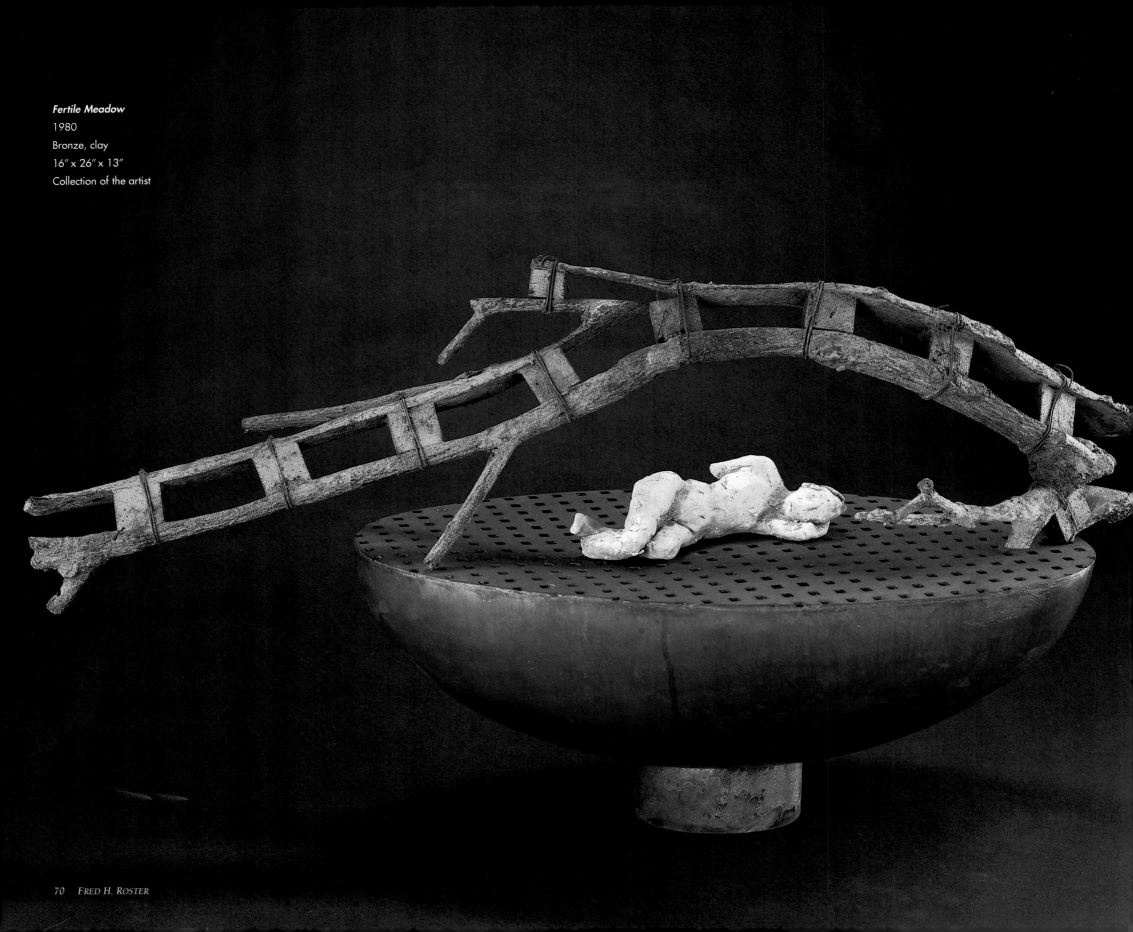

Fertile Meadow
1980
Bronze, clay
16" x 26" x 13"
Collection of the artist

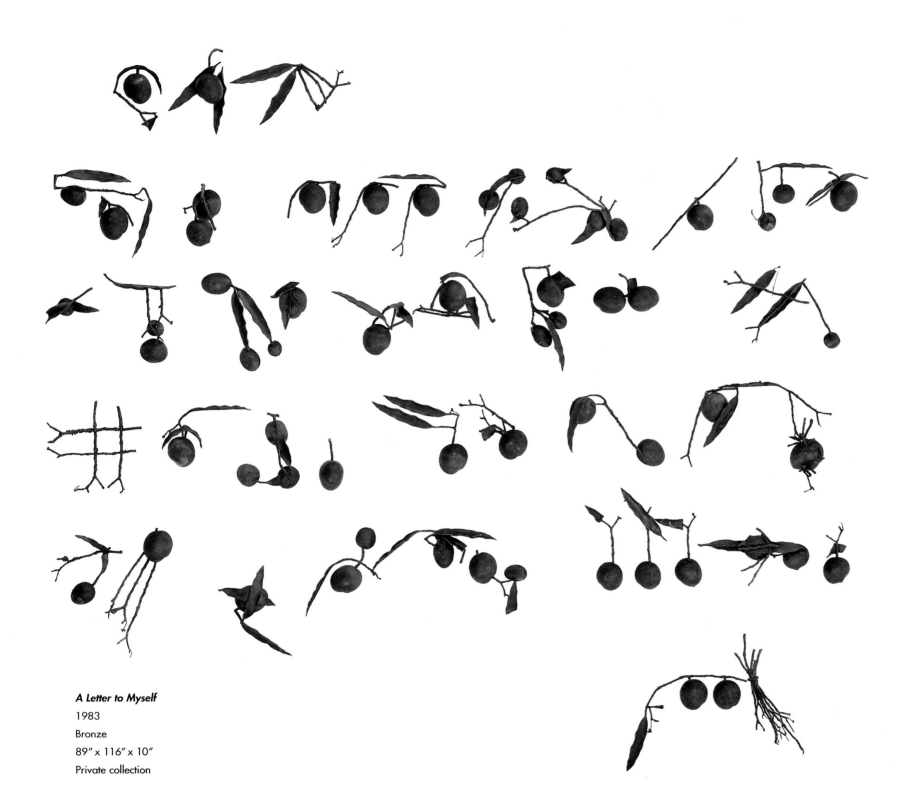

A Letter to Myself
1983
Bronze
89″ x 116″ x 10″
Private collection

BORN

Palo Alto, California,
1944

EDUCATION

B.F.A. and M.A.,
Ceramics/Sculpture,
San Jose State University,
San Jose, California

M.F.A.,
University of Hawaii
at Manoa,
Honolulu, Hawaii

MEDIA

Mixed media

SOLO EXHIBITIONS

New Clay,
The Stockbridge Gallery,
Menlo Park, California,
1969

Mexico Diary,
Gima's Art Gallery,
Honolulu, Hawaii,
1974

Retrospective:
Fred H. Roster,
Wiel Gallery,
Corpus Christi, Texas,
1978

Winds of Change,
Contemporary Arts
Center,
Honolulu, Hawaii,
1984

Observations from the River,
The Contemporary
Museum,
Honolulu, Hawaii,
1993

**May My Heart Be as
Beautiful Should I Live to
Be a Hundred**

1992

Wood, stone, bronze

70" x 142" x 74"

Collection of the artist

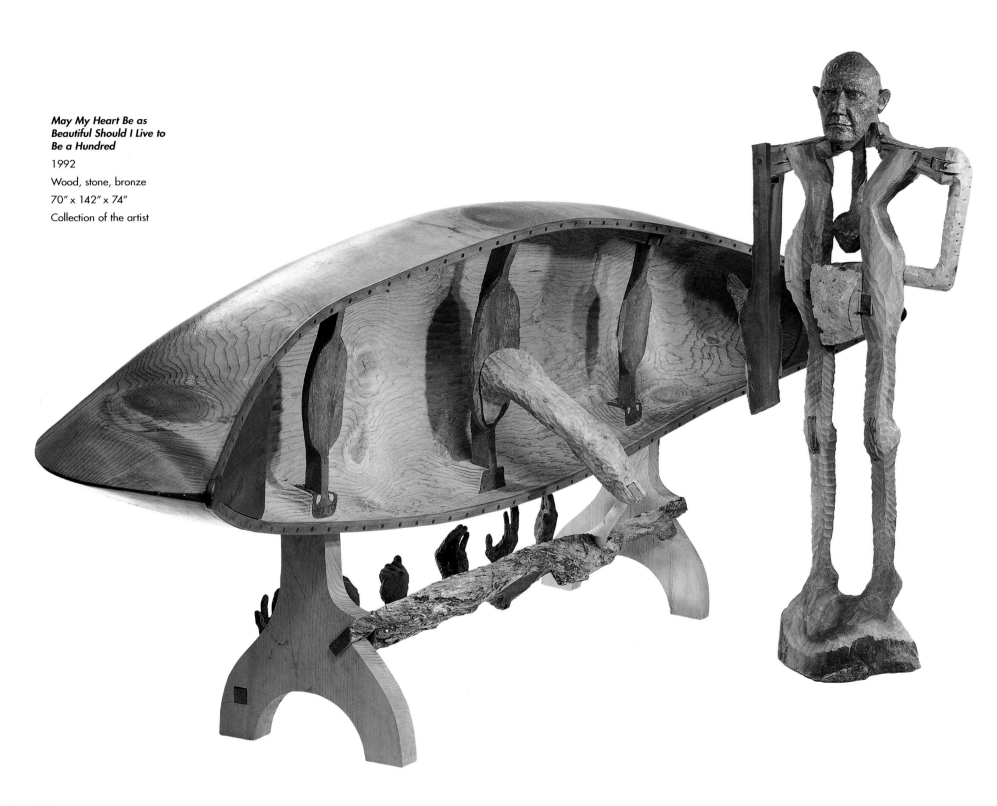

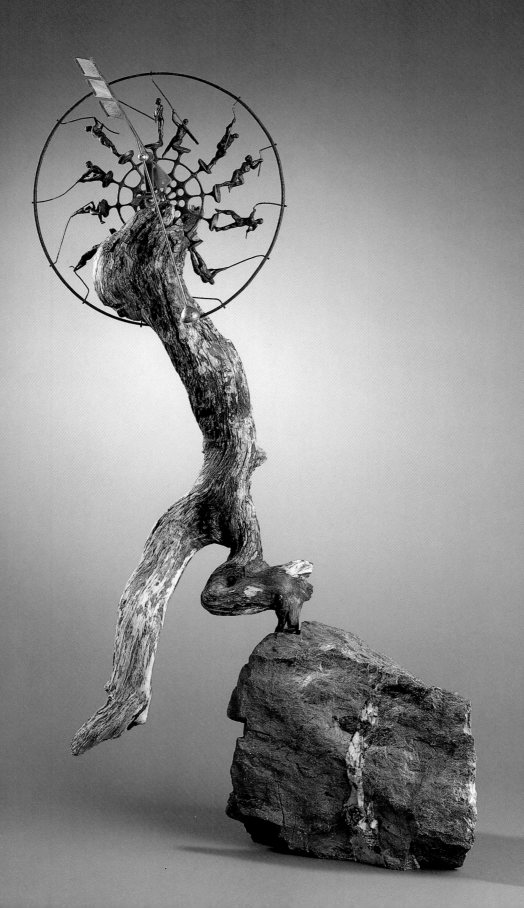

MOIRAGHI

"...to meet any
...rtists. I'm more
... consciousness.
...o sit in the shadows
...e painters and
...ing created.
...s an awareness of
...they were
...sform images.
...ists work, rather
...s of art."

I began taking pictures around the fifth grade using the family snapshot camera, developing and printing in a primitive darkroom set up in our laundry room. My early experiences of being in the darkroom were somewhat mystical. There was a similar quality to being in the Italian neighborhood Catholic church where I grew up: The lighting was dim, it was quiet, there were unusual smells and the sound of water. I got hooked by the experience which created magic for me.

A lot of magic takes place within the little dark box we call a camera. It is a mechanical device but it's also a spirit catcher. The way the camera, guided by perception, can infuse the photographic image with spirit is still a technological mystery.

Photography is very much about perception. During the hundredth of a second when the camera shutter is open, there is the possibility of focusing one's energy to make an image which resonates. This is where the transformation of straight photography into the realm of metaphysics takes place.

Much of my photography is documentary or journalistic in nature, but in some of my images the intent is metaphysical/metaphorical. There are many layers which transcend the figurative or literal imagery within a photograph. It can be compared to poetry, where the meaning is not always on the surface. If we are very lucky, then our images contain more than what we normally see. I am drawn to making these images, the ones that have this poetic quality.

Another aspect of photography I work with is its inherent ability to tell stories, either within a single frame or by grouping sequences of images together. One can take this capability of the medium, to take negatives made many years in the past and place them in sequences being worked on today, to draw on the past while pulling the meaning into the present. This sequential processing and thinking then becomes literary.

Art is a map to inaccessible places. The process of making art can transport you to mental states that cannot be accessed in any other way. That is one of the intents of working with metaphors and, for me, one of the strongest visions in art.

I believe that destiny brought me to Hawaii, with some help from Don Ho. I was in a bar in Dekalb, Illinois, after a depressing job interview and Don Ho's first TV special was on the screen. I had never seriously thought about living in Hawaii, even though I had applied for a teaching position at the University of Hawaii. The sight of the islands on the screen drew me in. The following day I received a telegram offering me the job teaching photography at UH-Manoa, which I accepted. I arrived here in the fall of 1968.

After being in Hawaii for a few years, I became captivated by something different than that TV image of Hawaii. My perspective was swept up by the Hawaiian cultural movement of the 1970s. I became sensitized to the land, Hawaiian mythology, and Hawaiian issues which have now come to the forefront. These issues have become a strong focus for much of my documentary photographic work: to feel and understand and be inspired by the depth of the Hawaiian culture. This then filtered into my subconscious and has led me more deeply into the metaphysical realm.

"A lot of people collectively have influenced me throughout my life. My only real mentor was a guy named Ben Gelman who was a writer/photographer for the regional newspaper I worked on in high school and college in southern Illinois. Through Ben's influence, I was introduced to a whole world of thought I had never encountered before.

Another strong influence came in the 1970s when I shared a studio in Hilo with the photographer, Walter Chappell—day-to-day contact with an older artist who had a strong intent to use art as a device to create a personal order from the chaos of life."

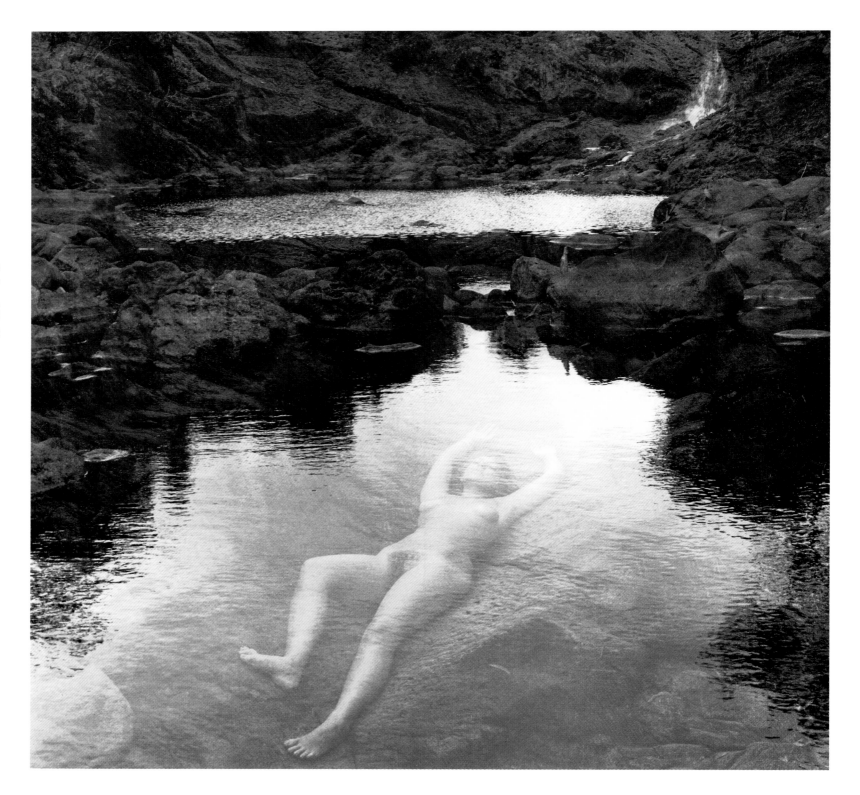

Underwater Nude
1977
Black and white photograph,
toned silver gelatin print
Collection of the artist

Wai 'Apo

1978

Black and white photograph,
toned silver gelatin print

Collection of the artist

BORN

Herrin, Illinois,
1942

EDUCATION

B.S., Communications/
Photojournalism and Art,
Southern Illinois
University,
Carbondale, Illinois

M.F.A., Photography,
Ohio University,
Athens, Ohio

MEDIUM

Photography

SOLO EXHIBITIONS

A Presence Beyond Reality,
Honolulu Academy
of Arts,
Honolulu, Hawaii,
1971

Photographs of Japan,
New England School of
Photography,
Boston, Massachusetts,
1977

Franco Salmoiraghi,
Contemporary Arts
Center,
Honolulu, Hawaii,
1978

*Photographs from
20 Years in Hawaii,*
Gallery EAS,
Honolulu, Hawaii, and
Stones Gallery,
Lihue, Hawaii,
1988

*Waipi'o—A Hawaiian
Valley,*
Bishop Museum,
Honolulu, Hawaii,
1988

**Sugar Mill Ruins,
Kipahulu, Maui**

1993

Black and white photograph,
toned silver gelatin print

Collection of the artist

Lele on Pu'u Moa'Ula and
Military Helicopter,
Kaho'olawe, Diptych

1994

Black and white photograph,
toned silver gelatin print

Collection of the artist

TADASHI SATO

*"I'd like to see again our
own Isami Doi. He gave me
a lot to think about. Through his
paintings, he made me smile
when I was about to cry. He gave
me a helping hand. By his mere
existence, by his own paintings,
he gave us the push to go
ahead and continue."*

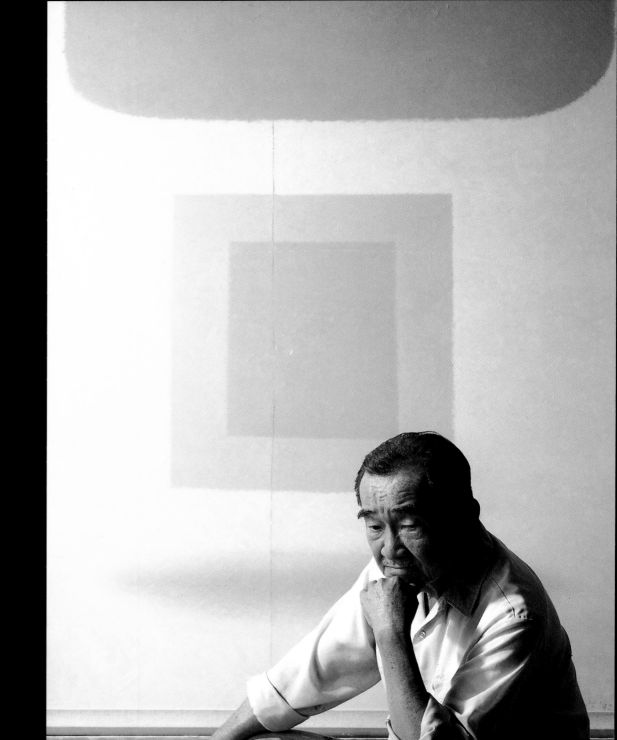

It was under the flagpole at an assembly for the entire student body of Kamehameha III Elementary School that my art career began. There I was, eight years old in 1931, receiving the first place award and $2.50 in prize money for a poster I submitted for a territory-wide contest in Honolulu. It was a proud and happy moment for a young boy from Kaupakalua.

I continued drawing even if there weren't any art courses offered in school. As a senior at Lahainaluna High School, I did the art work for the annual and the old English lettering on every graduation diploma presented that year. For that I received a savings bond.

When World War II began, I left my job at the pineapple cannery and volunteered for the 442nd Infantry. At basic training in Mississippi, they discovered I was very good at Japanese calligraphy, which I had studied at Japanese language school for 13 years. I was placed in a small team responsible for drawing military maps for the army, first in Australia and then in New Guinea and the Philippines.

At the end of the war, I returned to Hawaii where I investigated the possibility of returning to school under the GI Bill of Rights. I was interested in art, but there were no art schools. Instead, my Veterans Administration advisor suggested bookkeeping courses at the Cannon School of Business because of my "good handwriting." Somehow, I wasn't very interested and spent a good deal of time cartooning in class. One day, I drew a honey of a cartoon of my filing teacher and got caught. I was sent to the principal's office to see Mr. Cannon himself. When I arrived, I found him looking at the cartoon and laughing. All he said was, "Don't ever do this again." Strangely enough, as a result of this incident, I received a strong recommendation from Mr. Cannon to transfer to the Art School at the Honolulu Academy of Arts when it opened. Finally, at the age of 23, I began my formal study of art.

During the summer of my second year at art school, Ralston Crawford, a guest instructor from New York, saw my work and immediately took me under his wing. Upon his return to New York, he arranged a scholarship for me to attend the Brooklyn Museum Art School where I continued my studies. It was then I was introduced to the famous Stuart Davis and had the chance to study with him at the New School for Social Research in Manhattan.

My paintings reflect something of my calligraphy training. The positive line of concentration makes you aware of the negative areas which fit together to form a perfect balance. My paintings are balanced, actually balanced plus— that aesthetic area beyond the balance itself. For me, balance is almost everything. It brings beauty and all the aesthetics you can experience.

My paintings are non-objective, bordering on abstraction. Ideas come from everywhere. My memories and life experiences. Many come from Maui—its mountains, ocean, colors— but I make them mine.

I enjoy painting. The cross-hatch texture in my work is actually an effort to squeeze my brush on the canvas to ensure that the oil sinks into the weave. It feels good.

While I paint, there's an unconscious force that overwhelms me to the point that, for a split second, I momentarily surprise myself. It's an inner force that I can't explain. This is why even after stopping halfway in a painting, I can start up again later. To say that it all comes from the head is mistaken. It may start in the head, but it is carried on by this force. It happens many times.

"Ralston Crawford who was responsible for my getting a scholarship to the Brooklyn Museum and for introducing me to Stuart Davis."

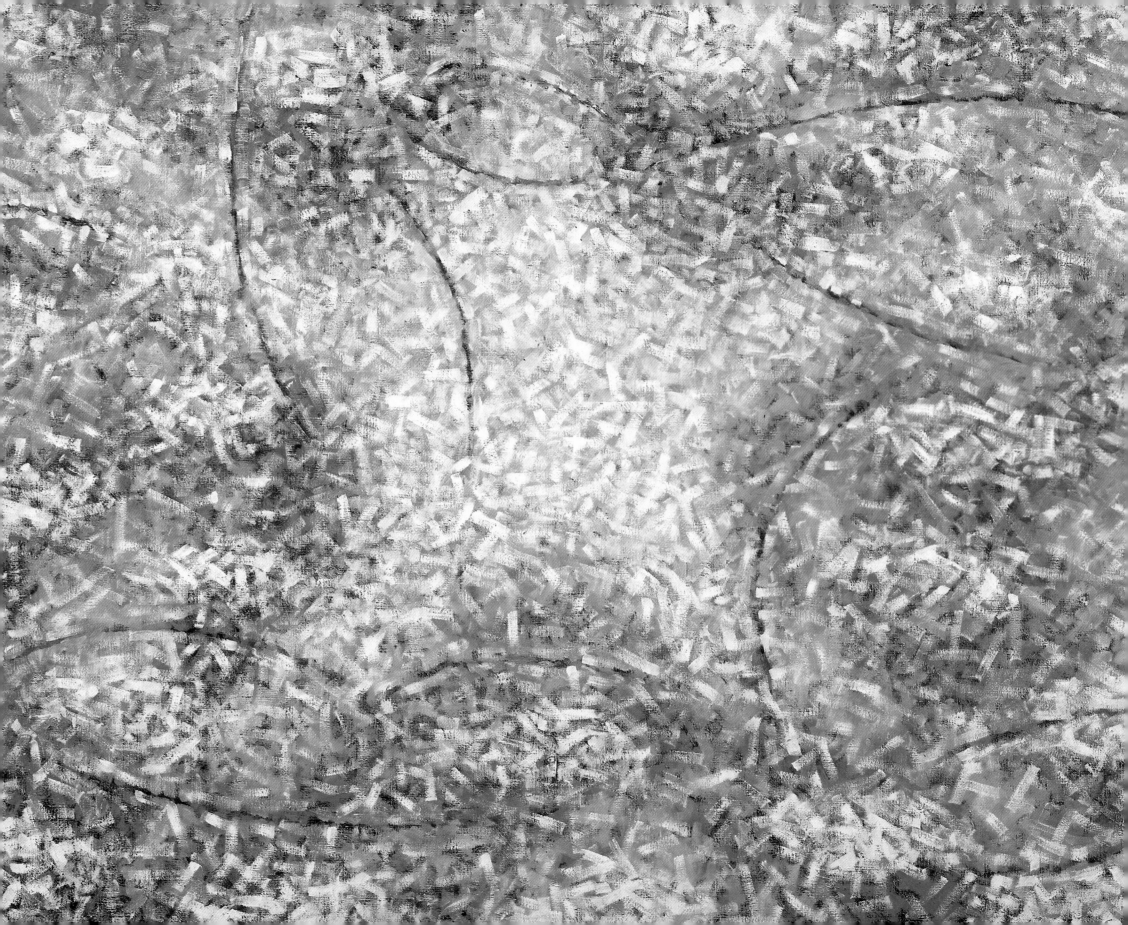

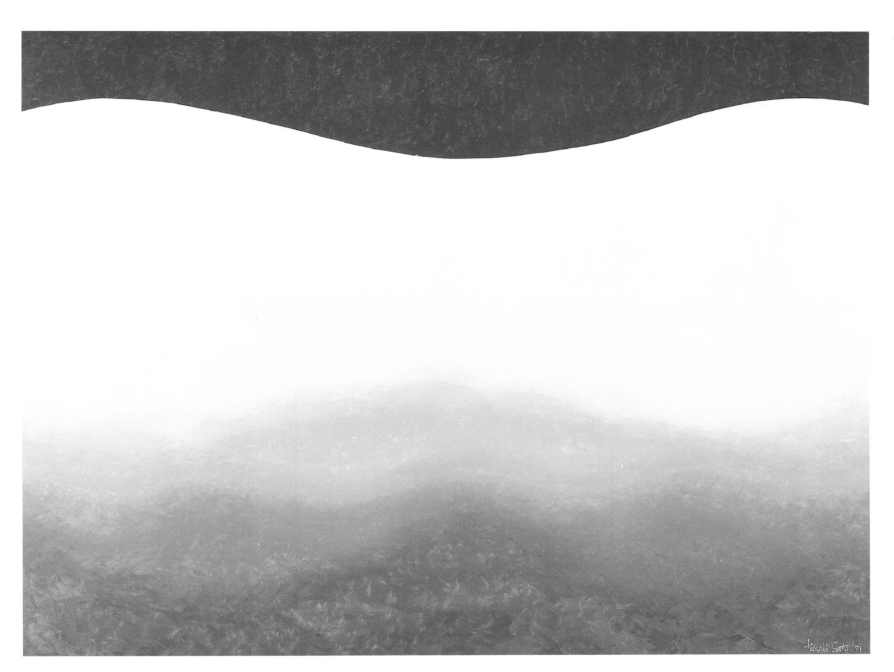

BORN

Kaupakalua, Maui,
1923

EDUCATION

Painting,
Honolulu Academy of
Arts School of Art,
Honolulu, Hawaii

Painting,
Brooklyn Museum
Art School,
Brooklyn, New York

Painting,
New School for
Social Research,
New York, New York

Painting,
Pratt Institute,
Brooklyn, New York

MEDIA

Oil painting, mosaic

AWARDS

Fellowship,
John Hay Whitney
Foundation,
New York, New York,
1953-1954

Best Painting in Show,
Honolulu Academy
of Arts,
Honolulu, Hawaii,
1954

Fellowship,
Honolulu Community
Program,
Honolulu, Hawaii,
1955

Albert Knapp Award,
Silvermine Guild,
Silvermine, Connecticut,
1956

Sand Dune
1971
Oil on canvas
50" x 68"
Private collection

◄

Sand Dollar
1959
Oil on canvas
40" x 50"
Collection of the artist

SOLO EXHIBITIONS

*Recent Works of
Tadashi Sato,*
Gallery 75,
New York, New York,
1953

Tadashi Sato,
Honolulu Academy
of Arts,
Honolulu, Hawaii,
1954, 1985

*Recent Works of
Tadashi Sato,*
Willard Gallery,
New York, New York,
1957-1960

*Recent Works of
Tadashi Sato,*
Contemporary Arts
Center,
Honolulu, Hawaii,
1965

Tadashi Sato,
Richard White Gallery,
Seattle, Washington,
1971

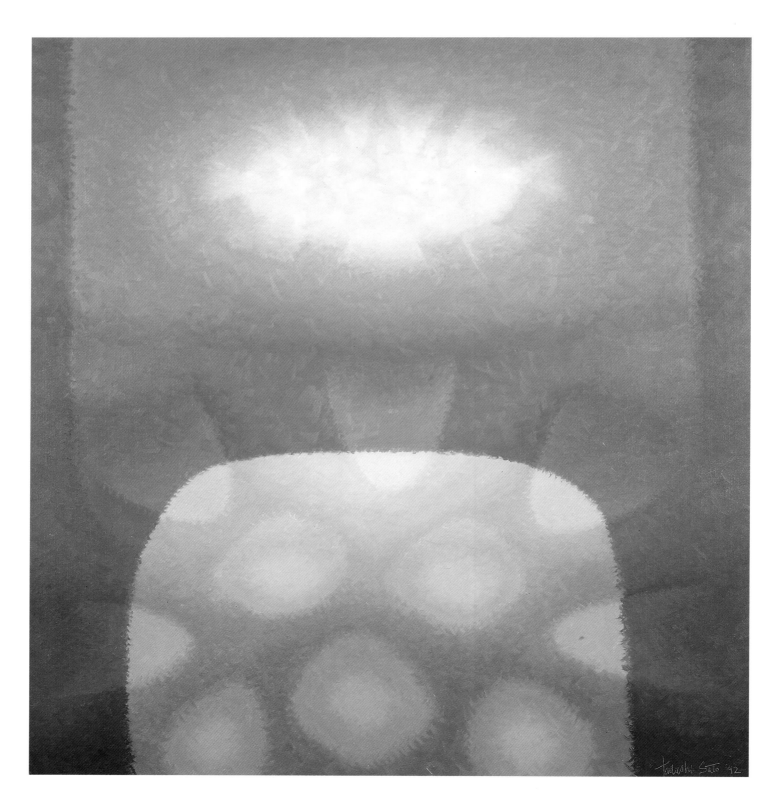

Submerged Rock
1993
Oil on canvas
38.25" x 36.25"
Collection of the
Halekulani Hotel,
Hawaii

▶

**Shadow in the
Walkway**
1991
Oil on canvas
50" x 60"
Private collection

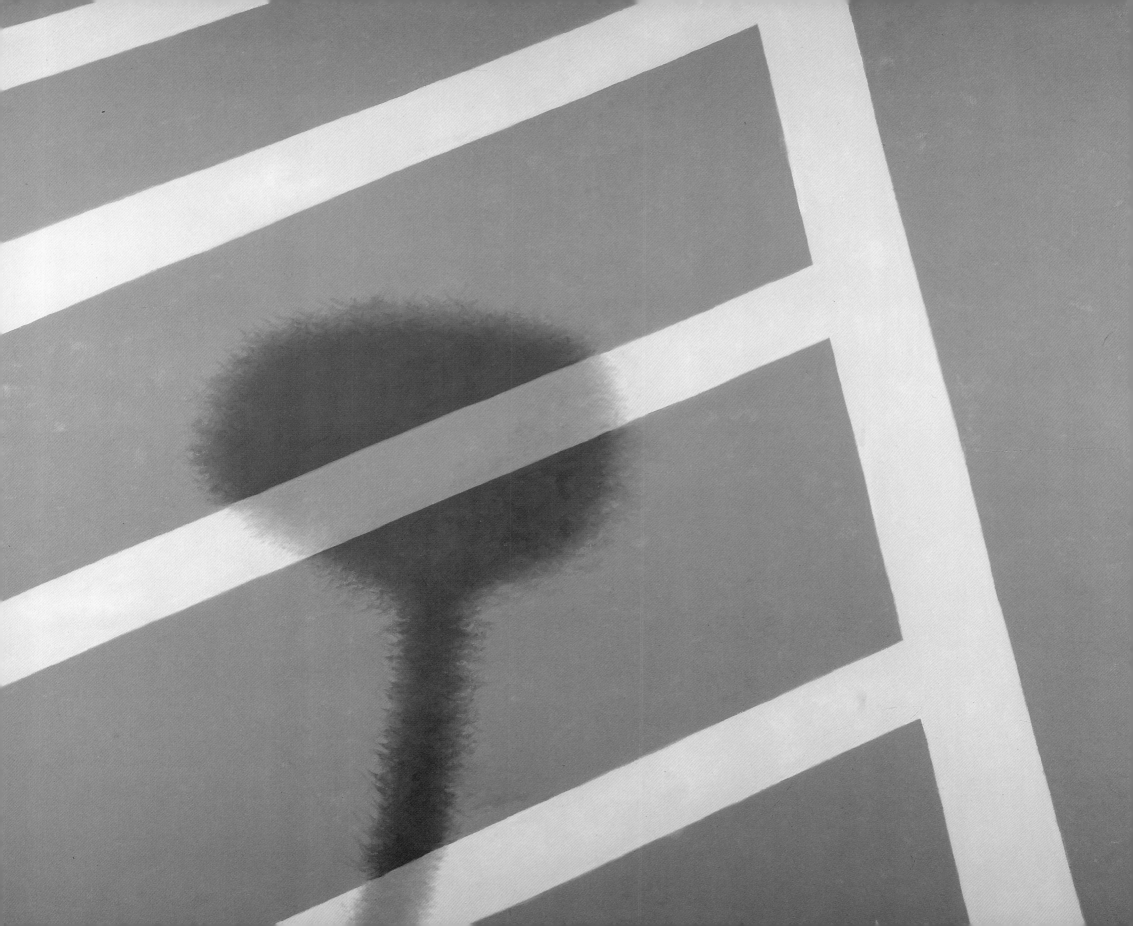

ESTHER SHIMAZU

"Alice Neel and Henry Moore are two artists I would like to meet. Haven't read up on them but their work is, first of all, figurative and feels personal and maybe even vaguely affectionate. I've been fortunate to have had the chance to meet Toshiko Takaezu, Wayne Higby, Tony Hepburn, Patti Warashina, Akio Takamori, Clayton Bailey, and Peter Vandenberge, among others."

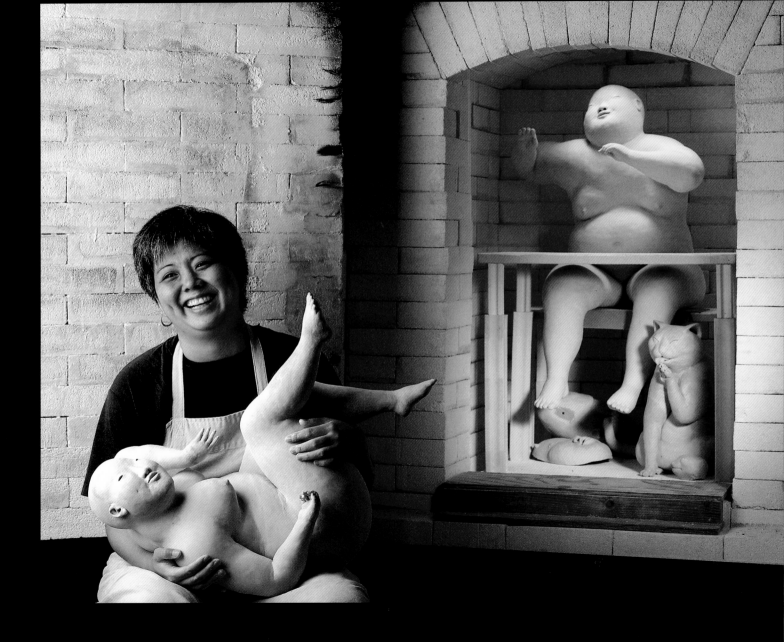

I've adored clay ever since I first got my hands on some when I was five and it became my all-time favorite thing to do in school. Nothing else had quite the same all-around appeal to mind, body, senses, and imagination. It remained a fixture in my life through after-school programs at the neighborhood park, art classes in school, workshops, and college degrees. Clay work went on in my parents' basement, my apartment bedroom, and, finally, my home studio (completed in 1993) and during off-hours from various jobs like dental assistant, Army craft shop instructor, and graphic artist.

By now, I'd say I'm fairly fixated. Clay has a life of its own and is quick and organic, wonderfully earthy and, most of all, adaptable and forgiving. It almost does what I want it to do after over thirty years of fussing with it.

The pieces I do are rendered in collaboration with clay, each sculpture made using standard vessel-making techniques. It's pottery bent toward the figurative. Body parts—toenail, toe, foot, lower leg, and so on—are separately shaped, arranged and joined into a continuous hollow form. They remain voluminous and thin-walled to remind me that they're pots, so I can shape them from within and without, still lift them, and not blow them up in the kiln. Surface treatment is last and very simple, with rubbed-in oxides and a light air-brushing and highlighting with commercial underglazes. Glazing, if any, is minimal.

The imagery starts off with some gesture, idea or expression, be it odd, funny, visually or technically challenging. Pieces sometimes hint of my relatives or friends in an abstracted pot-like way because you do what you love and know best. I don't aim for it; it just turns out that way. Buoyantly plump, out-of-proportion, and very individualistic, they shamelessly have no need for clothes or hair and are often androgynous and of no particular age. They probably come from some fantasy world of mine where you can finally stop worrying about acceptance, appearance, and accessories.

I'll be doing this as long as my mind and body—my hands—hold out. A large and expressive family and good friends provide endless material. I don't think there'll ever be a day when clay doesn't appeal, surprise, or tick me off.

"Paul Berube, one of my professors at the University of Massachusetts, told me I could pursue art professionally, something I hadn't thought about too clearly. Since coming home to Hawaii, the same odd idea was put forth by Honolulu gallery owners Ramsay and Robyn and Judy Buntin and John Natsoulas of Davis, California. Fellow artists Emma Lewis of Acoma, New Mexico, Virginia Jacobs, and others encouraged me by their acceptance and their example. Art angels Jay Jensen of The Contemporary Museum and Carol Khewhok of the Honolulu Academy of Arts Center at Linekona gave quiet but invaluable support and opportunities. And of course, my family, which has always been a tremendous gold mine of help and inspiration, not to mention hard labor."

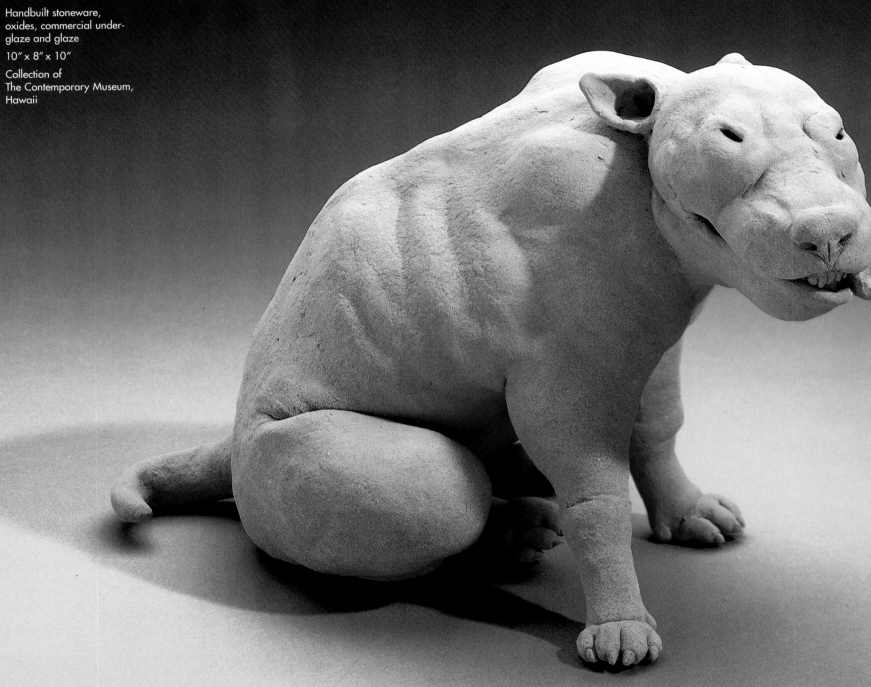

House Pet

1992

Handbuilt stoneware, oxides, commercial under-glaze and glaze

10" x 8" x 10"

Collection of The Contemporary Museum, Hawaii

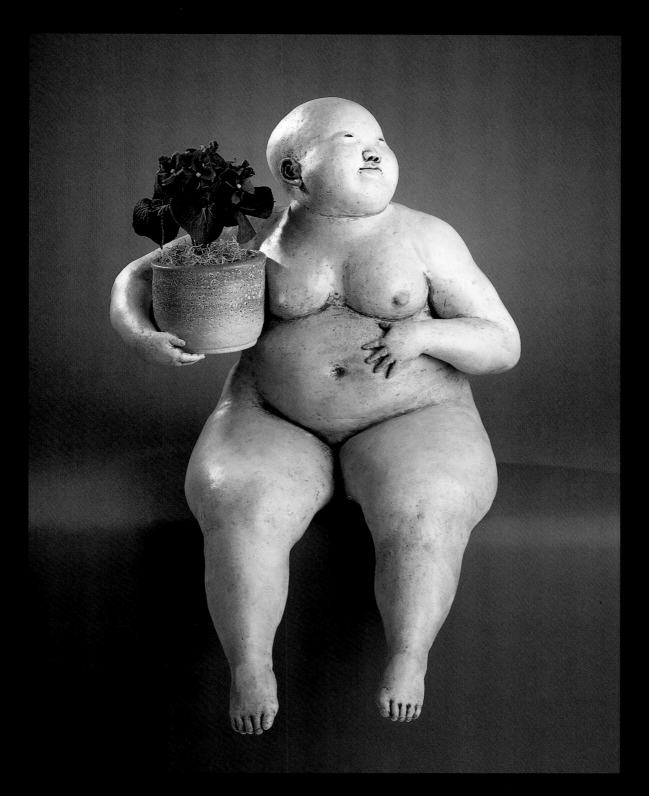

BORN

Honolulu, Hawaii,
1957

EDUCATION

B.F.A. and M.F.A.,
Ceramics,
University of
Massachusetts,
Amherst, Massachusetts

Fine arts,
University of Hawaii
at Manoa,
Honolulu, Hawaii

MEDIUM

Clay

AWARDS

Cynthia L. Eyre Award,
Honolulu Academy
of Arts,
Honolulu, Hawaii,
1991

Individual Artist
Fellowship,
Hawaii State Foundation
on Culture and the Arts,
Honolulu, Hawaii,
1995

Jardiniere
1993
Handbuilt stoneware,
white slip, oxides,
commercial underglazes
and glazes,
wheelthrown pot
27.25" x 21" x 20.25"
Collection of the Hawaii
State Foundation on Culture
and the Arts

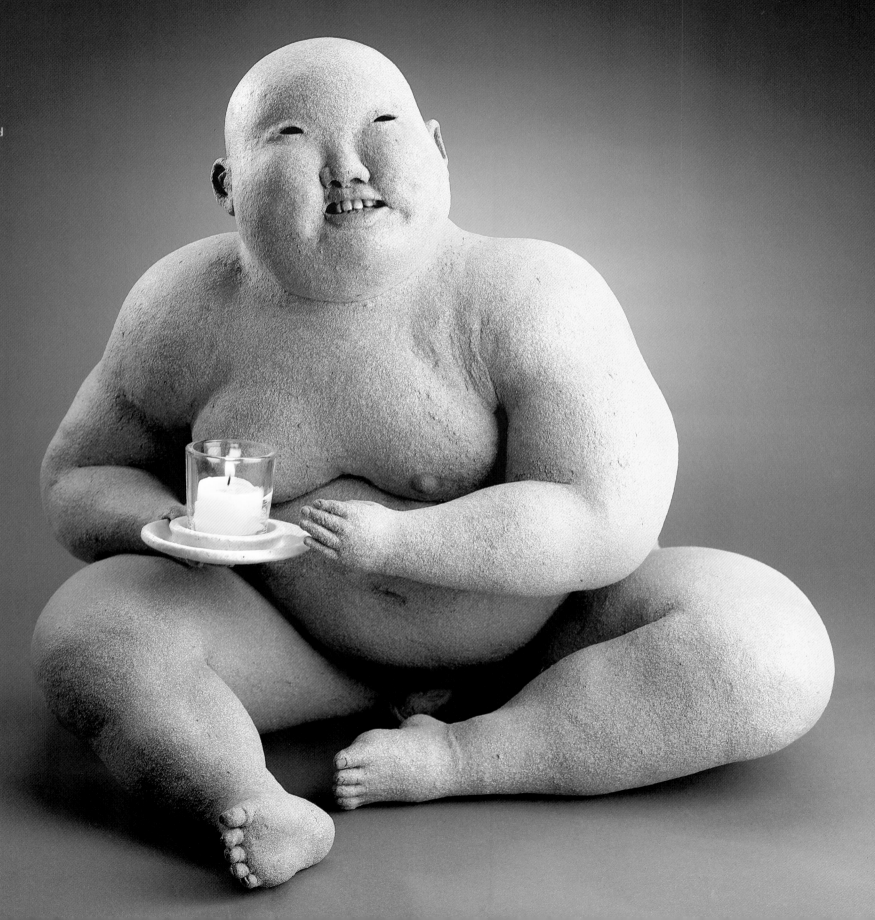

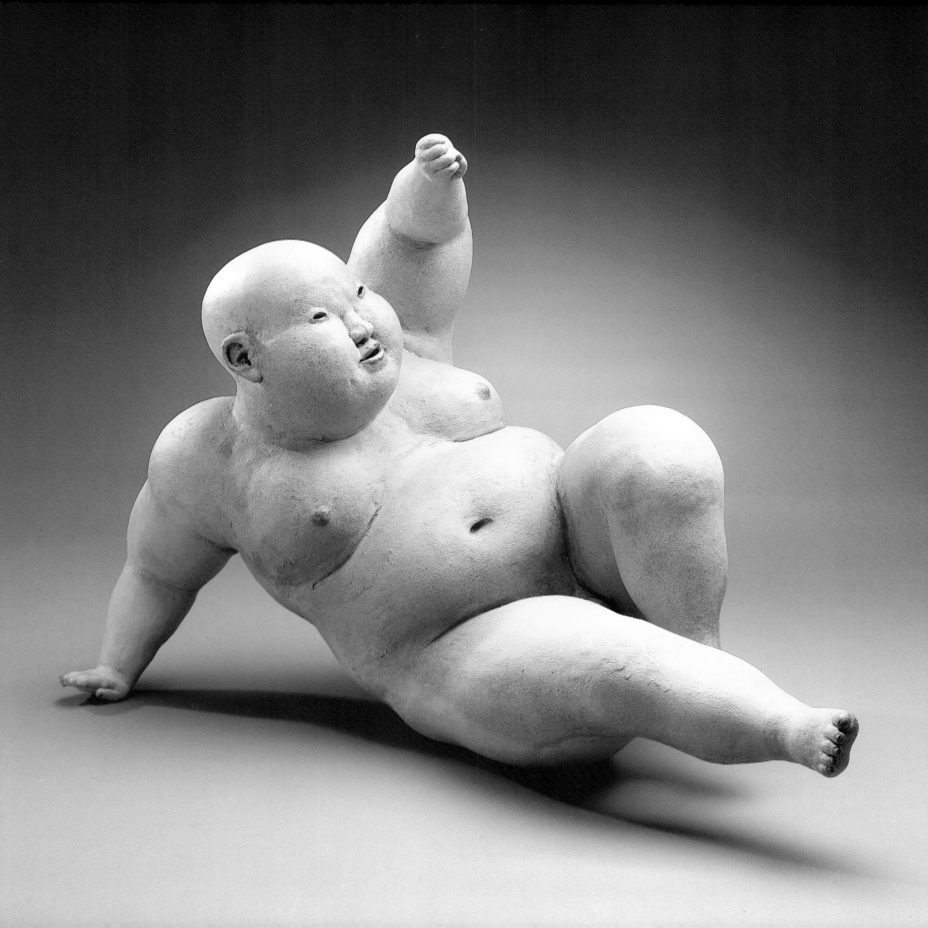

LAURA SMITH

*"I might like to meet Titian.
I like to work with Titian's things.
And he did some interesting woodcuts.
I like Italy, so I think meeting some
Italian artists would certainly be
interesting. Somebody from the
Renaissance; those people did so
many things."*

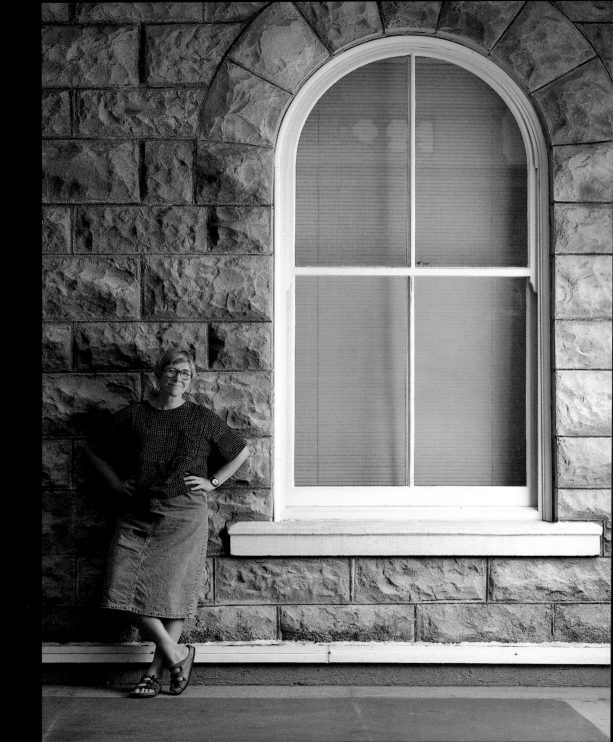

only do prints; I've always done prints. Figurative relief print-making.

They're about people. A lot of the prints I do are based on narratives, on stories or books I've read. I like the tightness of the organization of working with a story. And I like to read. It's a good choice to make prints about.

My interest is in the narrative, the telling of a story rather than a message. I am concerned about how the figures relate to each other or the story they tell. I can't say there's a deep message; I'm not interested in making a social statement or attaching a symbolic meaning.

Sometimes there are things that are missing from a story or something that wasn't quite explained by the author or wasn't explained in a way that satisfied me. So it leaves something kind of dangling which intrigues and interests me; these are the things I use to make prints about.

I like the work involved with printmaking. If you're a painter or you do drawings, there are always decisions that you have to be making. Every time you put a stroke down or make a mark with a brush, it impacts a lot on the other things around it. With printmaking, there's a lot you can do while you're working on the print that isn't quite so critical.

I find the actual labor of printing interesting. Making the plates, cutting the plates is interesting. I like how once you get a plate finished there are lots and lots of ways that you can print it. And it doesn't become quite so precious. I'm sure painters must have their own way of resolving these problems, too. But if you print it one way and it doesn't quite come out, it's no big deal. You just change the colors or you print it with something else. You can keep on experimenting with it. So printmakers, they've got drawers full of stuff. I find that nice.

Right now I'm mostly doing woodcuts—relief printmaking—and they're figurative. As for woodcuts, I like the cutting of the wood, the subtractive way of working. Most are made from one plate. You cut a small amount of the wood and print the whole edition; a lot of times I print them in different colors. And then go back to the plate and cut some more, then print the next color on top, cut some more, print the next color, cut some more, print the next color. So what you end up with is no wood left and you can't go back. It's all bare.

What happens is that colors are much more unified than if I worked with multiple plates or used another medium with it. The process of cutting all that stuff and printing it resolves the image, too. As you're working along, it all comes, it all works out, it works together. And you're never totally sure of how it's going to be until you get to the end, which is exciting.

Many people use a lot of color with monotypes. But for me, I find that really confusing. I just like to keep it black and white, very simple.

"I admire people whose work I know: Eric Fischl's paintings, and Edgar Degas especially for composition. I'm not sure that they're really mentors. But I've always been intrigued by somebody like Mary Cassatt who went off to France and made her career out of painting when people really didn't do that."

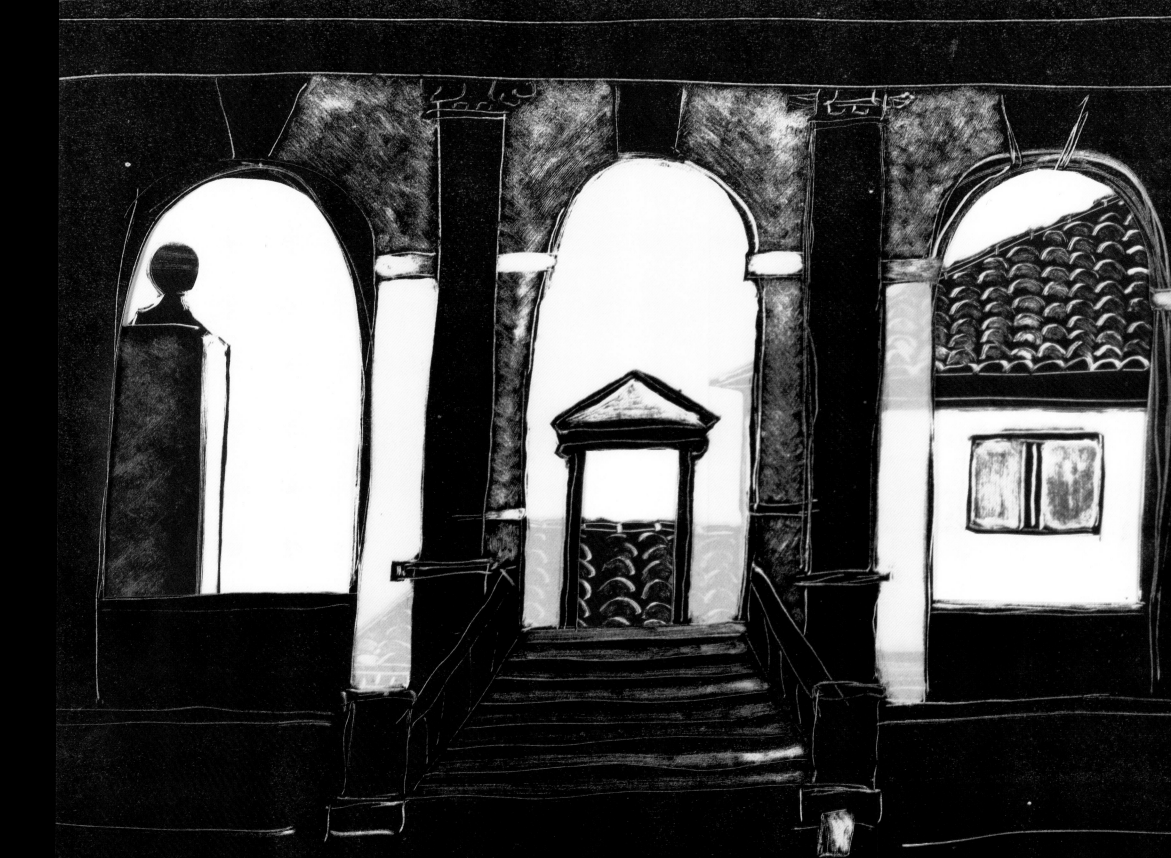

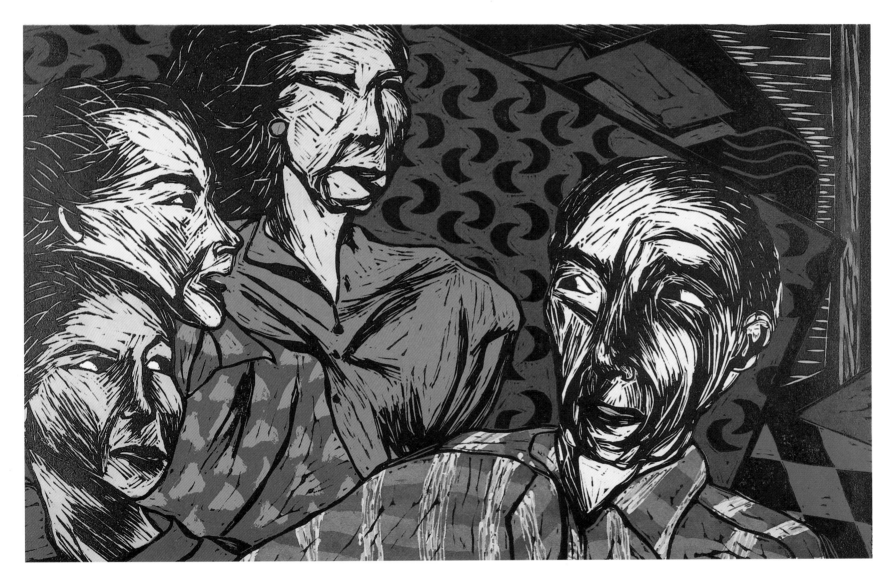

BORN

Charlottesville, Virginia,
1947

EDUCATION

B.A., Art History,
Wilson College,
Chambersburg,
Pennsylvania

M.F.A., Printmaking,
University of Hawaii
at Manoa,
Honolulu Hawaii

MEDIUM

Printmaking

AWARDS

Gift Print Artist,
Honolulu Printmakers,
Honolulu, Hawaii,
1990

Catharine E. B. Cox
Award,
Honolulu Academy
of Arts,
Honolulu, Hawaii,
1994

SOLO EXHIBITIONS

*Rain Series: Prints by
Laura Smith*,
Cox Award Exhibition,
Honolulu Academy
of Arts,
Honolulu, Hawaii,
1994

◄

Overlay Villa Godi

1993

Monotype on white paper
with overlay of another
monotype on translucent
paper

19.5″ x 25.5″

Collection of the artist

Stepping Out

1987

Linocut with screenprint

15″ x 23″

Collection of the artist

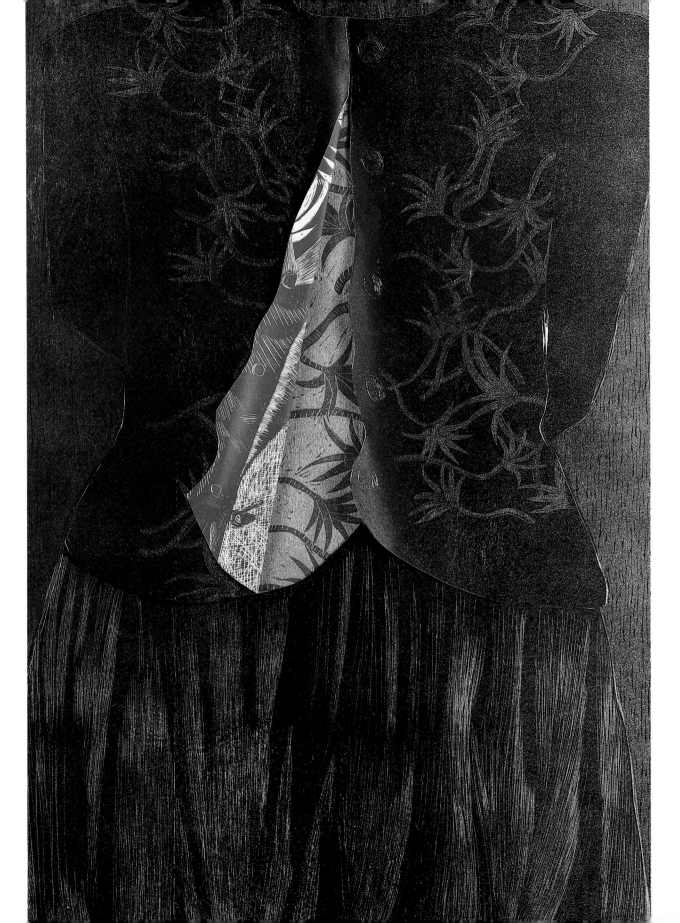

Dressed in Black

1994

Color reduction woodcut on two sheets of paper, cut and bent

40" x 26"

Collection of the artist

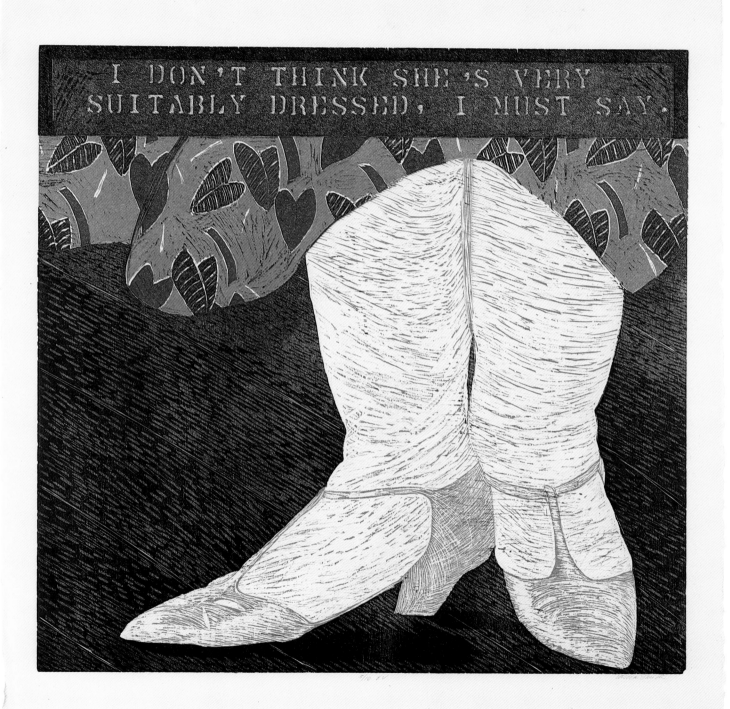

Suitably Dressed

1994

Color reduction woodcut
with stencils

24" x 24"

Collection of the artist

TOSHIKO TAKAEZU

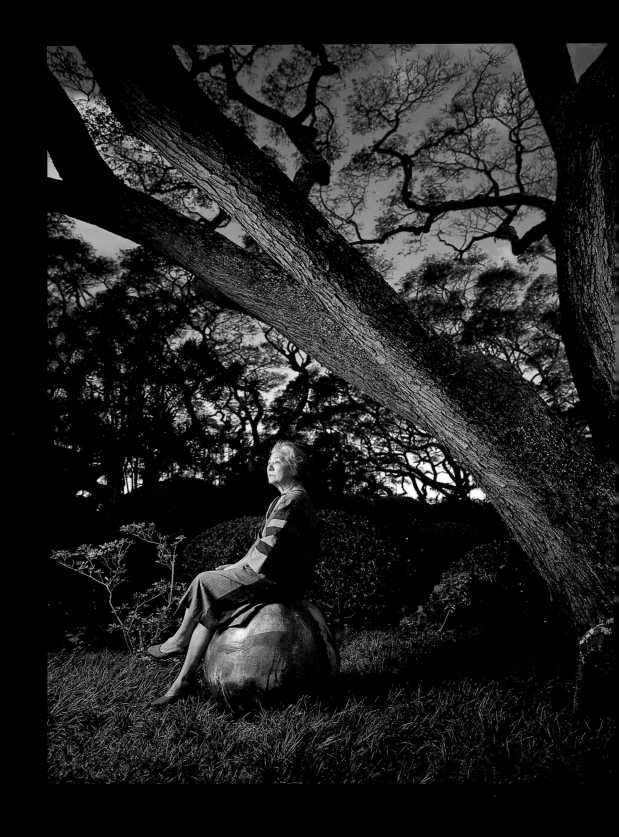

 left Hawaii in the early 1950s to expand my thinking and teaching skills. I studied at Cranbrook Academy for three years, thanks to a McInerny grant. I was supposed to come back to teach, but the opportunities in Hawaii were limited. I taught for a year at the University of Wisconsin, then went to Japan to study the core of my existence. Returning to the Mainland, I taught at the Cleveland Institute of Art. But I took a year off to fulfill my McInerny grant obligations and taught at the Honolulu Academy of Arts. I returned to the Mainland to teach; I retired from Princeton University in 1992.

Inspiration comes from everything that you touch, see, hear, or read. But I think you have to be curious about what you can do. I think curiosity is important and it's kind of fun to see what can happen in the process.

Opening the kiln is always exciting because you don't know what's going to come out. You have an idea, more or less, and you plan on some things. The kiln has much to say and the material has much to say. But it doesn't mean it comes out the way you expect it to.

There's always a collaboration between yourself and the kiln, the material, the glazing, the firing technique, the temperature. And when it's a beautiful piece, there may be still another element that might contribute to the piece—something you haven't planned on—that makes it better than you expected.

My pieces have become larger because there is a challenge to be able to do something big. The best part is the glazing of the piece. When you put the glaze on you have this motion in the application and a feeling of freedom, like dancing around the piece to apply the glaze.

Big doesn't always mean it's good. But if it's big and bad, it's worse. When you have the same thing in a small piece, there's much more feeling in it than a big piece. It's a challenge to do a big piece and have it come out well; it's hard work.

Sometimes I go back to certain shapes or glazes, but it's not the same. I can't go back to those two-spouted pieces I did in the 1950s because that period is over. After that, I did mask pieces, but that's over. But the bowls and things like that—that goes continuously. I've been doing those closed forms for thirty years or more, but to me they are all different.

I don't know if I've made the perfect piece. If I did, I wouldn't know. And probably I wouldn't want to know. I keep saying that I want to make the perfect piece and there's the possibility that I have. But I don't want to know. That's what you strive for: that everything is perfect—the feeling, the shape, the color. I like some of my pieces a lot but, is it perfect? In my mind it could be; it could be cracked and still be perfect in my mind. It's not the technical part of it. And what is perfection? I don't know; it's the ultimate goal.

Hawaii certainly does influence my work. I wasn't aware of it. But you can see the color in my pots—the color of the ocean, the sky, the sunset. People made me aware of its presence; someone said it looks Oriental. You're not always aware of these things; it's best not to be. You just do it; what's inside of you will come out. I'm sure that Hawaii has really influenced me in every way that I can think of. There have been so many influences—books especially, other artists, music, film.

"Claude Horan at the University of Hawaii was one of my mentors; Hester Robinson in weaving. In design, Bert Carpenter. Maija Grotell, my teacher at Cranbrook, was very important to me in discovering my own individuality. And Ken Kingrey, who gave me some ideas on teaching design when I wasn't too sure about how to get it across to students."

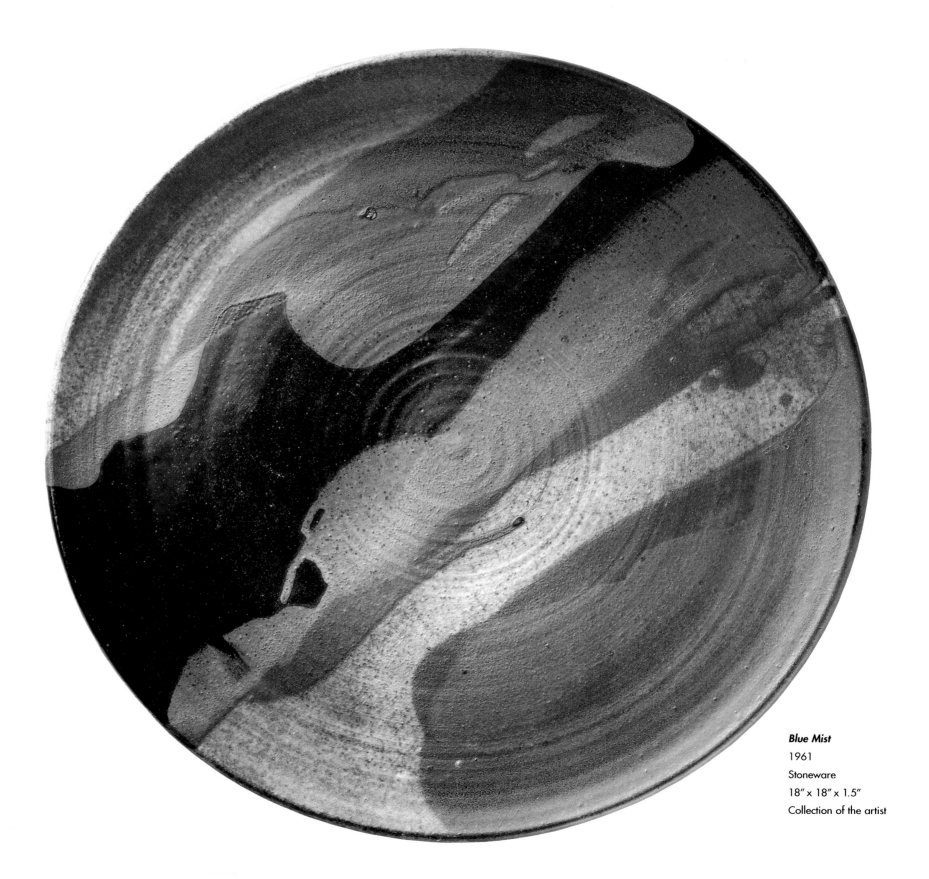

BORN

Pepeekeo, Hawaii,
1922

EDUCATION

Honolulu Academy
of Arts,
Honolulu, Hawaii

University of Hawaii
at Manoa,
Honolulu, Hawaii

Cranbrook Academy
of Arts,
Bloomfield Hills,
Michigan

Honorary Ph.D.,
Lewis and Clark College,
Portland, Oregon

Honorary Degree,
Moore College of Art,
Philadelphia,
Pennsylvania

Honorary Doctor of
Humane Letters,
University of Hawaii
at Manoa,
Honolulu, Hawaii

MEDIA

Clay, bronze, acrylics,
textile

Blue Mist
1961
Stoneware
18" x 18" x 1.5"
Collection of the artist

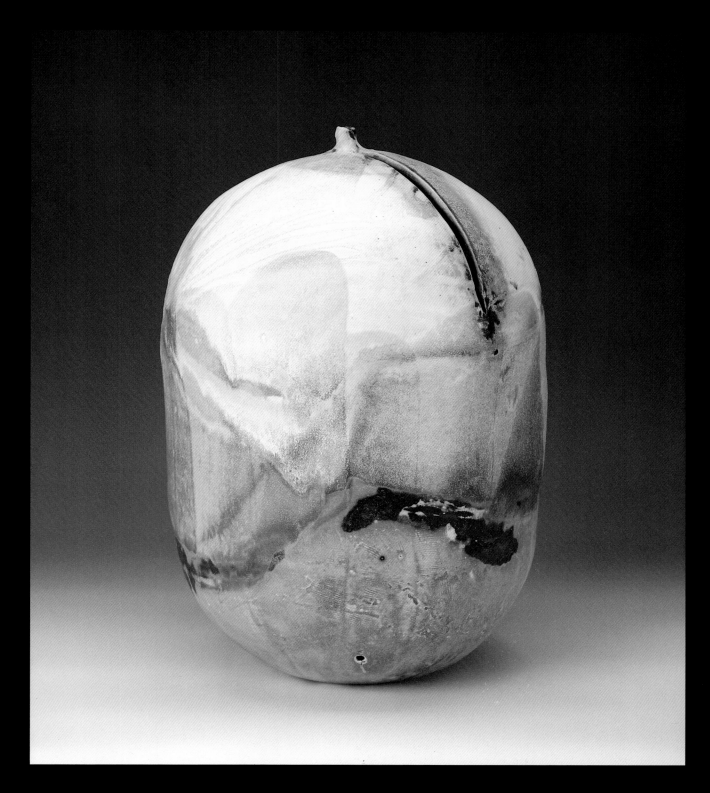

Shiro Momo
1992
Porcelain
21" x 14.5" x 14.5"
Collection of the Hawaii
State Foundation on Culture
and the Arts

SOLO EXHIBITIONS

Toshiko Takaezu,
Honolulu Academy
of Arts,
Honolulu, Hawaii,
1973

Toshiko Takaezu,
The Gallery at Bristol
Myer-Squibb,
Princeton, New Jersey,
1990

Four Decades,
Montclair Museum,
Montclair, New Jersey;
Allentown Art Museum,
Allentown, Pennsylvania;
Cranbrook Academy,
Bloomfield Hills,
Michigan,
1991

Toshiko Takaezu,
Philadelphia Academy
of Fine Arts,
Philadelphia,
Pennsylvania,
1992

Toshiko Takaezu,
Honolulu Academy
of Arts,
Honolulu, Hawaii;
The Contemporary
Museum,
Honolulu, Hawaii,
1993

*Toshiko Takaezu
Retrospective,*
The National Museum
of Modern Art,
Kyoto, Japan;
Naha City Gallery,
Okinawa, Japan;
Takaoka Museum,
Takaoka, Japan;
Seto Ceramics Museum,
Nagoya, Japan,
1995

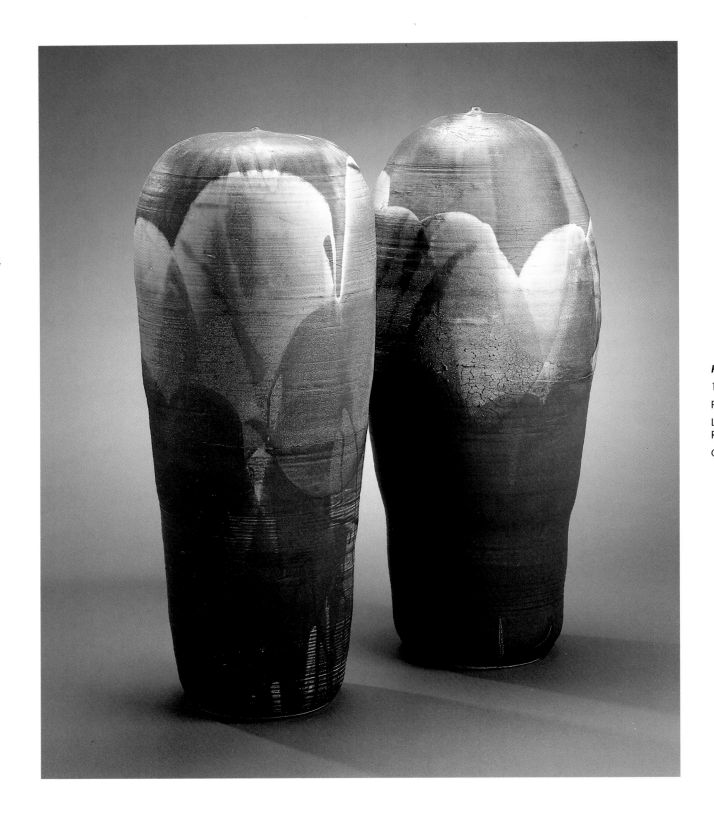

Pair of Ocean Edge Forms

1994

Porcelain

Left) 32″ x 13″ x 13″
Right) 33″ x 12.5″ x 12.5″

Collection of the artist

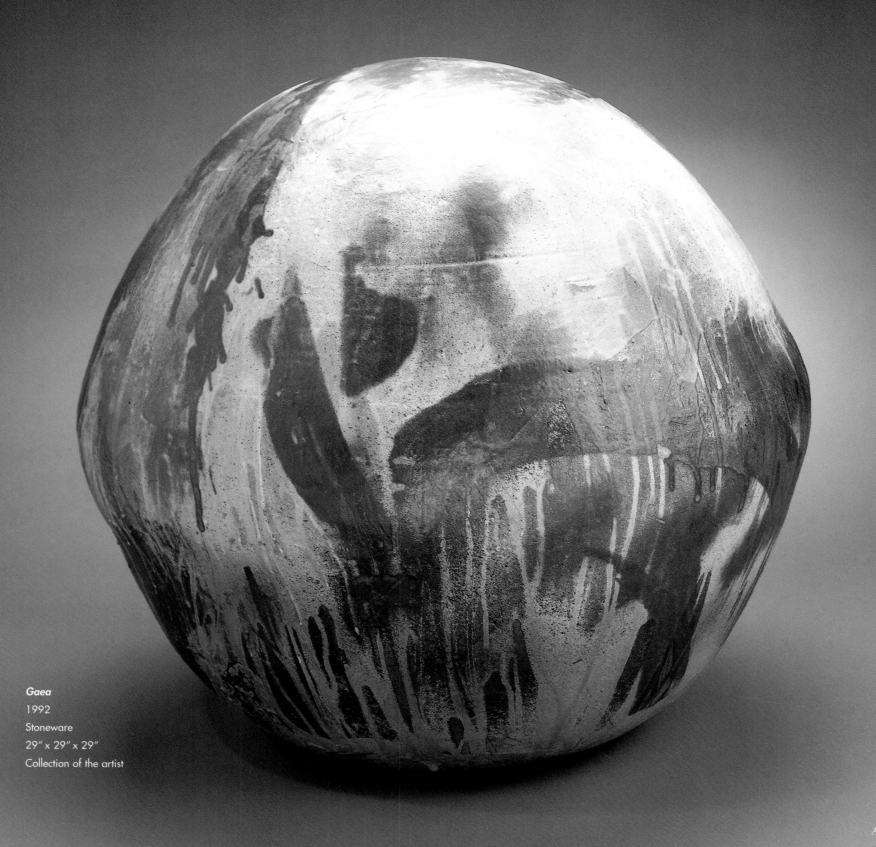

Gaea
1992
Stoneware
29" x 29" x 29"
Collection of the artist

MASAMI TERAOKA

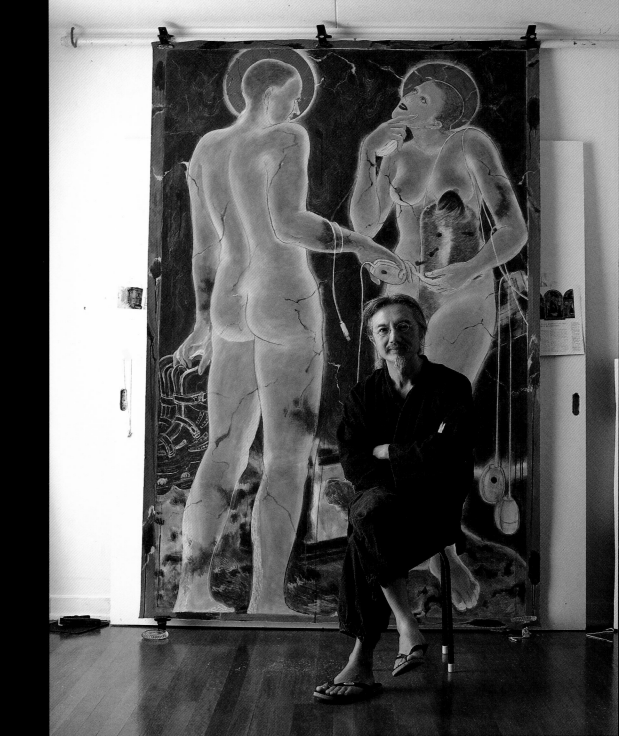

 was born in Japan, the only son in a family of four children. Because my father was inhibited by "number one son duty," he never had the chance to pursue his dream. So instead of forcing me to take over the family kimono business, my father gave me freedom. My father was an artist in his soul. He kept his dream for me, recognized my talent at an early stage, and always encouraged me. He felt creativity was the most important thing in life.

I came to America when I was twenty-five years old. At fifty, after spending half of my life in each country, I became an American citizen. Now I finally feel that I understand American culture in some depth (I still have a problem with finding the humor in comic strips), yet I'm still as excited about the freedom of American life as when I first arrived.

At one time, I could have easily described my paintings as an extension of *ukiyo-e* (Japanese woodblock prints), my style reflecting both my Japanese heritage and the American influence of Pop Art. I focused on achieving the translucent colors, line, and flatly painted forms of *ukiyo-e* in watercolor. My earlier work often depicted my own American experiences. Putting different cultural references together highlighted the contrast between American and Japanese attitudes.

Over time, my influences and subject matter have changed. As my themes became more universal in nature, my style became a synthesis of a wider range of influences. The Japanese influence has shifted to a looser *sumi* painting style as seen in artist Musashi Miyamoto's work. I also refer to the Kamakura period sculptures and paintings of Nio (a fantastic figure and temple protector). To this, I have added various influences from my adopted Western background—early Renaissance and Dutch paintings, in particular. It is difficult for me to categorize my current work, since I'm still evolving my own personal style from these diverse inspirations.

Early in my career I did three-dimensional work in fiberglass and resin, utilizing abstract forms. There was a tactility and sensuousness in the forms that interested me. Erotic drawing was the next phase, followed by the most opposite theme I could think of: McDonald's hamburgers invading Japan. Ocean pollution, toxic-shock syndrome, and an AIDS series followed.

Currently, I am working on themes relating to modern computer culture and the escalating level of violence in the world. My outlook on these issues has become less country-specific and more global.

Issues are the starting point for my paintings, but art needs visual engagement and poetic resonance to make the work strong. Art should provoke a satisfying aesthetic experience or it ends up as merely a technical exercise. The advantage of figurative painting is its ability to express specific ideas through the inherent meaning of each figure.

My inspiration comes from many sources: Seeing other artists' work, talking to friends, watching movies or TV news, reading, traveling. Actually, everything I do. Life in Hawaii gives me a lot of ideas. Its natural environment and mix of cultures often play a part in my paintings.

"Utagawa Kunisada has been an inspiration for my figure drawings; Hokusai, for my wave paintings. Hieronymus Bosch, who had an endless imagination and painted social, political, and religious issues, continues to be an inspiration. Early Renaissance and Gothic paintings have a strong aesthetic pull for me. Among contemporary artists, I have found the work of Edward and Nancy Reddin Kienholz, Ann Hamilton, Manuel Ocampo, and Joel-Peter Witkin stimulating and provocative."

**New Views of Mount Fuji/
Ocean Cleanup**

1979

Watercolor on paper

11" x 55"

Collection of the artist

BORN

Onomichi, Japan,
1936

EDUCATION

B.A., Aesthetics,
Kwansei Gakuin
University,
Kobe, Japan

M.F.A., Painting,
Otis Art Institute,
Los Angeles, California

MEDIA

Watercolor and
mixed media

AWARDS

Artist's Fellowship,
National Endowment
for the Arts,
Washington, D.C.,
1980, 1989

Distinguished Alumnus
of the Year Award,
Otis College of Art
and Design,
Los Angeles, California,
1994

SOLO EXHIBITIONS

Masami Teraoka,
Whitney Museum
of American Art,
New York, New York;
Honolulu Academy
of Arts,
Honolulu, Hawaii;
Newport Harbor
Art Museum,
Newport Beach,
California,
1979-90

Masami Teraoka,
The Oakland Museum,
Oakland, California,
1983

*Waves and Plagues:
The Art of
Masami Teraoka,*
The Contemporary
Museum,
Honolulu, Hawaii,
1988

Masami Teraoka,
Pamela Auchincloss
Gallery,
New York, New York,
1994

Masami Teraoka,
The Arthur M. Sackler
Gallery/Smithsonian
Institution,
Washington, D.C.,
1996

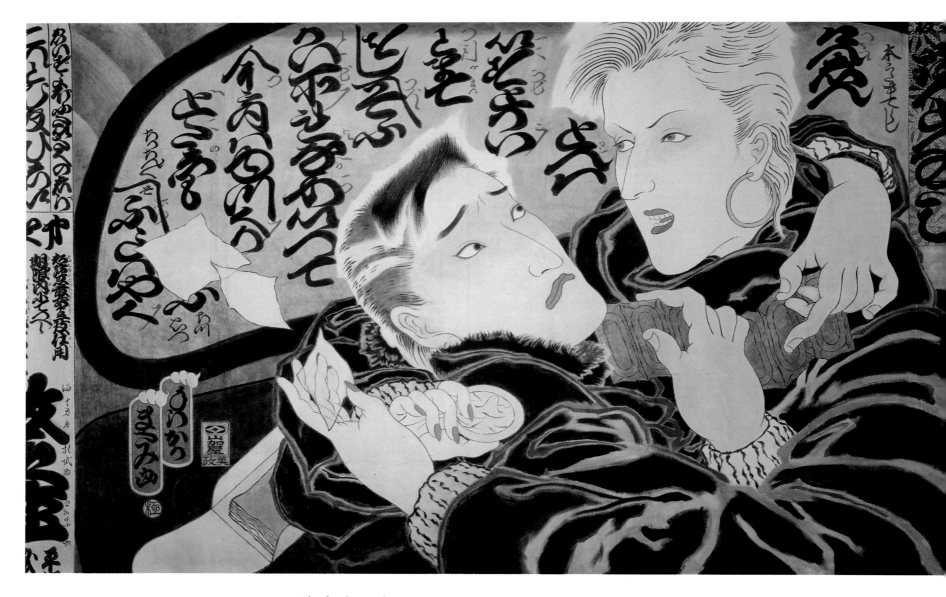

**Tale of a Thousand
Condoms/Mates**

1989

Watercolor on canvas

81.5″ x 136″

Collection of the artist

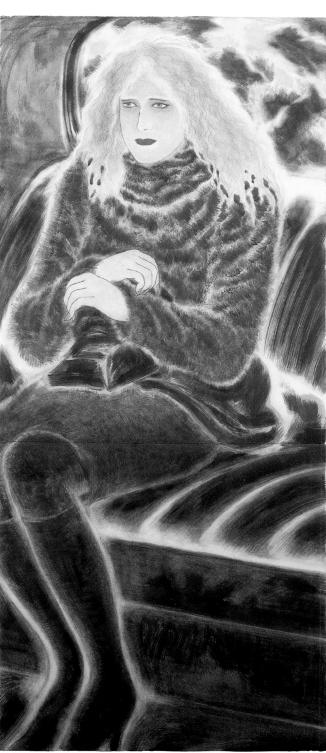

*London Taxi Series/
Emu Woman*

1992

Watercolor on paper

51.25" x 22.5"

Collection of the Hawaii
State Foundation on Culture
and the Arts

Eve and Three Blind Mice

1995

Watercolor on paper

90" x 42"

Private collection

MICHAEL TOM

"There are two artists I would like to meet: John Coltrane, who created music that for him was both meditative and expressive. Michelangelo—to work with him would have been challenging."

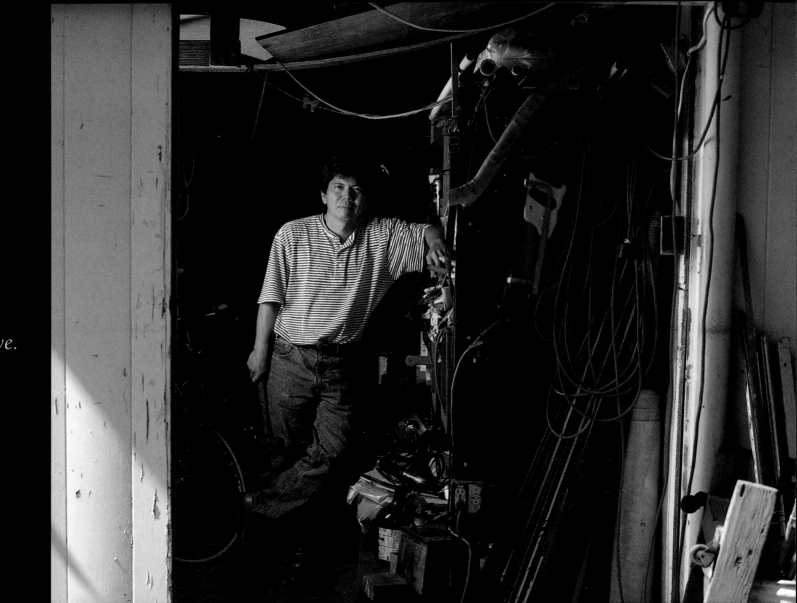

 began my artistic career as a painter. However, over the years the emphasis of my work changed from two dimensions to sculpture and, most recently, a combination of the two. I felt more of a need to physically interact with my artistic medium. After a brief period in which I did no art work, I began experimenting with jewelry. It was not intended to be worn, but it was a sculptural state-ment. Jewelry led to metal-smithing, then to sculpture, and finally to mixed media with an emphasis on fabricated metal.

Much of my work is done in copper. The shapes of my pieces are done by hammering them over large steel stakes and anvils. I will generally leave some evidence of the hammering process on my pieces to suggest human involvement.

I am basically a maker of objects. The object is the language I use to communicate my concerns about human losses and vulnerabilities in post-modern times. I still believe that the artist's voice should open new vistas, either internally or externally.

Over the years, I have worked either directly or indirectly with the theme of death. I've always believed that an artist should be an inquisitor of all phases of human existence and, therefore, questioning death is my way of seeking the purpose of existence.

All my ideas are planned mentally and visualized by drawings. Once a concept begins to materialize, I must realize how best it can be developed. Making a piece may not be difficult, but making a piece that says what you want it to say is difficult. I have pieces that should never have been made, but without them I could never have moved on to the next level.

I intentionally avoid doing representational work of Hawaii. I am not interested in capturing a piece of Hawaii, but I am sure it influences my work at different times. When I was in graduate school, I was assigned to do a silver teapot. I failed miserably because a silver teapot was totally foreign to my upbringing. I eventually made an urn which I remember seeing in temples in Honolulu and in people's homes.

Hawaii does affect my attitude and the way I see things. I grew up learning to accept differences, but there is still this anger from having grown up in a time when ethnocentricity manifested itself in forms of superiority or self-denial.

"Helen Shirk, who teaches at San Diego State University, was very influential in my doing vessel forms. Akio Makigawa, an Australian artist, opened my mind to installations."

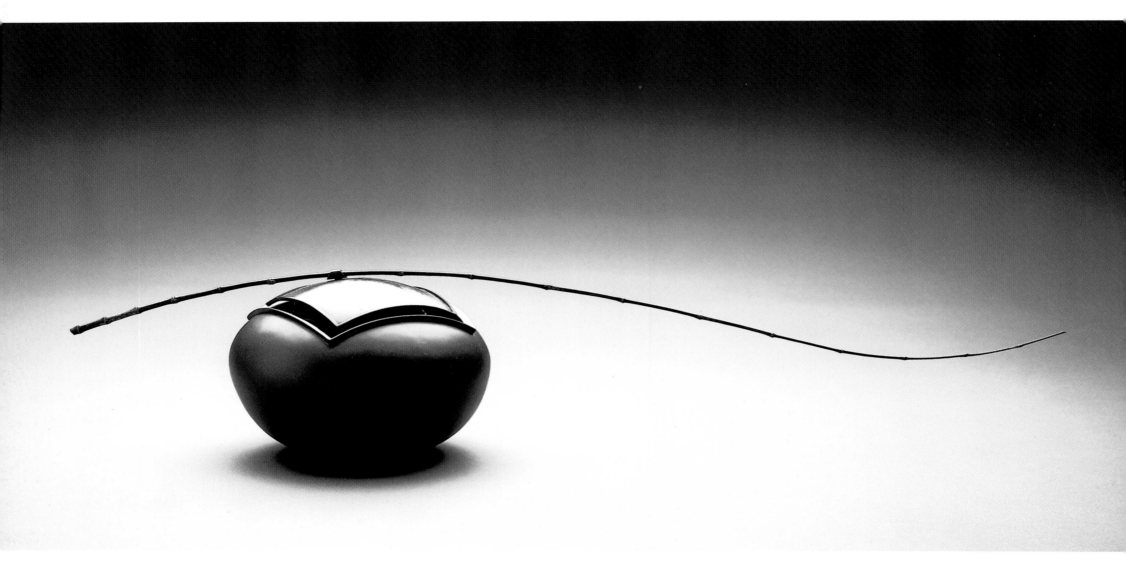

Silence
1982
Copper, black bamboo
8" x 22" x 8"
Private collection

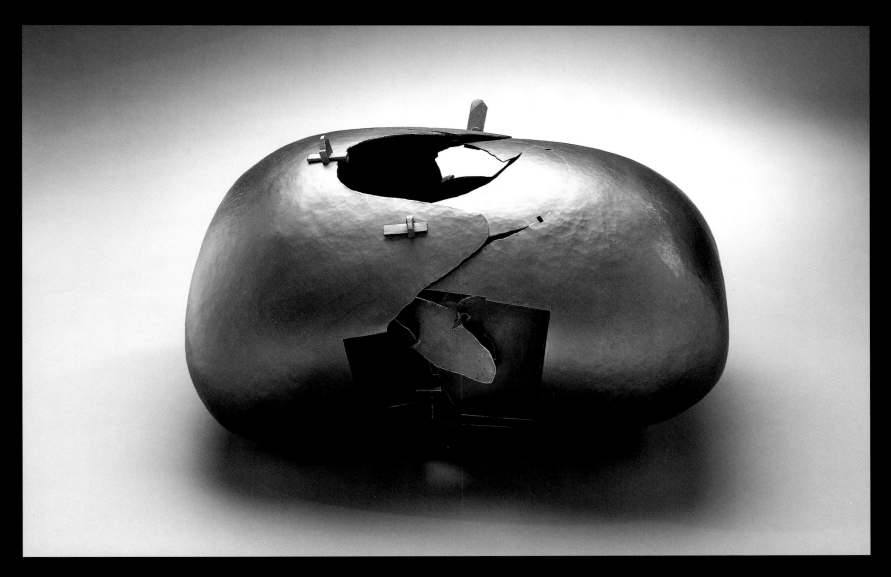

BORN

Honolulu, Hawaii,
1946

EDUCATION

B.F.A., Painting/
Metalsmith,
Sonoma State University,
Rhonert Park, California

Graduate studies,
San Diego State
University,
San Diego, California

Professional Diploma,
Sonoma State University,
Rhonert Park, California

MEDIA

Copper, mixed media

AWARDS

Exhibition Award,
Sarratt Gallery,
Vanderbilt University,
Nashville, Tennessee,
1986

Catharine E. B. Cox
Award,
Honolulu Academy
of Arts,
Honolulu, Hawaii,
1992

Alden B. Dow Creativity
Fellowship,
Alden B. Dow Creativity
Center, Northwood
University,
Midland, Michigan,
1995

Hollow Shell of a Stone

1992

Copper

11″ x 19″ x 13″

Collection of
The Contemporary Museum,
Hawaii

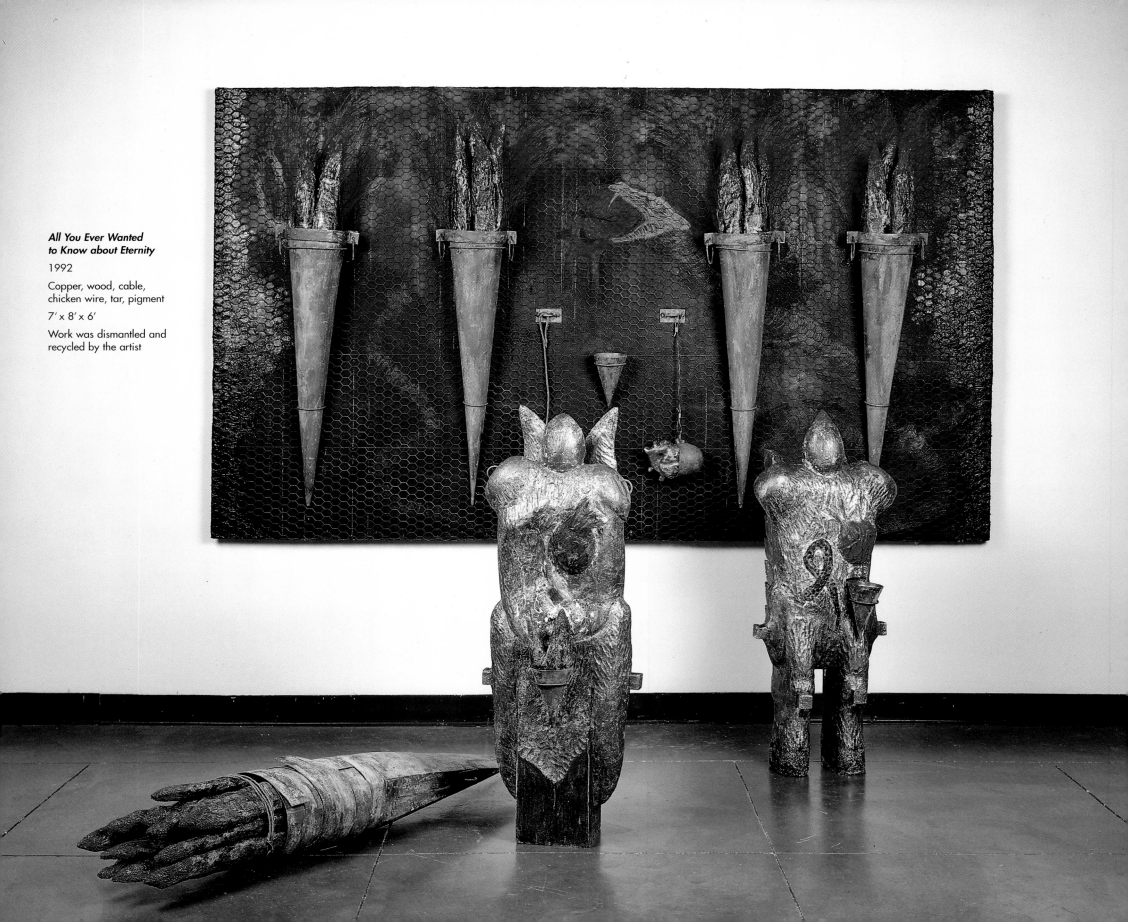

*All You Ever Wanted
to Know about Eternity*

1992

Copper, wood, cable,
chicken wire, tar, pigment

7' x 8' x 6'

Work was dismantled and
recycled by the artist

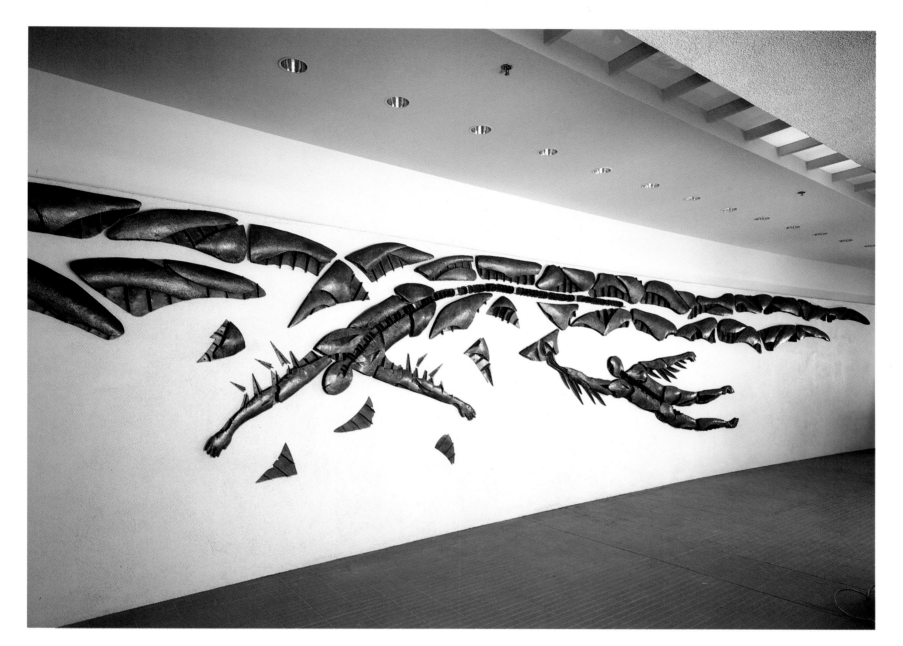

Unknown Shores
(detail)

1994

Copper

9' x 70' x 6"

Collection of the Maui
Arts and Cultural Center,
Hawaii

SOLO EXHIBITIONS

Vessel as Metaphor,
Contemporary Arts
Center,
Honolulu, Hawaii,
1985

Metals Exhibition,
Appalachian Center
for Crafts,
Cookeville, Tennessee,
1986

Exhibition Award,
Sarratt Gallery, Vanderbilt
University,
Nashville, Tennessee,
1986

Recent Work,
Cox Award Exhibition,
Honolulu Academy
of Arts,
Honolulu, Hawaii,
1992

ROY VENTERS

"I have met Andy Warhol but I would like to have met him on a more professional level. I would have liked to work in his Factory. If it's about sculpture, give me the Pop artists of the mid-1960s and early 1970s."

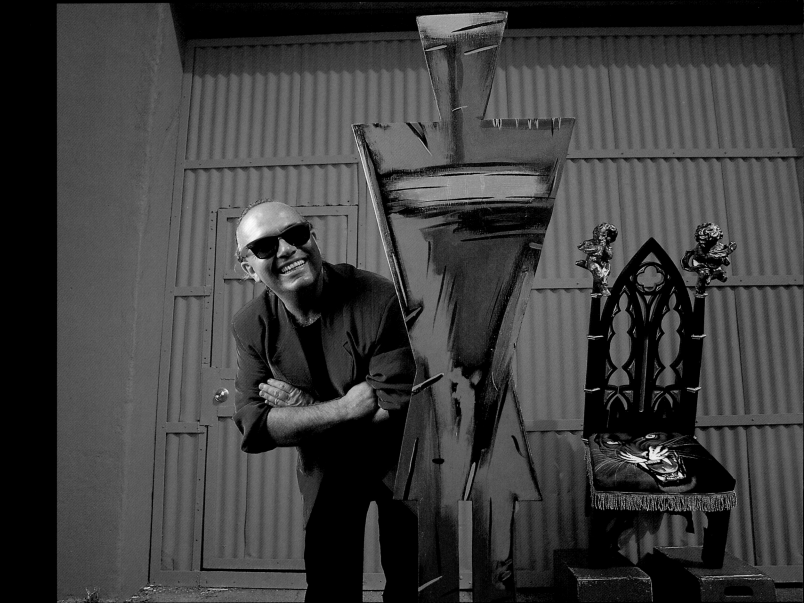

My work is about the riot of obsession. I think my work is visceral; at times it breaks the rules. Not for the sake of breaking the rules, but it has an irreverent quality about it that I really enjoy. My work is self-indulgent. I get lost in what my vision is and I can pretty much disregard and shut out all the rest. It gets me into trouble sometimes. Every time I have a show, I try to reveal a portion of my vision. I consider myself a future primitive and an urban archaeologist.

When I'm working with traditional two-dimensional materials, I really want it to become three.

I love internal dialogues. I have a level of taste that can be dark, another that can be whimsical and funny, and another that deals with serious issues of the time. I try to put it all together in the work: hunting, gathering, searching for intellectual ideas and materials that go with these ideas. My work is really a beautiful collection of things that means something to me and sets up a visual language.

Process, thoughts, and pieces of things out of context have always been parts of my work. Taking one thing from one place and putting it in another means another metaphor of thought. You have to actually view and consider the process that it went through. So the process of the work is important; that's been true since the very beginning.

I really love to shop. I shop for materials. I get out there, look at things and see what kind of triggers start to go off. It's a combination of my state of mind, what's happening in my life, what's happening in the world and then—an object. Suddenly an object triggers a direction. Then the concept starts to roll like a snowball. The metaphor comes before and during the process. For the viewer, it's after. Sometimes it's not the same metaphor. I love it when a piece suggests something to someone else that has not occurred to me.

A strong piece allows the viewer to have a totally different interpretation. An artist who doesn't want to have another interpretation is kind of missing something. I've been known to say I know exactly what I'm doing even when I don't.

Hawaii influences my work quite a bit. The culture is really strong here. It has made a big difference in my primitive style—the Hawaiiana, the myth and mystery, the masks, tools, and the whole lifestyle. On another level, it's just very sensual to me. The clarity of color here is really wonderful. The quality of life is real important to me. I like the laid-back quality of the lifestyle. The stress is off, though that is changing. And there's a healthy competition here among artists. They're willing to share their ideas, to talk, to network. I think in Hawaii you get to keep a little more of your soul.

"Laila Twigg-Smith, Fred Roster, Barbara Engle, Ken Bushnell, Helen Gilbert, Harue McVay, Roman Maziarz."

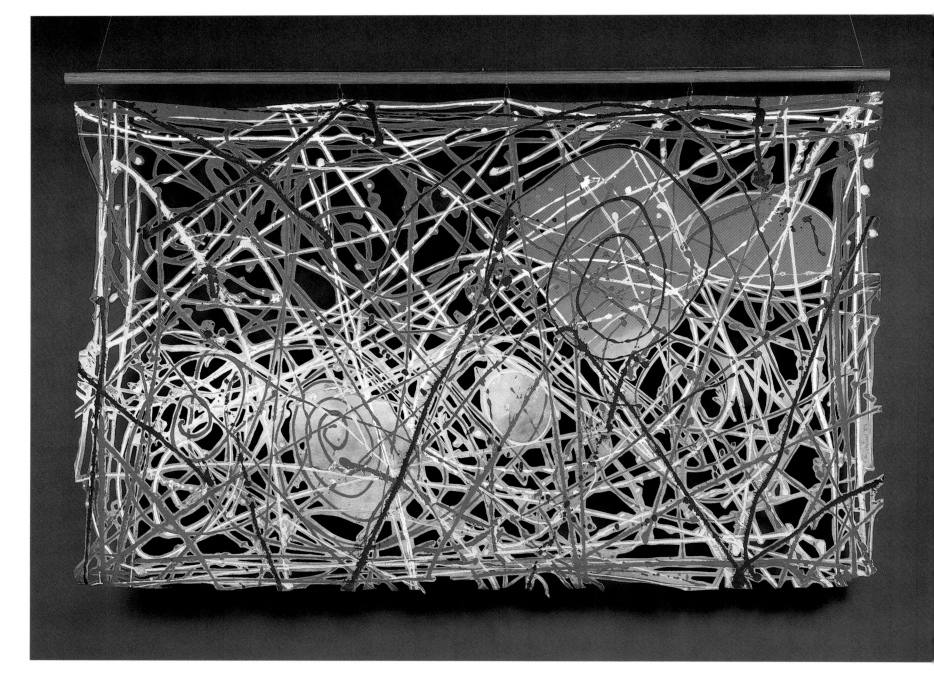

Soft Landing

1984

Mixed media

52.5" x 84"

Collection of the Hawaii
State Foundation on Culture
and the Arts

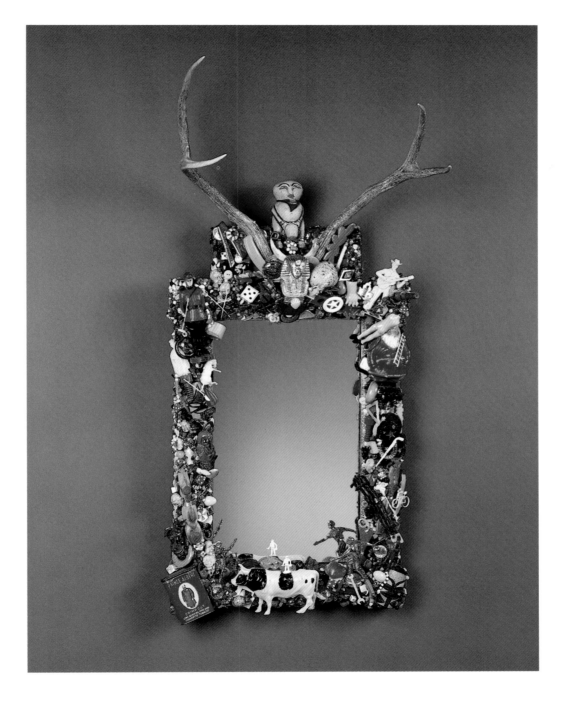

Shrine to Self
1990
Assemblage
48" x 20" x 14"
The Persis Collection,
Hawaii

BORN

Fleming-Neon, Kentucky,
1949

EDUCATION

B.F.A., Sculpture,
Morehead State
University,
Morehead, Kentucky

Sculpture,
University of Hawaii
at Manoa,
Honolulu, Hawaii

MEDIA

Mixed media,
found objects

SOLO EXHIBITIONS

Mixed Space Travel,
Contemporary Arts
Center,
Honolulu, Hawaii,
1975

Future Primitive,
The Contemporary
Museum Cafe,
Honolulu, Hawaii,
1990

Mud,
The Hot Java Cafe,
Honolulu, Hawaii,
1993

Ritual B.B.Q.,
Keiko Hatano Gallery,
Honolulu, Hawaii,
1994

Arte Povera,
Lucoral Museum,
Honolulu, Hawaii,
1994

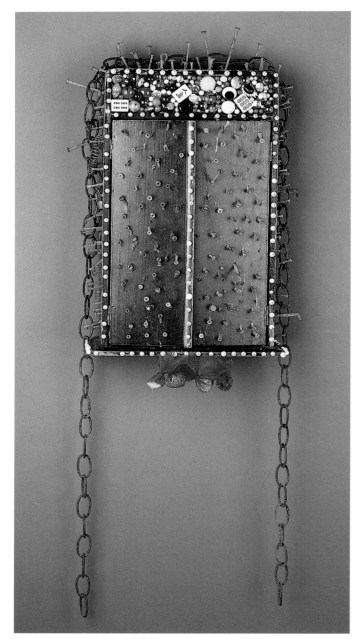
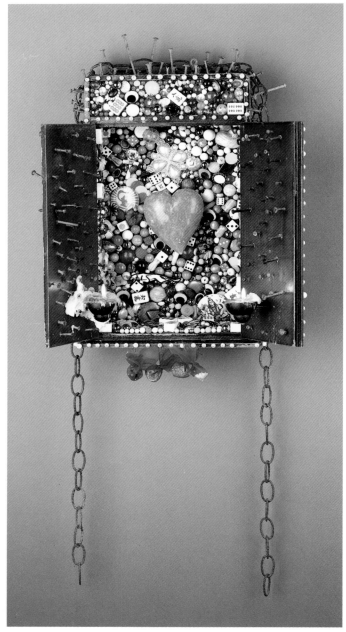

Heartbreak

1994

Assemblage

38" x 18" x 9"

The Persis Collection,
Hawaii

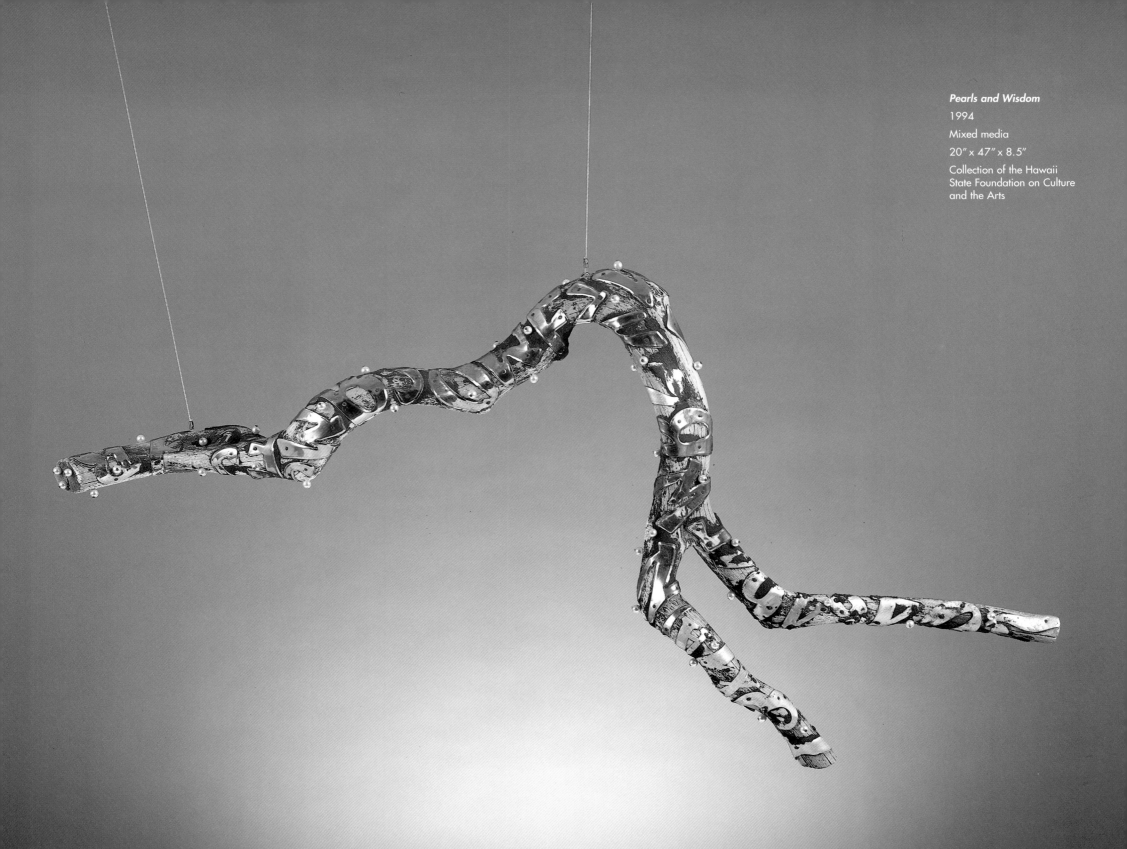

Pearls and Wisdom
1994
Mixed media
20" x 47" x 8.5"
Collection of the Hawaii
State Foundation on Culture
and the Arts

SUZANNE WOLFE

"I would like to meet lots of artists: Joseph Nigg, an Austrian china painter who did flower and landscape paintings on tiles that would knock your socks off; I want to know how he did it. The sculptors who made the set of Lohans from the Liao Dynasty. Josiah Wedgwood—he was a fantastic innovator of ceramics. My favorite contemporary artist— Laurie Anderson."

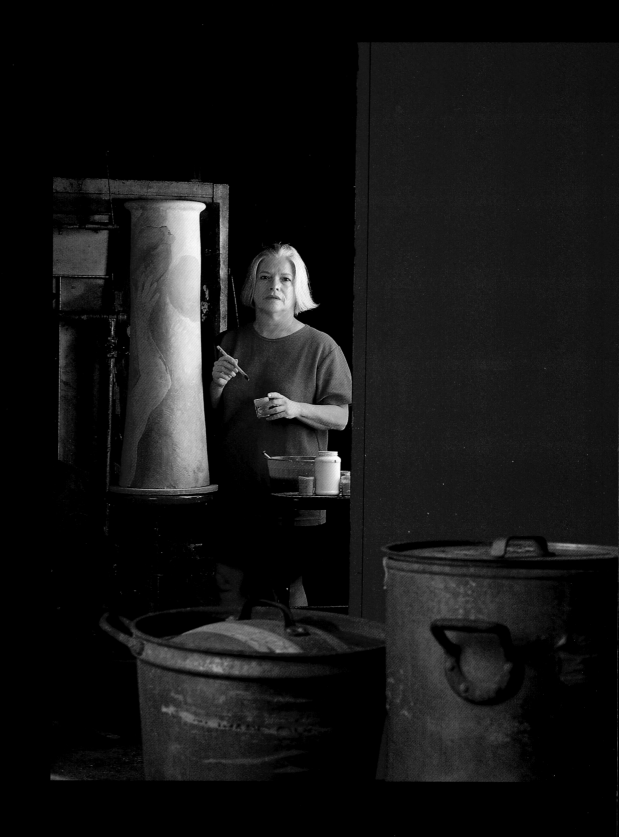

began in painting but I kept realizing that I wanted to paint around the edges of everything. And I couldn't understand why my brush would only touch the canvas surface and I couldn't go around the corners somehow. After two semesters of painting, I realized what I wanted to do was deal with things that were real in space. So I switched to sculpture. I finally managed to get into a ceramics class; I touched clay and I knew I was home.

After school, I went off to France. I worked in a pottery there—production pottery using French clay. The material was intriguing to me because it was greasy and you could never wash it off. I returned to Chicago and got a job in computers. Then I came to Hawaii to teach at the University of Hawaii at Manoa. Otherwise, I could have been a computer programmer today.

I like teaching because it makes me think about my ideas. Art trains you to look at things in a critical, non-linear, intuitive way. It's important in terms of discovering alternative ways of thinking about things. We're looking at a total redefinition of art and we need to give our students the wherewithal to go out there and explore, develop, survive.

There are approaches to clay other than a plastic one. I'm comfortable today with a loose way of handling the material, something that was not true 10 years ago, for example.

There are so many different kinds of clay that can become or represent so many different kinds of other materials that it's mind boggling. And there's the surface; the fact that you can actually paint on a form is really intriguing to me. There is nothing like glaze on a piece for depth and texture and surface. It beats paint hands down in terms of richness.

I've always been intrigued with ugly things. People accuse me of making ugly things. Much of my work has to do with more abstract ideas than comments about specific things. I do

slip casting because I gravitate to images. I like to take common images and transform them by changing their contexts. My interior/exterior vessels really have to do with what's inside, what's hidden on the inside coming out. I'm interested in surfaces and in what's underneath those surfaces.

When I first moved here, Hawaii influenced the way I approached color and surface. There seemed to be so much color here that I couldn't see the form—visual cacophony.

I appreciate living in Hawaii because of the generosity toward different views. There's a certain attitude about "Live and let live" and that "Your views don't threaten my views." It's really wonderful; it makes me feel comfortable, though I'm not convinced that being comfortable is always important or beneficial to our lives.

"Bob Stall, my teacher when I was a grad student, was my best mentor."

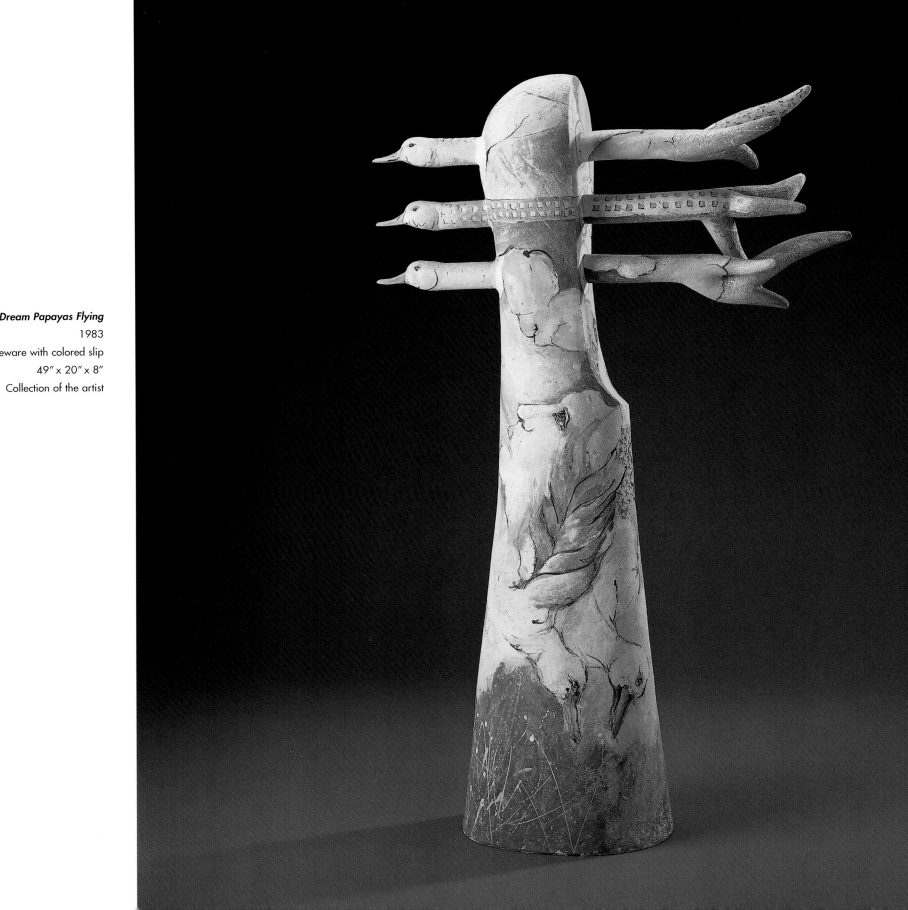

Dream Papayas Flying
1983
Stoneware with colored slip
49″ x 20″ x 8″
Collection of the artist

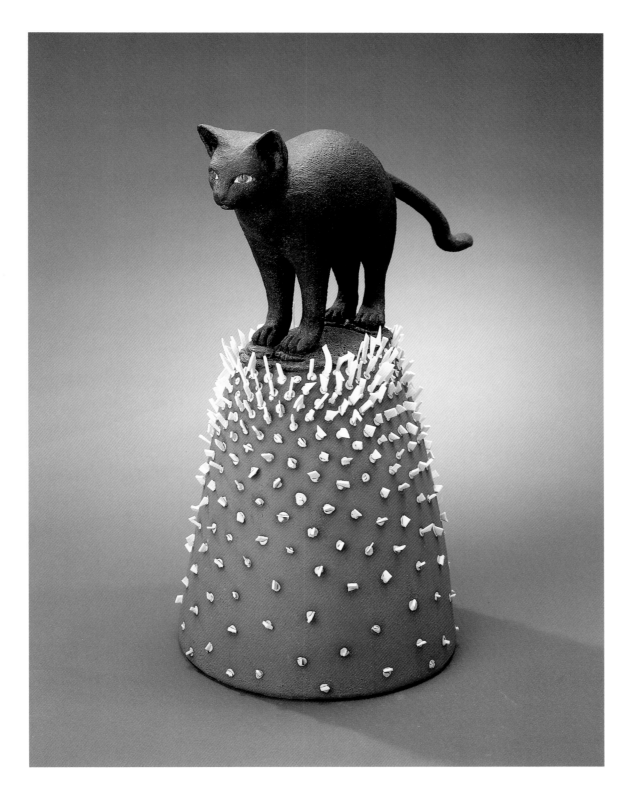

It's Tough to Be at the Top
1985
Stoneware with
porcelain shards
30" x 18" x 18"
Collection of
The Contemporary Museum,
Hawaii

BORN

Chicago, Illinois,
1942

EDUCATION

B.A., Anthropology,
University of Michigan,
Ann Arbor, Michigan

B.F.A., Fine Arts,
University of Michigan,
Ann Arbor, Michigan

M.F.A., Fine Arts,
University of Michigan,
Ann Arbor, Michigan

MEDIA

Clay, mixed media

AWARDS

Faculty Enrichment
Award for Professional
Development,
Chancellor's Office,
University of Hawaii
at Manoa,
Honolulu, Hawaii,
1981

Arts and Humanities
Fellowship,
College of Arts
and Humanities,
University of Hawaii
at Manoa,
Honolulu, Hawaii,
1990

SOLO EXHIBITIONS

Recent Ceramic Sculpture,
Contemporary Arts
Center,
Honolulu, Hawaii
1981

Ceramics,
The Art Loft,
Honolulu, Hawaii,
1984

New Works,
The Art Loft,
Honolulu, Hawaii,
1986

The Play,
The Contemporary
Museum,
Honolulu, Hawaii,
1988

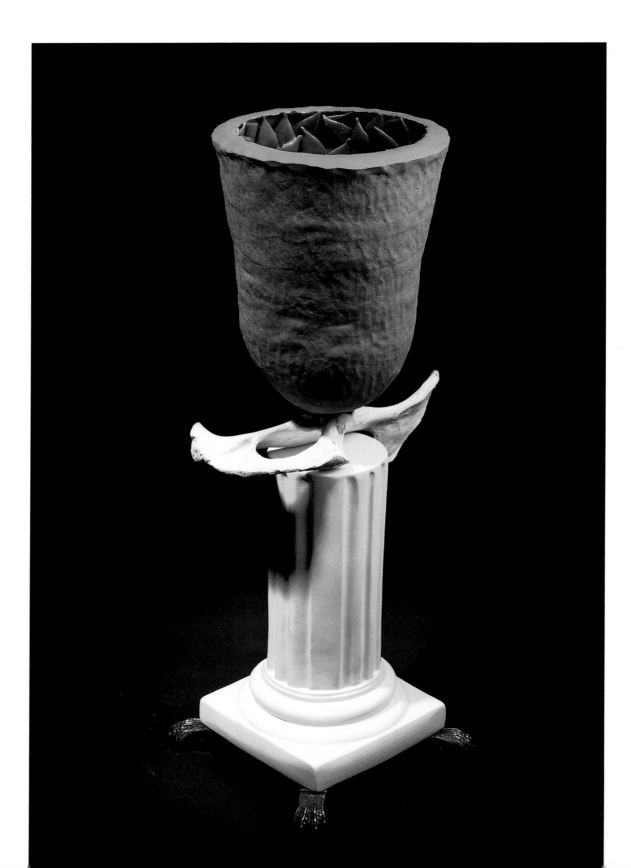

***Other Ways of
Getting There***

1993

Low-temperature clay,
bone and bronze

40″ x 8″ x 8″

Collection of the artist

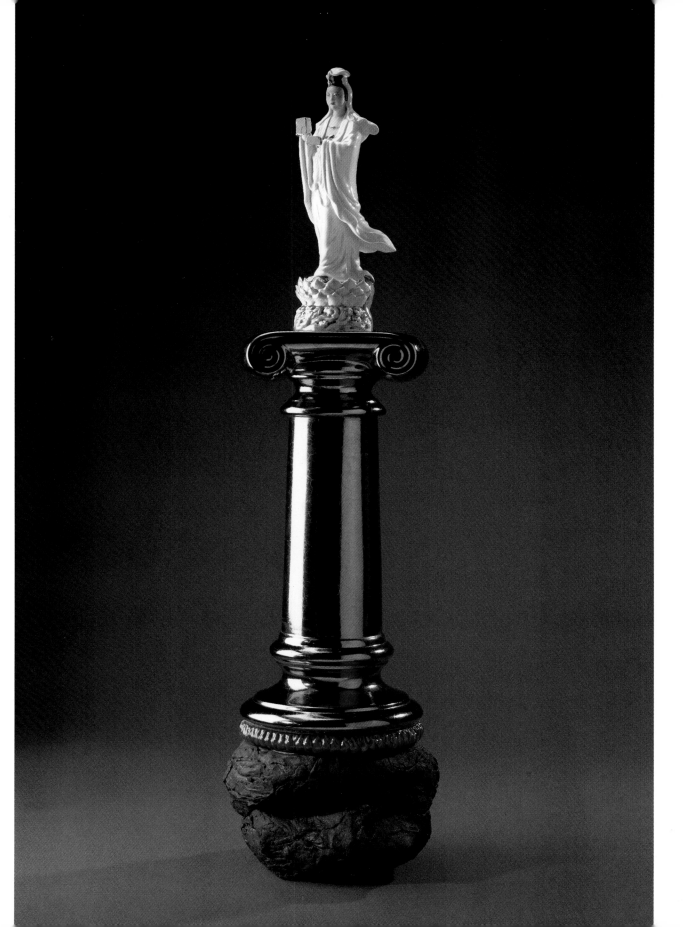

**Frustrations of the
Contemporary Bodhisattva**

1994

Fabricated and found
ceramic objects

47" x 11" x 10"

Collection of the artist

DOUG YOUNG

"When I was in college, I used to listen to the Allman brothers a lot. There was a guy who used to play with them, Duane Allman. He died in a motorcycle crash. I wish I could have seen him play. The same goes for jazz artist Paul Desmond."

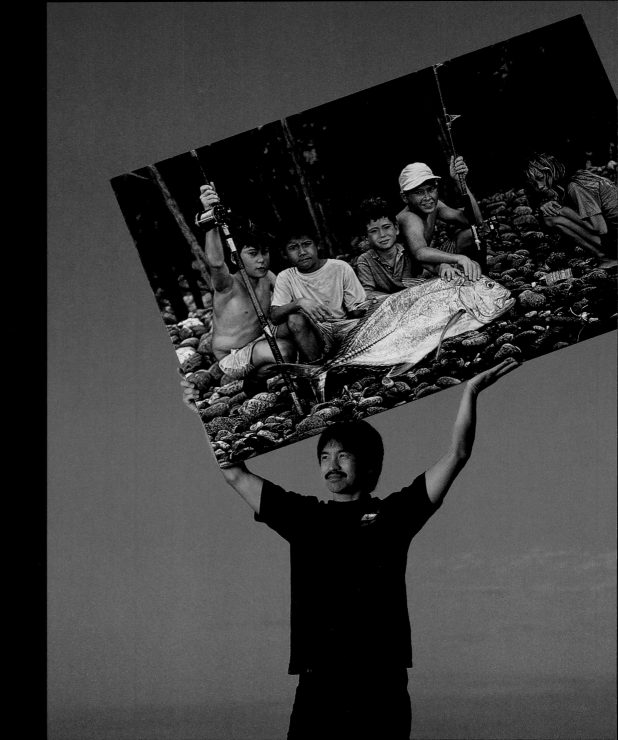

When I went to college in Iowa, part of the program was to send people to New York on a work-study basis. I worked in galleries, installing shows, stretching canvases, sweeping floors, just to get the feeling of how they do things.

I was an assistant to Duane Hanson in New York and Germany for two years. I worked for Ivan Karp at O. K. Harris in Soho. People were warm, mellow; it helped me in settling down to business and providing a steady life as a full-time artist. If I really wanted to be an artist for art's sake, I would have stayed in New York. But my family is here, I love being here, next to the water. I like to surf. You have to balance your life.

When I was in New York in the early 1970s, the thing that was happening was photo-realism. I brought it back here and have been mixing it with local imagery. I've done a lot of different series: Chinatown, koi images, Hawaii Theatre, Civic Auditorium, places we used to hang out. Another was the fish auction series; I was painting fish and then I got into fishing. Painting, in this case, influenced my lifestyle—though in most cases it reflects my interests.

In the photo-realistic frame of thought, you're catching an instant: while the sun is always moving, the light is always changing. The painting comes out to be a conglomeration of maybe a whole day or couple of days that you've been there. Photo-realism is such a precise record; it's based on moving images and you're actually capturing an exact moment. My sketchbook is the camera. I can take a series of shots, put the camera down and then I can go and experience the place.

I don't see myself as a pure photo-realist, separate from the image and uninvolved. I'm really involved in my image because that's how my life is. From the camera to the canvas, it's your gut feeling. I have my own personal feelings about the subject; I'm connected to it.

I do this sectioning of images because life, really, is a conglomeration of all these different, uneven experiences that come at you. A lot of them don't come at you perfectly; they're overlapping. We think ideally as a perfect picture, like a perfect sunrise. At times, it's not, but when you reflect back, you know in an Eastern way it is. I'm always playing with that duality in life—yin and yang; our perception of what is perfect and what really happens.

I always like to see a connection to Hawaii and I hope I can show my love for Hawaii. I want to connect an earthiness to a place or subject, to give it a sense of Hawaiianness, of localness. You can paint the same building and go back another day. It would be the same building, but it would be a different perspective. You can always go back; it's endless.

All that matters is painting as true as you can. Once you put it down on the canvas, you can't go back and change it. I'm here to be a mirror, to hold it up and paint the images of our time. And another guy will paint the images of his time. Pretty much matter of fact. I just do what I like to do. It's hard to tell someone that because once you begin to paint an image, you're stuck with it for many, many months.

"My art teacher Robert Kocher. Duane Hanson whom I worked with in New York and Germany. Luis Jimenez, a sculptor, and painter Eleanore Mikus."

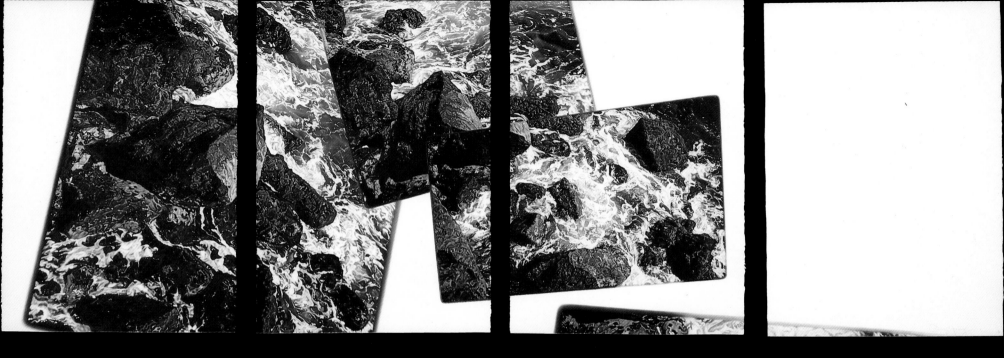

East End Moloka'i

1986

Watercolor on paper

67" x 191"

Collection of the artist

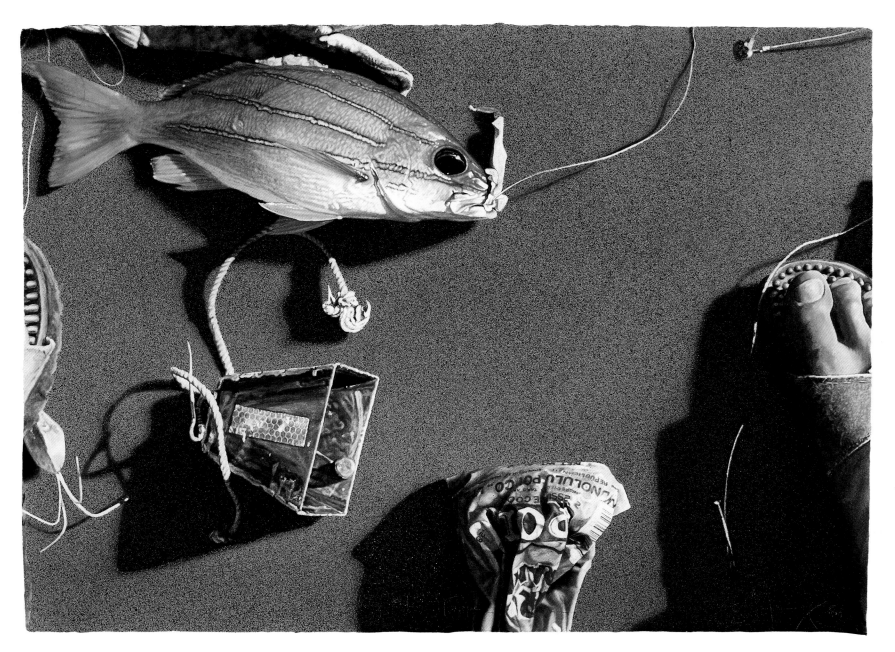

BORN

Honolulu, Hawaii,
1951

EDUCATION

B.F.A., Fine Arts,
Coe College,
Cedar Rapids, Iowa

New York University,
New York, New York

University of Hawaii
at Manoa,
Honolulu, Hawaii

MEDIA

Watercolors, acrylic on
canvas, photography

AWARDS

Best in Show,
Fine Arts Gallery,
San Diego, California,
1976

Hawaii Artists League
Award,
Hawaii Artists League,
Honolulu, Hawaii,
1981

Samuel O. King Award,
Springfield Art Museum,
Springfield, Missouri,
1990

Individual Artist
Fellowship Merit Award,
Hawaii State Foundation
on Culture and the Arts,
Honolulu, Hawaii,
1995

Taape, Fish Study 1
1989
Watercolor on paper
22" x 30"
Private collection

SOLO EXHIBITIONS

Doug Young,
Contemporary Arts
Center,
Honolulu, Hawaii,
1974

Doug Young,
Space Gallery,
Los Angeles, California,
1977, 1979, 1988

I'a Stew,
Contemporary Arts
Center,
Honolulu, Hawaii,
1983

Moloka'i Journal,
The Contemporary
Museum,
Honolulu, Hawaii,
1991

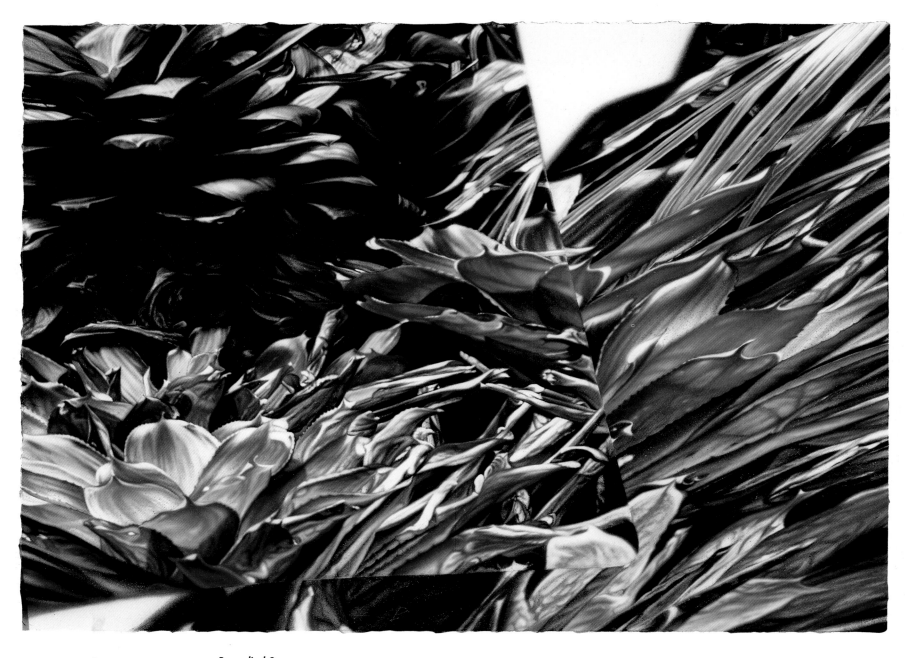

Bromeliad 2
1993
Watercolor on paper
45″ x 60.75″
Private collection

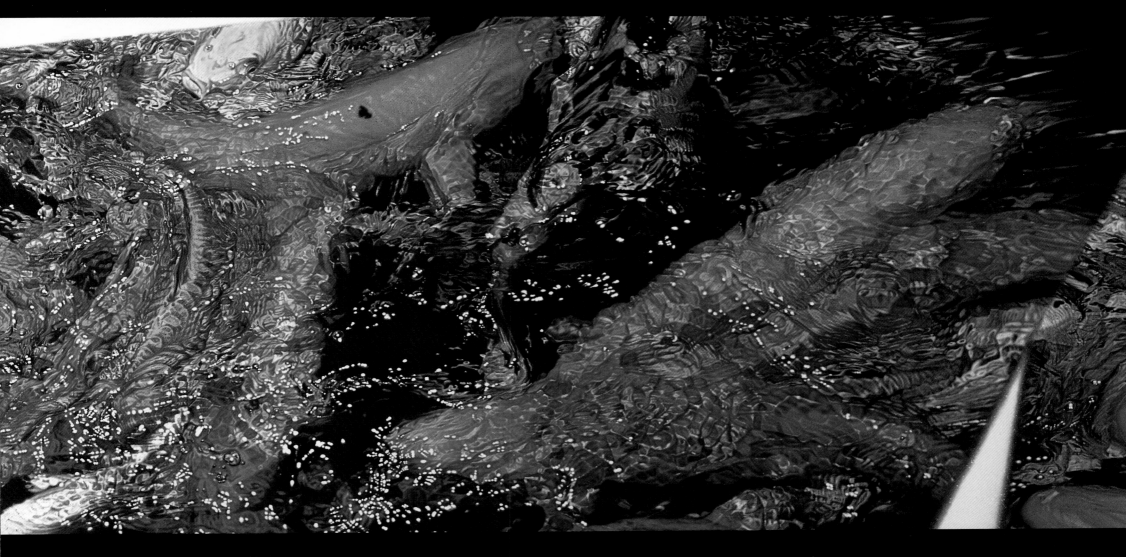

Koi Series 19
1993
Acrylic on canvas
42.5" x 90"
Private collection

PHOTO CREDITS

All photographs in *Artists/Hawaii* were taken by Dana Edmunds except for the following:

Tibor Franyo:

Page 23, *The Garden Club,* courtesy of the Honolulu Academy of Arts
Page 25, *Ritual Protection,* courtesy of the Honolulu Academy of Arts
Page 47, *Sand Ripples,* courtesy of the Honolulu Academy of Arts
Page 101, *Shiro Momo,* courtesy of the Honolulu Academy of Arts
Page 114, *All You Ever Wanted to Know about Eternity,* courtesy of the Honolulu Academy of Arts

Bradley Goda:

Page 42, *Still Water*
Page 43, *Midden and the Made*
Page 70, *Fertile Meadow*
Page 71, *A Letter to Myself*
Page 126, *Other Ways of Getting There*

Moira Hahn:

Pages 106 and 107, *New View of Mount Fuji/Ocean Cleanup*

Lynda Hess:

Page 108, *Tale of a Thousand Condoms/Mates*
Page 109 (Right), *Eve and Three Blind Mice*

Franco Salmoiraghi: Pages 76, 77, 78, and 79

Shuzo Uemoto: Page 41, *Walking Man*

Doug Young: Pages 130, 131, 132, and 133